D0759895

War of the Unknown Warriors:
Memories of Britain 1939-45

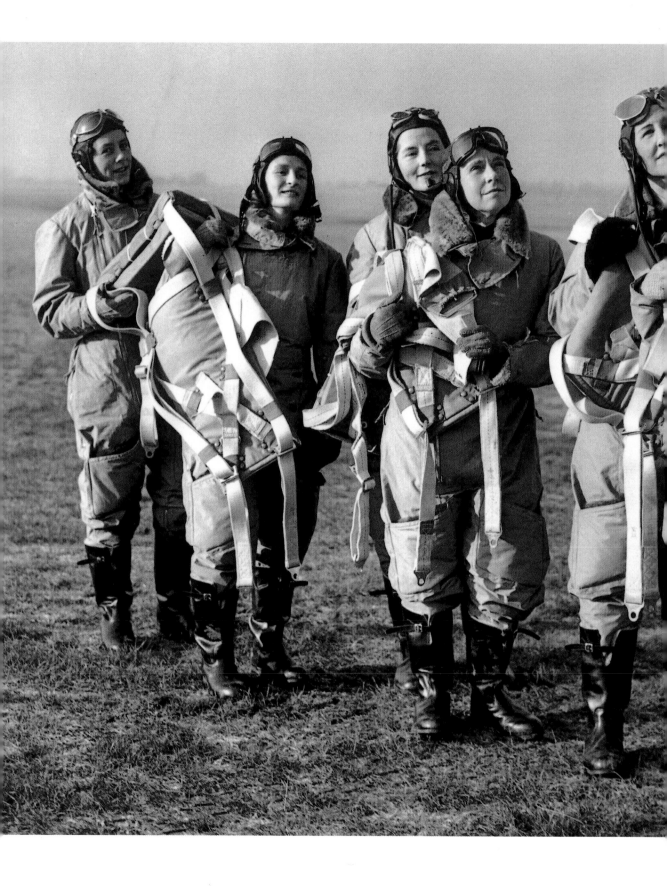

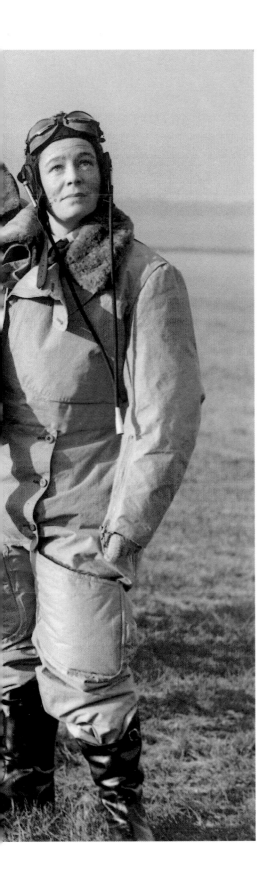

War of the Unknown Warriors: Memories of Britain 1939-45

David Souden

The National Trust

First published in Great Britain in 2005 by
National Trust Enterprises Ltd
36 Queen Anne's Gate
London SW1H 9AS
www.nationaltrust.org.uk

Text copyright © David Souden 2005
Oral archive transcripts copyright © The National Trust 2005

ISBN 0 7078 0388 8

No part of this publication may be reproduced in any material
form whether by photocopying or storing in any medium by
electronic means whether or not transiently or incidentally to
some other use for this publication without the prior written
consent of the copyright owner, except in accordance with the
provision of the Copyright, Design and Patents Act 1988 or
under the terms of the licence issued by the Copyright Licensing
Agency of 90 Tottenham Court Road, London W1P 0LP

The moral rights of the author have been asserted

Cataloguing in Publication Data is available from the British
Library

Picture research by Grant Berry
Designed and typeset in Quark Xpress 4.0 and New Baskerville
Printed and bound in Italy by G. Canale & C.s.p.A

Previous pages: A group of women pilots of the Air Transport
Auxiliary (ATA) Service photographed in their flying kit. The
'Legion of the Air', as it was sometimes called, was made up of
women of all nationalities who were trained as pilots and performed
a vital function in delivering planes from factories to squadrons,
shuttling planes back for repairs and providing transportation and
communications

Contents

Chronology

1939	1 June	Women's Land Army formed
	1 September	Germany invades Poland
		Evacuation begins in UK
	3 September	UK declares war on Germany
		First air raid warnings – false alarm
	17 September	USSR invades Poland
	mid-September	British Expeditionary Force arrives in France
	30 November	USSR invades Finland
1940	9 April	Germany invades Norway
	10 May	Germany begins invasion of Low Countries
	10 May	Neville Chamberlain resigns;
		Winston Churchill becomes Prime Minister
	14 May	Netherlands surrender
	14 May	Formation of Local Defence Volunteers (later Home Guard)
	25 May	British Expeditionary Force withdraws from France
	28 May	Belgium surrenders
	29 May	Internment of 'enemy aliens'
	4 June	Dunkirk evacuation ends
	10 June	Italy declares war on UK and France
	22 June	France signs armistice, establishment of Vichy government
	10 July	Battle of Britain begins
	17 July	Hitler orders plans to invade Britain
	August	Renewed evacuation programme in Britain
	7 September	Blitz on London begins
	17 September	Cancellation of German invasion of Britain
	October	Italy invades Greece, invasion repelled
	31 October	Battle of Britain effectively over
	13 November	Bombing of Coventry
	29-30 December	Bombing of City of London
1941	March	US Congress passes Lend-Lease Act
	28 March	Italian navy defeated at Cape Matapan by British
	6 April	Germany invades Yugoslavia and Greece
	17 April	Yugoslavia surrenders
	24 April	Greece surrenders
	1-7 May	Bombing raids on Liverpool
	10 May	Rudolf Hess attempts to broker peace between Germany and UK
	18 May	Italy surrenders in Abyssinia
	24 May	British battlecruiser HMS *Hood* is sunk
	27 May	German battleship *Bismarck* is sunk
	22 June	Germany attacks USSR
	12 July	UK and USSR sign Treaty of Mutual Assistance
	12 August	Signing of Atlantic Charter between USA and UK
	7 December	Japan attacks US fleet at Pearl Harbor
	8 December	UK and USA declare war on Japan
	11 December	Germany and Italy declare war on USA

1942	19 January	Japan invades Burma
	15 February	Fall of Singapore to Japan
	February	Intensive bombing raids on Germany begin
	23 April	First 'Baedeker' air raid on Exeter
	21 June	Fall of Tobruk to Germany
	7 August	USA forces land on Guadalcanal, Solomon Islands
	19 August	British raid on Dieppe with heavy losses
	4 November	British victory over Germany at El Alamein
1943	January	Germany surrenders to USSR at Stalingrad
	16-17 May	Dambusters raids on Germany
	9 July	Allied invasion of Sicily
	3 September	Allied invasion of Italy
	8 September	Italy surrenders, Germany resists in Italy
1944	January	Siege of Leningrad relieved
	June	Rome liberated
	6 June	D-Day landings in Normandy
	16 June	V1 bomb raids begin on Britain
	4 July	Japan defeated in Burma at Kohima-Imphal
	July	First German concentration/extermination camps liberated in Poland
	1 August	Warsaw Rising
	15 August	Allied landings in southern France
	25 August	Paris liberated
	26 September	Failure of Allied offensive at Battle of Arnhem
	December	German re-offensive in Ardennes
1945	January	V2 rocket raids begin on Britain
	4 February	US troops liberate Manila
	February	Destructive Allied bombing raids on Dresden
	22 March	Allies cross the Rhine
	16 April	USSR troops reach Berlin
	25 April	Allied and USSR troops meet on River Elbe
	30 April	Hitler commits suicide
	2 May	German forces surrender in Italy
	2 May	Berlin surrenders to USSR
	7 May	German forces surrender
	8 May	VE (Victory in Europe) Day
	May	Rangoon liberated
	6, 9 August	Atom bombs dropped by USA on Hiroshima and Nagasaki
	14 August	Japan surrenders
	15 August	VJ (Victory over Japan) Day

Introduction

T is a scene that has been re-staged countless times in British films and television dramas. Across the nation, groups huddle round a wireless set. The date is Sunday 3 September 1939, the time 11.15 am. Over the airwaves comes the voice of the British Prime Minister, Neville Chamberlain. The ultimatum given to Herr Hitler and Germany, to pull back from the invasion of Poland or face the consequences, expired at 11 am but there has been no reply. 'Consequently,' the brittle voice says, 'I have to tell you that we are at war with Germany.'

Gladys Leigh was a housemaid at the Kent house, Emmetts, in 1939 when she took part in a real-life version of this scene.

> *I can remember us all sitting round the radio in the maids' sitting room and hearing that war was declared – and wondering what we were all going to do and what was going to happen …*

Meanwhile, at Sudbury Hall in Derbyshire, Sheila Donnelly was one of many Manchester schoolchildren who had been evacuated from the city to live in the big house and its surrounding estate cottages. She had different emotions when she heard the news:

> *We were walking in the village and, as we were not very old, the thoughts of war did not mean very much to us, only that this holiday we had come on would last a bit longer. Hurray!*

Rather than being at home at Sissinghurst Castle in Kent with his wife, Vita Sackville-West, Harold Nicolson MP was attending to pressing parliamentary business in London. His diaries record the twists and turns of public life in the 1930s and 1940s. On the day that the war was declared, he was with a group of fellow-politicians:

> *I watch the minute-hand of my watch creeping towards 11 am, when we shall be at war. When the watch reaches that point, we pay no attention. The Prime Minister is to broadcast at 11.15 and we have no wireless. The housemaid has one and she comes and fixes it up in a fumbling way. We listen to the PM. He is quite good and tells us that war has begun. But he puts in a personal note which shocks us. We feel that after last night's demonstration [of poor control in the House of Commons] he cannot possibly lead us into a great war.*

Previous pages: Early morning in the misty grounds of Kingston Lacy in Dorset. It is hard to believe that this peaceful parkland was home to a large American hospital complex purpose-built to cater for casualties from the D-Day landings in 1944

Right: A newspaper seller on the Embankment in London displays a placard giving the news which all had feared

There were many others who did not hear directly, but were soon informed of the news. The stepbrother of Marion Game (now Ricketts), in the Dorset village of Pamphill on the Kingston Lacy estate heard it on the wireless on the Sunday morning.

> *So he rushed up the road into the church and handed a note to the Reverend Parry-Evans, who gave it out at the morning service. From then onwards, everything seemed to change.*

So much did change in the six years that followed, before the ending of fighting in the Far East in August 1945. Memories like these and contemporary photographs reproduced here record the experiences of those years – as refracted through the lens of the National Trust. Human interest at home is at the heart of this

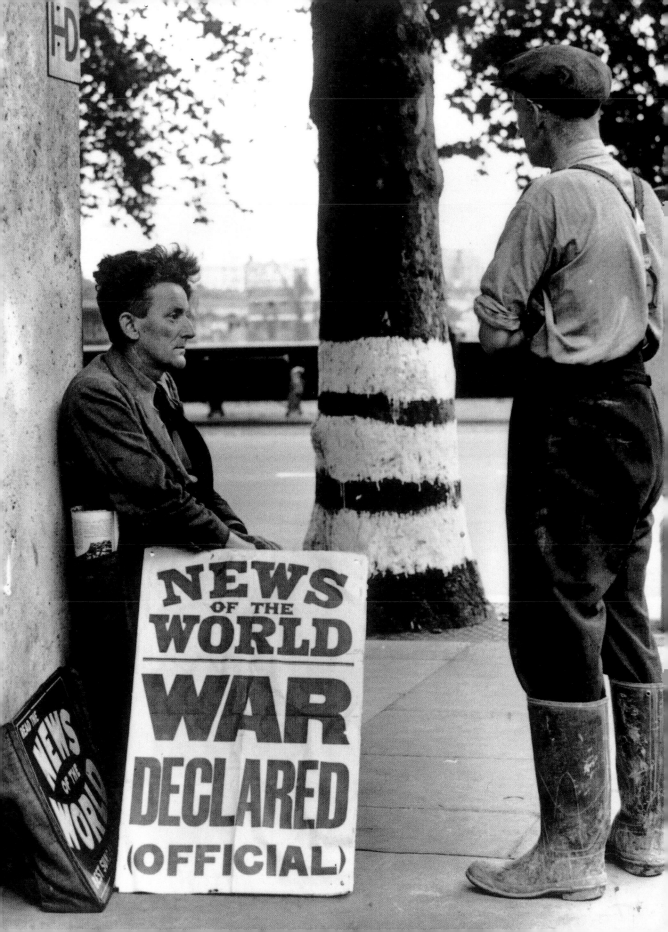

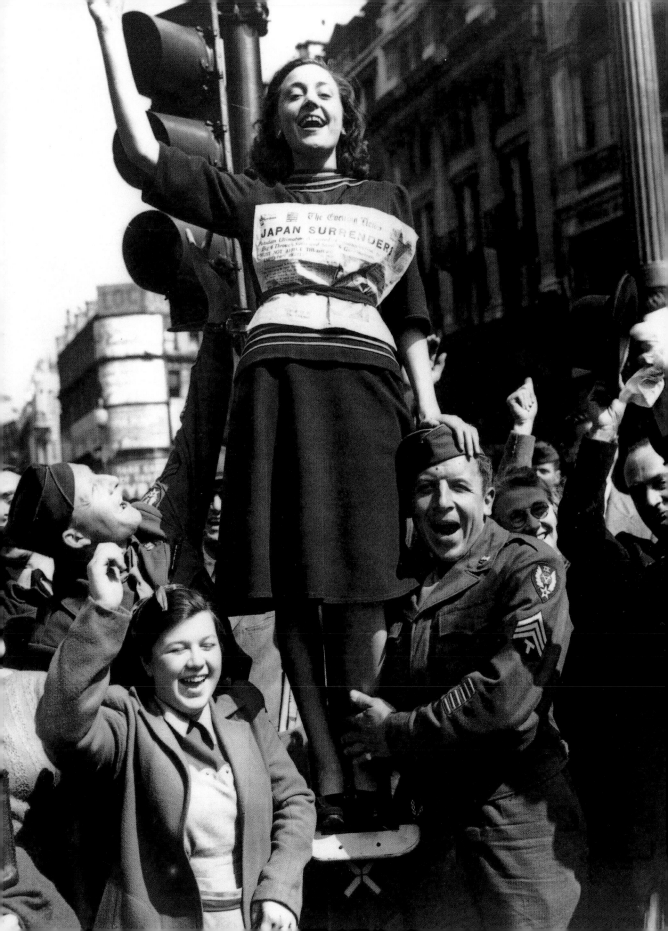

book. Here are experiences that were quite ordinary or quite extraordinary, sorrows and joys, the curiosity of children and the world-weariness of adults who had lived through a previous world war. These are the often-untold stories that have helped shape the world since 1945 – and that often reshaped the places that the National Trust now owns.

Between 1939 and 1945, Britain had for a time been forced right back to the wall, standing alone in a Europe otherwise totally dominated by Nazi Germany. The fears that Britain too would be invaded and overrun were real, although the invasion never came. Across England and Wales, there was dislocation: millions were moved, either to places of safety or because their properties were needed for war purposes. Town and countryside were subject to massive bombing raids in which tens of thousands died and many more had homes and belongings destroyed. Men and women joined the armed forces; those who could not, and a number who would not, worked on the 'home front' in auxiliary occupations or in jobs that were essential to keep Britain alive. Food was rationed, petrol was rationed, clothing was rationed. At night, the blackout kept the nation in darkness that was lit up by bombing, burning buildings, searchlights and anti-aircraft fire. Large, grand households were obliged to reduce their establishments; the country houses themselves were frequently requisitioned, whether as military bases, art stores or as accommodation.

After 1942, the tide began to turn. With the entry of the USA into a conflict that became truly global after Japan's declaration of war in December 1941, ultimate victory was almost assured. This was still but the mid-point in a long and grinding war. In June 1944 the massed forces of the Allies entered France with the largest invading army the modern world had ever seen, and the final push to victory began. Germany surrendered on 8 May 1945 and Japan surrendered on 15 August, after the first atom bombs had been dropped on Hiroshima and Nagasaki. The Second World War was over.

More than a quarter of a million British combatants had died and 60,000 civilians had been killed by bombing in the course of the conflict. A third of the nation's housing stock had been damaged, and 4 per cent had been totally destroyed. It had cost £28,000 million, financed by taxation and crippling borrowing. In the meantime, the coalition government that had been led by the Conservative Winston Churchill throughout the war (since Neville Chamberlain resigned in May 1940) was roundly voted out by the electorate in July 1945. A new Labour government promised a fine new world, ushering in social reform – notably the introduction of the welfare state – that the war years had shown was urgently needed.

What was it that Britain had been fighting for? There were the clear military objectives: preventing the advance of Germany, defending Britain from attack and invasion, combating the Axis powers of Italy and Japan. The British Empire required protection. Above all, Britain was fighting to preserve the British way of life: family and home; soaring cathedrals and village greens;

Two cheering American soldiers supporting a British girl with a London newspaper tied to her chest giving the headline news of the Japanese surrender on 15 August 1945

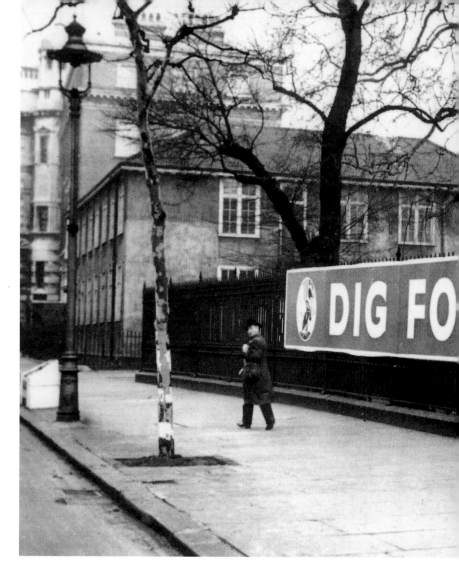

Banners and posters like these from the Ministry of Information were displayed on the streets of towns and villages encouraging the public to do their bit

cockney singalongs and country estates; cotton mills and pints of bitter. Posters everywhere exhorted the people of Britain to *Dig for Victory*, warned them that *Careless Talk Costs Lives*, or asked *What Can You Do?* Billboards with coloured views of the South Downs urged, *This Is What You Are Fighting For.*

In the battle for preservation, the struggle itself brought huge change: the beginning of the end of Empire, the establishment of the ideal of a welfare state and the decline of once-great landed estates. The war years were also a watershed for the National Trust. Founded in 1895 to preserve places of historic interest or natural beauty, it began to acquire for the first time the great series of houses and estates that it now owns in perpetuity for the nation. This frequently stemmed from the fact that the former owners were no longer able to cope.

One of those houses was Dyrham Park in Gloucestershire,

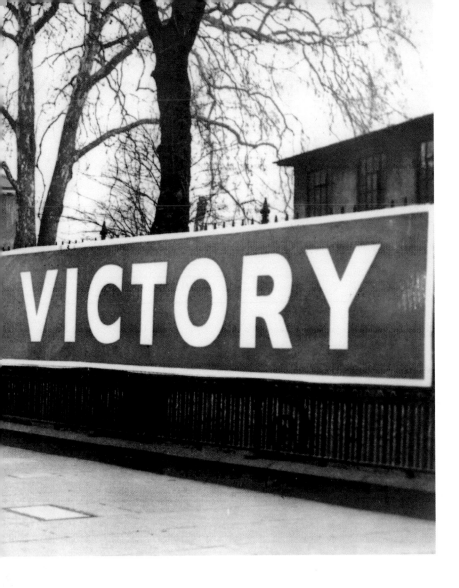

given to the nation in lieu of taxation in 1956. The baroque
house and garden were then transferred to the ownership of the
National Trust by the Land Fund, the official body that acquired
property on behalf of the people of Great Britain. In the transfer
it was explicitly stated that the house was a symbol of the England
that had been fought for in two world wars.

Dyrham Park had itself seen war service, as an orphanage, nurs-
ery and hospital. In the sixty years since the end of the Second
World War, the National Trust has preserved an ever-widening
range of landscapes and buildings. These ranged from beaches
and clifftops to country houses and cottages, suburban semis, tex-
tile mills, and workhouses. None of its properties was untouched
by war. For some, it was a temporary nuisance. In other cases, the
places and their inhabitants were at the heart of the war, whether
seeing action or planning its future stages. In most instances, it
was a matter of everyday survival – 'the one thing you could never

forget for long was that there was a war on', as many whose words fill these pages say.

War of the Unknown Warriors records, in words and pictures, many of the stories and incidents associated with the great range of properties that are now in the care of the National Trust. Memory banks have been unlocked. One of the main sources is the National Trust's own Oral History Archive. Over the last twenty years, a huge body of evidence of life in twentieth-century Britain has been built up in the form of audio recordings with many hundreds of people who have been associated with National Trust houses and landscapes. Property-owners, residents, parlour maids, gardeners, woodsmen, land agents, bystanders, and eccentrics have all taken their turn at the microphone.

This treasure trove of material has had little exposure until now. Often collected for practical purposes, to discover how properties were used in the past, the archive casts piercing shafts of light on to many aspects of British life. Here, that evidence has been combined with diaries and letters from the time. In 2003, National Trust members responded to a call for personal photographs also relating to wartime experiences associated with Trust properties. Thanks to them, to the National Trust Photographic Library and other archives, a wide variety of illustrations – many previously unpublished – is collected here, along with the memories that they too contain.

This is a history of Britain in the Second World War with a purpose: not only to tap – and record for posterity – recollections of life in wartime, but also to recover hidden histories in familiar places. The scars of war have often healed: ravaged landscapes have been repaired by nature, bomb-damaged houses have been rebuilt, the raw memories of personal loss have faded. The history of wartime use may still be seen as a temporary aberration in the long chronicle of a historic house – yet it is as much a vital part of a house's story as the roll-call of architects and artists who originally built and adorned it, and one that relates directly to the lives of many.

Given the nature of the places in the Trust's ownership, this cannot be a comprehensive picture of Britain in the Second World War. The memories and images relate substantially to the countryside and coastline of England, and to a lesser degree Wales and Northern Ireland. Towns and cities are nevertheless far from forgotten – and town and country were closely allied through the experiences of evacuation. Gladys Leigh had sat in Emmetts in 1939

> *wondering what we were all going to do and what was going to happen.*

This is what they did and what happened.

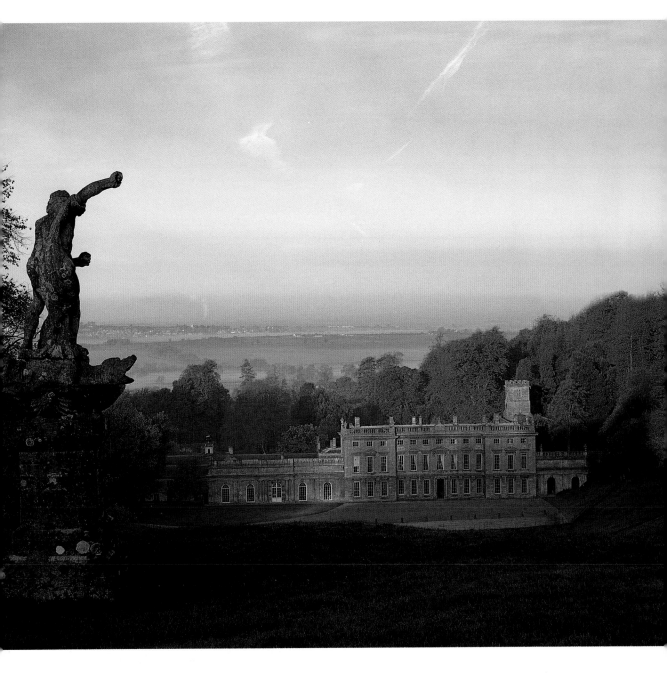

Dyrham Park in Gloucestershire which saw service as an orphanage, school and hospital. It was given to the nation in 1956 as a symbol of the England that had been fought for in two world wars

Back to the Land

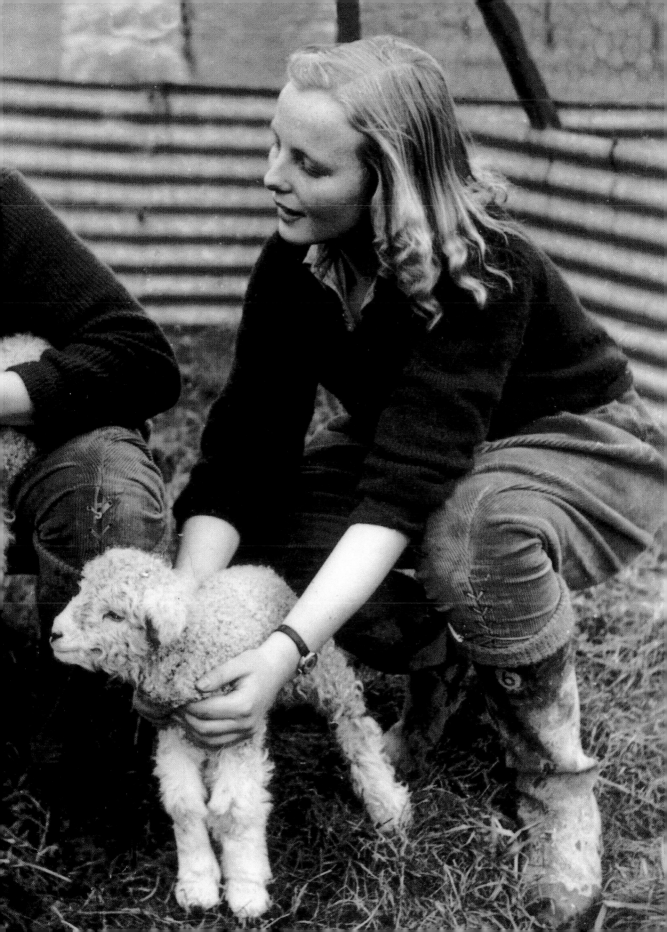

A S the greatest concentration of properties of the National
Trust is in the countryside of England, Wales and North-
ern Ireland, it is in the countryside that the story begins.
Many aspects of rural life were transformed by the experience of
war: agriculture itself, the very underpinning of the countryside;
a greater understanding of townspeople who were persuaded if
not forced to move away to what was perceived as relative safety;
and perhaps above all the realisation that the era of total war
brought the conflict right to people's doorsteps.

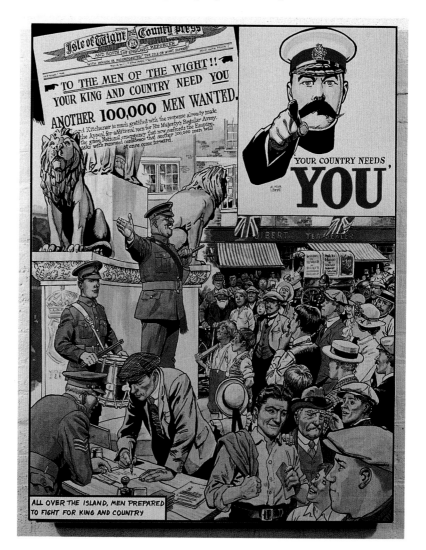

Previous pages: Land
girls' duties were hugely
varied and not confined
to working the land; a
quarter were involved
in milking and general
farm work. Others cut
down trees, worked in
sawmills and over a
thousand women were
employed as rat-catchers

Right: A mural by Geoff
Campion in the Needles
Old Battery on the Isle
of Wight showing the
famous Lord Kitchener
First World War poster
encouraging men to
join up. The battery,
guarding the western
Solent, saw action in
both world wars

The First World War only a generation before had a deeply scar-
ring and emotional effect on the British population, as virtually no
family had been untouched by death and wounding. Yet with few
exceptions, the fighting and devastation took place overseas, on
the killing fields of Flanders or in the eastern Mediterranean. Now,
after 1939, everyone, everywhere was to feel the effects of war.

EVACUATION

During the days immediately before war was declared, the greatest mass migration in British history took place. In excess of two million civilians, the great majority of them children, were taken away from the cities, industrial centres and ports to what was seen as the relative safety of the countryside. It was expected that enemy action would start straight away, and it would take the form of mass bombing of the main centres of population and

Mrs Daphne Hickman (as a child) with fellow evacuees who were temporarily housed in the Church Room, West Wycombe Village in Buckinghamshire. The conditions in the room and loft were extremely primitive. Ladies were accommodated in the room downstairs and men lived in the loft. The evacuees had to use lavatories and get water from a nearby factory. Blankets were hung up to curtain off sections to obtain a little privacy. Nevertheless, some of the evacuees stayed on in West Wycombe after the war

industry. There were to be two more such waves of evacuation in the course of the war, in August 1940 and September 1944, coinciding with each successive danger from enemy attack, the Blitz and the V-bombs. Nothing quite matched in scale or concentration that first mass move; in September 1939 with evacuation and mobilisation, a third of all people in Britain changed address.

Evacuation had a major effect both on those who went and those who received evacuees. Two different parts of Britain that once had had little to do with each other now came face to face – the poverty of the inner cities and the different type of poverty amid the relative plenty of the countryside. It changed a generation; the modern welfare state may be said to have grown out of the distress and dissatisfaction that wartime uncovered. For many children, it was also a liberation.

Posters published on the eve of war showed a mother and children struggling out of a bomb-wrecked city, accompanied by the message:

It might be YOU.

Caring for evacuees is a national service.

The preparations were thorough. The Ministry of Health, Ministry of Transport and Board of Education were charged jointly with the task of organisation. The Women's Voluntary Service

(WVS), founded by the Marchioness of Reading, also played a significant part in overseeing the evacuation process. The first WVS member recruited in Lancashire was Rachel Kay-Shuttleworth of Gawthorpe Hall, who drove 22,000 miles in the first eight months of 1939 inspecting homes, finding reception centres and preparing the way. There, as in many parts of England and Wales, evacuation proceeded incredibly smoothly.

Children in all the main centres were marshalled with their small suitcases and gas masks, in the care of schoolteachers, parents, clergymen or volunteers, on the journey into the unknown – literally so, as most did not have any information on their destination. One London teacher was among those charged with getting children away from the vulnerable cities to the countryside. It was an awesome task:

Right: The great hall at Nymans in West Sussex, transformed from a pastiche 14th-century hall to a 1940s dormitory complete with metal beds and crude tables, although some of the tapestries remained

Far right: Evacuees waving good-bye to their parents from a train window. Poignant scenes like these occurred at many stations across the country as children were sent away to 'safety'. Parents rarely knew where their children were going and could only hope to be sent word of where they ended up

All you could hear at Waterloo was the feet of the children and a kind of murmur because the children were too afraid to talk. We had a big banner with our number in front. Mothers weren't allowed with us but they came along behind. When we got to the station we knew which platform to go to, the train was ready, we hadn't the slightest idea where we were going and we put the children on the train and the gates closed behind us. The mothers pressed against the iron gates calling, 'Goodbye, darling.' I never see those gates at Waterloo that I don't get a lump in my throat.

Terry Dunn and his younger brothers and sister were evacuated from Birmingham to Calke Abbey in Derbyshire. It was all quite a shock to the group of twenty-two children on the train.

We arrived at a small country station. There was this man on the platform, with a walking stick, looking for a certain number of children he could take in. [The schoolteacher] said there was no way the children could be split up, because the older lads had come on the condition they could look after their younger brothers and sisters ... [Colonel Mosley, owner of Calke] took us eight boys, four older and four younger in the house, and the others on the farms and houses outside ...

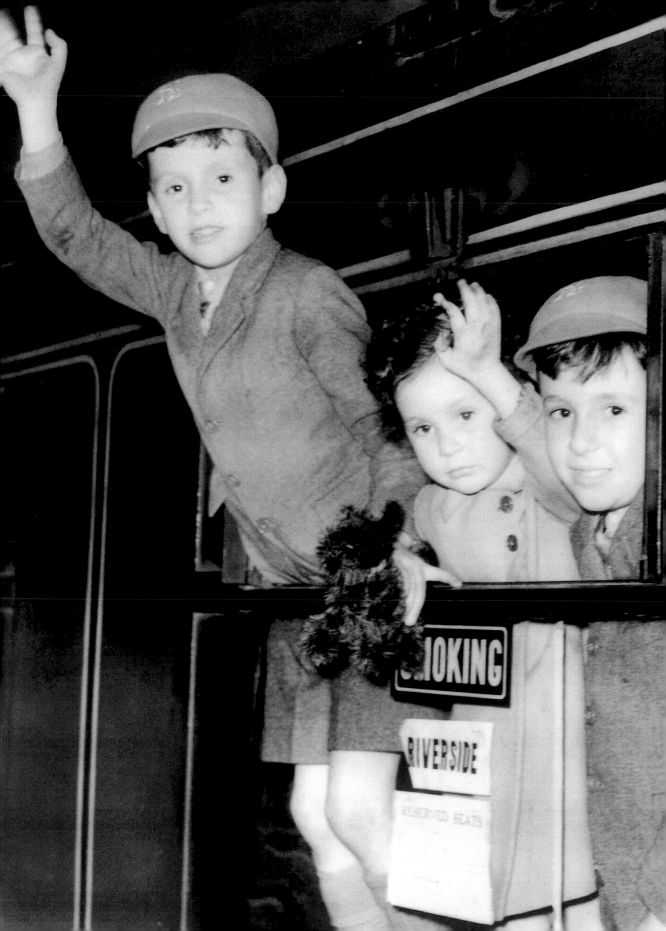

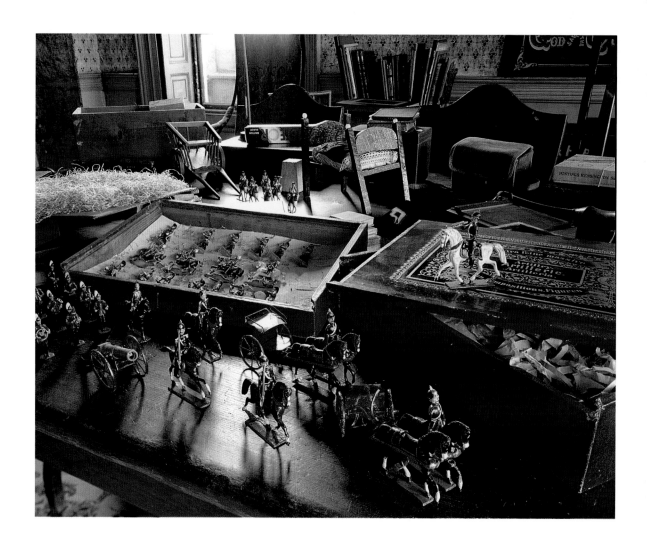

Above: Children had to be kept amused and took much delight in playing at war: their games were never far from the reality of the conflict. These toy soldiers, a relic of earlier childhoods, are from the schoolroom at Calke Abbey

Right: Calke Abbey which to Gerry Dunn looked like Buckingham Palace

To Gerry Dunn aged 8, Calke Abbey 'was more like Buckingham Palace'. He remembers it vividly:

We ... got a view of the Abbey, and somebody said this was where we were going. I didn't believe it. We saw this huge building, a stately home like you see in the films, and I thought there was no way I was going to stay there. They got us off the coach and into the front entrance. I can remember looking round at all the deers' heads – they terrified me. Colonel Mosley, who was a very tall man, came and introduced himself – and that was the last time I ever went into the entrance hall. We were never allowed in the front entrance again.

Evacuated children experienced every kind of situation, from the most luxurious to the most desperate. For the Dunn boys,

It was a Huckleberry Finn kind of adventure, and we were going to make this the thing of our lifetime. School was secondary in our minds. The teachers were fabulous, treating us like their own children ... Every day seemed a fun day – even when it was a school day, we would be off into the woods. It was always like a summer day.

It was not just the woods that beckoned. As Terry Dunn recalls,

We went round the house, often where we were not supposed to go. We found a bow and arrows. Suddenly we became Robin Hood and his Merry Men, opening the windows and firing the arrows out of the gate. Colonel Mosley came round and we had a right ticking off ... The butler was very friendly. He lived on the ground floor, towards what we were told was the dungeons. During one of our visits down there, we found ammunition for a shotgun, and thought, what can we do with it? So we broke it open and laid a powder trail up from the dungeon to the butler's room. We threw the empty cartridge into the fireplace, lit the trail and ran. There was an enormous bang; it was fire all over his bed. The things we did! But we were lads.

For all the fun and games, the evacuees could never forget they were lads in wartime, who 'climbed on the roof when they had air raids on Derby. You could see the lights, and the flash from the guns.' Then at Christmas,

Mum and Dad came and brought us a present – a piece of wood with cut-out German soldiers. You stood with a popgun, stood five yards away, and aimed. When you knocked the cut-out out, the next one came into place. All one afternoon, everybody wanted to use it. We played that for weeks. Perhaps it's still there [at Calke], among all the stuff.

The good times at Calke did not persist for the Dunn boys. Gerry Dunn remembers:

It only lasted nine months. Some children in other places were there for four years. We were taken back in the middle of the summer, and I spent the next three years at nights in an air raid shelter.

At the same time, just before war was declared, Sheila Donnelly was evacuated from Manchester to another Derbyshire house, Sudbury Hall.

On Thursday 31 August my mother told me and my two brothers we were going on holiday for a few days with the school I had previously attended. She bathed us, washed our hair and dressed us in new clothes, and also packed small parcels for us. We thought this was wonderful – a holiday and new clothes! On Friday 1 September we arrived at school with our small parcels, also our gas masks that had been issued to us a few weeks before. (We had to carry these gas masks with us wherever we went.) ... Also a postcard on which we had to write when we arrived at our destination, informing our parents where we were. We eventually arrived at Sudbury village school where a lot of local ladies were waiting to collect their 'evacuees' ... Our names were called along with those of about ten other children and we were taken by a young man in khaki shorts to Sudbury Hall. There were a few very young children in our party and I remember one youngster crying for his mother. His sister, who could have been no more than eight, got into bed with him and nursed him to sleep.

Unlike the Dunn boys, Sheila Donnelly stayed at her new home throughout the war years – a brief return visit to Manchester had proved to be more traumatic than anybody had expected:

My mother decided to have us home for Christmas in 1940 as we had spent Christmas 1939 at Sudbury. On the Sunday night before Christmas

Firemen dealing with blazing buildings during a raid on Manchester, 23 November 1940. The date of the photo is at odds with Sheila Donnelly's recollection of the Blitz starting on the 'Sunday night before Christmas'

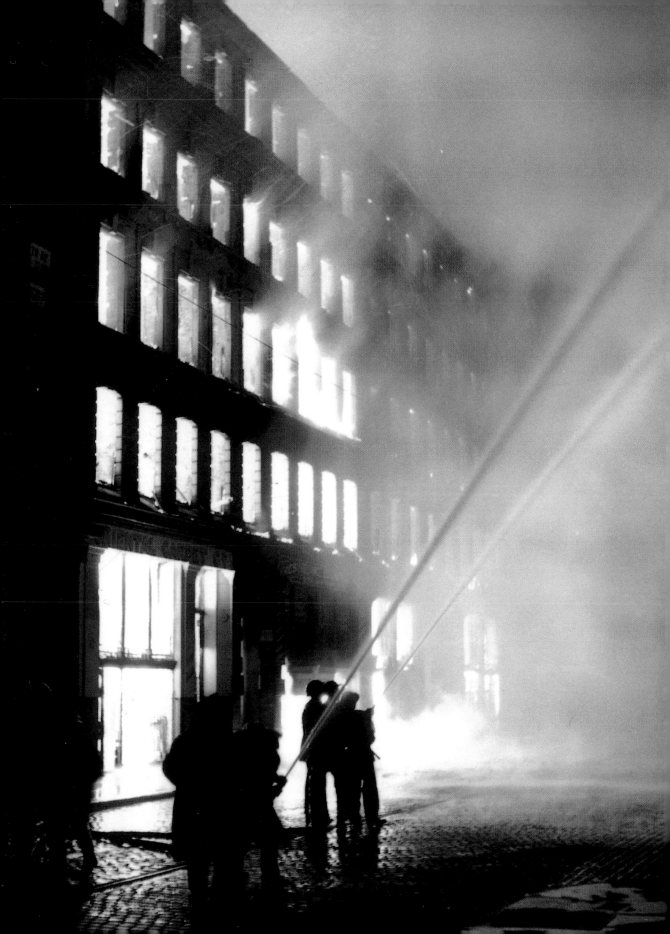

the Blitz started in Manchester. We were taken into an air raid shelter under a warehouse. This caught fire from an incendiary bomb and we had to run out to another shelter whilst bombs were flying around us. It was all very frightening … The next morning we went back [home] to find all the doors and windows had been blown in. My parents decided then and there we had to go back to Sudbury that day. We spent all day travelling back. Monday was the worst night of the Blitz for Manchester. Many people were killed and many made homeless.

Only towards war's end would she see Manchester – and a very different Manchester – again.

Evacuees usually arrived at their destination after long and slow journeys through unfamiliar countryside – 'We got tired of counting fields as we passed them, even though for many of us it was the first time we had seen fields,' one child recalled. Less common modes of transport were pressed into action; contingents of children from south-east London were put on to paddle steamers at Gravesend bound for the coastal villages of north Norfolk, fearing both enemy attack and the waves in equal measure. Many children had to undergo further indignities as reluctant country families eyed up the unfamiliar newcomers. To a child dumped in a Suffolk estate village, it felt like market day:

We were told to sit quietly on the floor while the villagers and farmers' wives came to choose which children they wanted. I noticed boys of about twelve went very quickly – perhaps to help on the farm. Eventually only my friend Nancy and myself were left – two plain, straight-haired little girls wearing glasses and now rather tearful. A large happy-looking middle-aged lady rushed in asking, 'Is that all you have left?' A sad, slow nod of the head from our teacher. 'I'll take the poor things.' We were led out of the hall with this stranger and taken to a farm where we spent two years. Happy years.

Whole schools would be evacuated, even groups of nursery-age children who might find themselves together with their teachers and some of their mothers at the grandest houses such as Waddesdon Manor in Buckinghamshire or Dyrham Park in Gloucestershire, or even at the curiosity of the sixteen-sided Georgian house A La Ronde in Devon. Miss Doris Pleydell-Bouverie had lived at Coleshill in Oxfordshire intermittently from 1924. From her point of view, the evacuees were very strange creatures indeed:

When the war happened in '39, there was the evacuation from London in the 'phoney war', and from the Isle of Dogs – lock, stock and barrel – came the children in the schools there down to Coleshill. Some were quartered on the villagers, some in the house, and all their teachers were in the house. We used to meet together in one of the cellars and have lunch on our rations … This lasted to March of '40, to help with all these children. They all had to be entertained in the evenings. Beena [her sister] took the little boys for sword-dancing, and I took the little girls to make nightdresses. They were quite good, but they didn't really enjoy it much. We kept them occupied.

There was a marvellous moment when everybody began to lose their buttons. The little boys had a funfair of their own, where the currency was buttons – and they came off dresses, old ladies' boots, and anything that

Right: Evacuee children pull on their Wellington boots beneath a marble bust in the dining room ante-room at Waddesdon Manor in Buckinghamshire. These children from London's East End nursery schools were luckier than most in their accommodation

Overleaf above: Evacuees and staff playing in what is now the parterre at Waddesdon

Overleaf below: Dinner-time at Waddesdon Manor for the many small children evacuated there; a huge contrast to the sumptuousness of the dinners enjoyed by Baron Ferdinand de Rothschild, who built the château in 1889

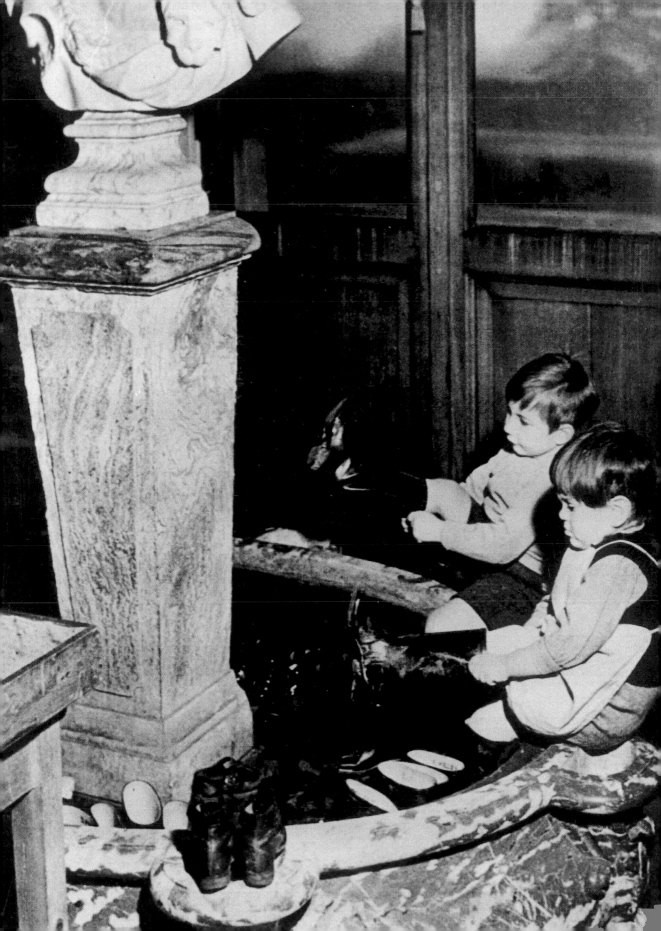

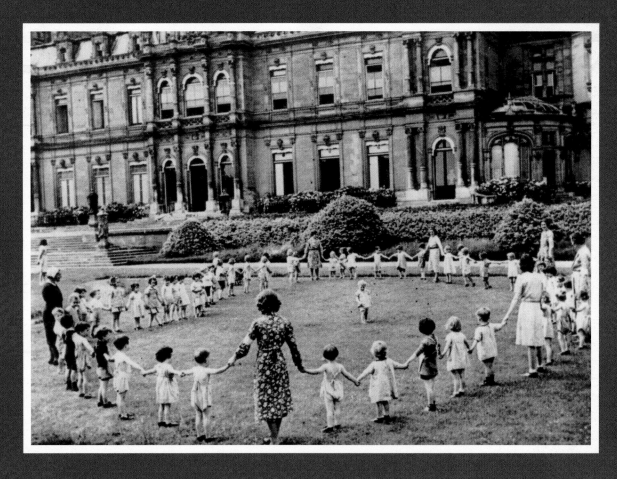

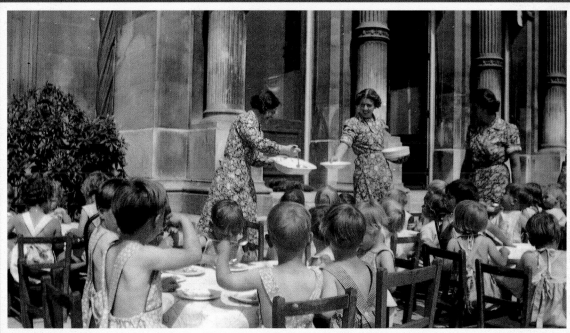

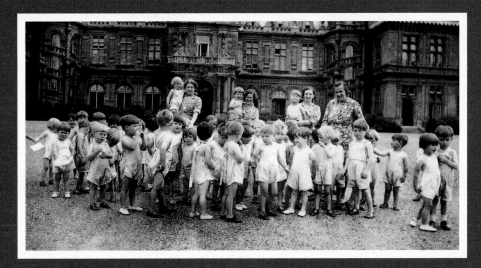

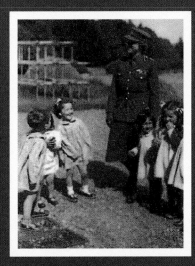

had buttons. (We did get most of them back again.) ... The evacuees adapted extremely well – because children are adaptable – but they were very naughty ... I think they were homesick – but the parents more so than the children.

In other substantial houses, the emphasis was more openly on fun. Evelyn Archer, who was personal maid to Miss Everilda and Miss Violet Agar-Robartes at Lanhydrock in Cornwall,

couldn't go to the war when the war came, for we had seventeen children, evacuees ... But most of the maids went ... [Miss Eva and Miss Violet] decided they would like to have children. Miss Violet went up to our Memorial Club. She was supposed to bring ten back and she brought seventeen. 'I couldn't leave them, Evelyn,' she said. 'Those two, I couldn't keep them apart.' ... Those children had the time of their lives. They worshipped them. They didn't want to leave.

Alex Hodgkinson and his sister Madeleine were the pair that had decided Miss Violet:

[We] had a note pinned to our collars saying that we were not to be split up. My sister was four and I was five years old ... We arrived at Lanhydrock House and were shown our respective rooms in the nursery wing.

These evacuee children did indeed love the spinster ladies of Lanhydrock. Daphne Woosnam was sent to Cornwall from bombed-out London in 1940:

I can see Miss Violet now with the dogs at her heels and children hanging on her arms and a basket, and we'd all go up to the kitchen gardens. She'd got a birthday cake from Bodmin and, walking down there, she ate a pastry in the street – and Miss Eva told her off ... And they played trains. Miss Violet had to be the guard. Miss Eva would be the train driver. All the way round the corridors. We used to play round the front of the house at games or charades. Miss Violet was marvellous at charades ... It was really remarkable when you think they'd had no experience of children ... It was like bedlam, noisy and exciting, another world.

For all the fun, there was also wistfulness and loss – on both sides:

When I first went to the house I was about ten, and when I left I was fifteen, so it was quite a big gap in my life. I came down a child and went back quite a young lady ... I think looking back we were in on the end of the gracious living scene ...

The majority of the nation's evacuees were billeted with ordinary families in ordinary homes. Every woman in the countryside was in theory liable to have evacuees foisted on her. Many welcomed the children, but others resented the strain of taking people in and the forced relations with total strangers. By November 1939, Women's Institute members were describing compulsory billeting as 'dictatorship to the housewife – and after all, we are supposed to be fighting a dictatorship.'

Yet, there was a war on and the threat that posed to vulnerable town families seemed all too real, however 'phoney' the first ten months of conflict proved to be. The Dorset coastal village of Studland was isolated in the war years. The people in most of the

Previous page: Photographs from the family albums of those evacuated to Waddesdon during the war. Many came from Deptford in south London and from Croydon in Surrey. The picture bottom right shows the Princess Royal, George VI's sister, visiting some of the children

Right: Looking down a corridor at Lanhydrock in Cornwall where evacuees were billeted with Everilda (Eva) and Violet Agar-Robartes. Daphne Woosnam describes (see left) how they played trains winding through the corridors with Miss Violet as guard and Miss Eva as driver

surrounding farms and settlements had been forced to leave; all the villagers had to show passes, as the bay was the centre of many experiments and secret military exercises – yet even Studland received its own share of evacuees. Cyril Upshall, who was aged eight when the war started, remembered that it all seemed,

an advantage to us kids. When the evacuees came, the school wasn't big enough, so we did half a day and they did half a day. We had much more time to see what was happening around. It wasn't a war to us, it was an adventure. Everything happened – and we were never far away.

Not everyone valued this excitement. Dorothy Harvey was the chauffeur's wife at Emmetts. Kent proved to be both less interesting and less safe than the authorities had imagined:

A cottage on the estate that was empty, [the American owners] wanted to be let to evacuees should war take place, and would I help my husband get it fixed up with necessities that people would need? … Two families came from Welling with their children. They were soon dissatisfied – because no raids started – but why? They had a really jolly good holiday there, their husbands came out weekends to them, and we were disheartened to see what we had done for them and that was the gratitude shown for it. After that, things got bad, and they put a family bombed out of Croydon in

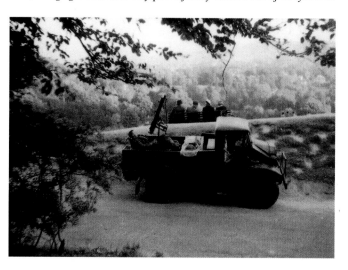

A 15-cwt truck armed with a Vickers heavy machine gun on anti-aircraft (AA) duties at Reigate Hill in Surrey in the tea shop car park. This type of improvised anti-aircraft defence was in use along the Surrey section of the North Downs, defended by men of the Royal Canadian Artillery in August 1940 during the Battle of Britain. The truck is parked in the slip road between the National Trust tea room and the A217 near Reigate Hill. Both road and bench are still there, according to the photographer, Tim Richardson

there. Again, a most ungrateful family. 'How the so-and-so can you live in a place like this? Drive us round the bend – we couldn't do it.'

Her husband William recollects that the countryside came to seem just as dangerous as the town:

Believe it or not, the first plane that crashed in England crashed at Ide Hill church, and the first bomb that fell in our part of England fell at Toys Hill. That was the end of the refugees – 'We're going back to Croydon – don't get bombs there!'

By the early months of 1940 the great majority of evacuated mothers and children had gone home – only for many to head countrywards again when bombing really did begin in the towns and cities.

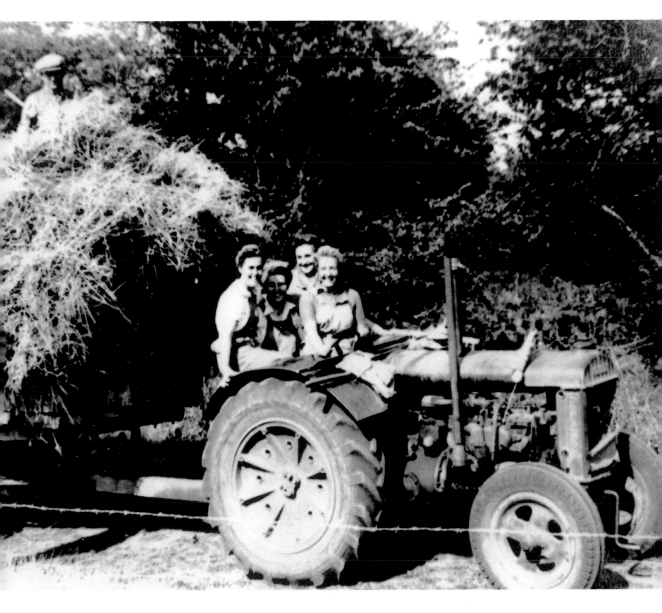

Land girls at Sutton Hoo in Suffolk on a tractor pulling a load of hay. Members of the Women's Land Army swiftly proved that they could do anything a man could do in agriculture

THE LAND

Stan Hollingdale went to work at Saddlescombe Farm, hidden in the Sussex Downs close to Brighton, as a fourteen-year-old lad in 1939. It was even then a farm that seemed trapped in time – and seems all the more so now. The war years helped force new ways of life in this remote place just as much as it did on almost every farm and smallholding in Britain:

When I started there was ten on the farm hand-milking, seventy-odd cows to milk … Still used one of the old threshing machines, steam-driven … My father was shepherd for several years, but he died early. My brother took over until 1942, when they were all moved over to Eastbourne and that was the finish of sheep at Saddlescombe. The military took the ground over for firing practice. The farm sold all the other animals on 8 May, the sheep went a fortnight earlier. They had just a few cows and four horses left. The horses had been used for ploughing, reaping, mowing, carting. Everything was done by the horses but they went in 1942. After that they got mechanised, had their first tractor. It couldn't get into all the places the horses could get, on the sides of the hills …

Long years of agricultural depression, even since the 1870s, had made many areas of rural Britain seem relatively backward. In the 1920s and 1930s, thousands of acres of good arable land remained unfarmed and ill-maintained while agricultural work was low-paid and tenure was often at a landowner's whim. Rural communities felt they were left behind – and many wartime evacuees from towns discovered quite how far the villages to which they were sent had indeed been left behind in terms of basic amenities such as water, electricity and sewerage.

The years of the Second World War and their aftermath were to be a second agricultural revolution. The Depression was now over, and the state not only guaranteed farming conditions but also actively stepped in to ensure that there would be prosperity on the land. A free trade policy had steadily diminished the amount of food that Britain provided for itself. At the outbreak of war, Britain produced less than 40 per cent of the food it required to feed the home population. By 1943, the proportion was 70 per cent. Twelve million acres of farmland were under the plough in 1939; four years later the figure had risen to 22 million acres. A further 17 million acres of former marsh and moorland – some, if not most, probably never ploughed before – were added to the total. Expanding agricultural production at almost any cost was a wartime necessity.

In the spring of 1942, on his travels to country houses in his role as Historic Buildings Secretary for the National Trust, James Lees-Milne observed the fast-moving changes in parts of the countryside. In Wiltshire, for instance:

At Stonehenge we looked at our land, part of which on the north of the Amesbury road has been ploughed. I cannot see that this matters in the present circumstances, although the archaeologists make a clamour.

The Cursus, one of the principal monuments in the Stonehenge landscape, was almost obliterated together with a number of burial mounds, but the national imperative seemed greater then than the need to preserve a few bumps in the grass. Soon after, in north Norfolk, walking around Felbrigg Hall with Mr Ketton-Cremer, its owner, Lees-Milne noted that virtually the whole parkland had been ploughed.

Even Wicken Fen in Cambridgeshire was ravaged: the last remaining bastion of an ancient Cambridgeshire fenland landscape was drained and put to the plough.

James Lees-Milne at his desk in the National Trust's London headquarters in 1950

Wicken Fen in Cambridgeshire is one of the few remaining fragments of the fens that once covered East Anglia. During the Second World War Wicken was drained, ploughed and used for agriculture. This picture, taken in 1994, shows the wetland site recovered from farmland, with one of the last wind-pumps to survive in the county

Eric Ennion lamented the destruction (which has since been reversed) of the carefully-managed wetland.

It is more than a year since the red and white surveyors' poles glinted above the reeds, blazing a trail for the draglines that were soon to follow. The diggers came, each with a gaunt arm cutting the gentle skyline, clanking and threatening, laying their tracks as they rumbled along … In a few short weeks the scoops had torn a channel twenty feet wide from end to end, ripping the backbone out of Adventurers' Fen … When all was dry, men set the fen on fire … Reed beds, sedges and sallows vanished in a whirl of flying ashes amid the crackle and the roar.

Another ancient way of life was destroyed on Maidenhead and Cookham Commons in Berkshire. Raymond Nash was a child when he saw the changes that took place during the war:

The commons were ploughed up. They started at Thicket Corner, then they took the Pinkneys Green Commons … and then the last whole piece to go was the Furze Common. They brought all these land girls up there, thirty plus two or three men. They'd come up with tractors, big chains, to pull all the scrub out. Did a marvellous job. We used to get rides on their tractors … The last piece they attempted was on Moorlands Drive, and they started this to show the King what they were doing. King George VI and Queen Elizabeth both came, and for days they dug round two big ash trees – this was to be the showpiece for the King. The land girls were there with their tractors and chains, the King got out and walked across, they pulled and pulled but the trees didn't budge. Hadn't dug enough roots out. All a bit red-faced over that. The war ended, and they decided not to clear that one out.

German submarines were the farmer's friend; the threat to imported food supplies posed by blockade and attack on merchant shipping made the expansion of home production vital; achieved through the carrot of guaranteed prices and the stick of coercion. The farmed landscape changed dramatically, and familiar sights disappeared. Not only was marginal, derelict and neglected land reclaimed and a record acreage of land put under the plough, but in order to save on feedstuffs large numbers of animals were slaughtered. Root crops took their place alongside cereals, and farmers were told what to sow. Mechanisation was not only encouraged but actively enforced, using a system of local 'tractor stations' that was borrowed in concept directly from the Soviet Union and the collectivisation of agriculture under Lenin and Stalin. That first new tractor at Saddlescombe described by Stan Hollingdale did not arrive by magic on a farm that would otherwise not have been able to afford one (or indeed would have wanted one). Wages for male agricultural workers improved, as did returns for farmers and landowners. If the country-estate owners no longer called the tune on their own land, they benefited all the same from the new policies. The government's main agent for change in the countryside was the network of War Agricultural Executive Committees – universally known as 'War Ags' – composed of academic advisers, staff from local authorities, land commissioners and 'enlightened' surveyors, landowners and farmers. They had the power to allocate scarce resources of feed, fertilisers and machinery, they issued

Above right: 'The last load home': a tractor at Plattwood Farm near Sutton Hoo with a land girl at the wheel

Below right: A land girl driving a tractor through Ipswich in Suffolk, parading the achievements of the Women's Land Army detachment based at Sutton Hoo

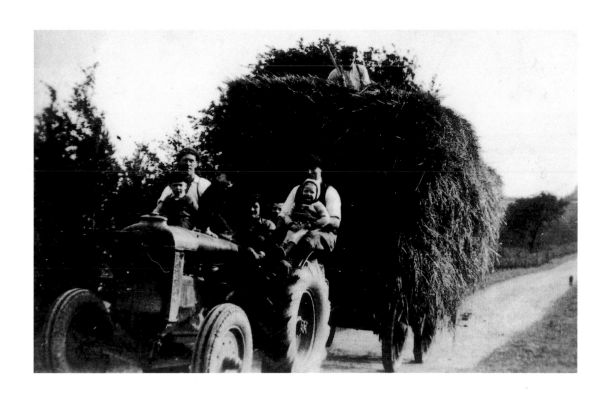

instructions, they offered advice. In extremity they had the powers to evict farmers who would not comply, and some 13,000 farmers and landowners suffered that indignity. With the financial help received from the USA under Lend-Lease in the spring of 1941, when vital farm machinery and equipment were high on the list of American imports, the situation was transformed. Although there were those who feared and loathed the War Ags, for most farmers they were a route to prosperous change. Land, animals, and machinery all needed labour. Douglas Eavis, who farmed Manor Farm at Kelmscott on the Buscot estate in Oxfordshire was one who blithely disregarded the mood of the times:

The cowman was a reservist, and he was called up. I had to have land girls. There was a big [army] camp up at Faringdon, they used to be picked up by the soldiers and brought back at all hours. So I sold the cows. The War Ag said I couldn't sell the cows, but I said I had already done it.

In the first year of the war there was a shortfall of 100,000 workers on the land; although farm work was a reserved occupation, there had been a long drift into factories while many agricultural labourers now chose to enlist in the armed forces. The retired, children, and later prisoners of war, helped to make up the numbers. But the farming industry's greatest single help towards achieving the food production target was the Women's Land Army (land girls).

By the outbreak of war, 17,000 women had already volunteered for work on the land, with a thousand of them ready for immediate deployment. The farmers still had to be persuaded they could bring in the harvest, but it was rapidly clear that the land girls were eminently capable of doing that. By 1944 the Women's Land Army was 80,000 strong. Mr Eavis remained less kindly disposed towards the land girls who worked on his property than many other farmers seem to have been. The writer and poet Vita Sackville-West was a frequent visitor to the headquarters of the Women's Land Army at Balcombe, Sussex, as she contributed articles to the *Land Girl* magazine (and eventually wrote the Women's Land Army's wartime history). She described how

in the outbuildings ... from floor to ceiling are stacked the familiar green jerseys, the brown breeches, the black gumboots, the fawn overcoats, the pale Aertex shirts. All so neat, so beautifully piled. It gives one some idea of the work involved in supplying the needs of 80,000 girls.

That was nothing to the work the land girls actually did, on farms, estates and smallholdings throughout Britain. They came from all classes and walks of life. Officially portrayed as a romantic band in their characteristic uniforms, the reality was harsher. Uniforms – and especially rubber boots – were in short supply. Work was hard, particularly in the series of cruel winters of the war years. Even the official manuals could not gloss over that fact: land girls were advised to train for the job by carrying full buckets of water for half an hour and then to 'attempt to pitch earth on to a barrow'.

Women in the Land Army wore green jerseys, brown breeches and brown felt slouch hats as well as the ubiquitous Wellington boot

Not all the ploughing done by members of the Women's Land Army
was mechanised. Traditional methods were still used in some areas

Working hours were officially fifty a week, but in practice more like seventy. There were good homes with kind farmers, and there were exploitative and harsh farmers. Above all, wages were pitifully low and nowhere near the already mean levels of pay received by male farm workers. Joan Chapman (who lived at Sissinghurst for some of the war years), recorded of their chronicler, Vita Sackville-West:

She always said she thought our pay was not too bad – yet she spent more on cigarettes than we earned for a week's work.

Especially in more remote areas, the land girls were often the first to learn how to drive the new tractors, lacking the traditional disdain for mechanised innovation of the men around them. For every one who discovered bulls cannot be milked there were many who adapted with ready ease to the demands and rigours of farm life and farm labour. There was a wide range of skills to learn and places to work. Monica Robinson was employed as a land girl in Savernake Forest in Wiltshire, learning to be a 'lumberjill'. Like other woodland areas, it was used for munitions storage as well as more traditional forestry work. She needed to know both timber and avoidance techniques:

Beneath corrugated-iron shelters and scattered over a wide area, large US Army munition dumps were concealed, guarded by soldiers standing like statues against the silvery trunks of the beeches lining the Avenue on every side; perfectly camouflaged in their grey-green uniforms, they delighted in leaping out from behind the trees to startle and challenge us.

At Trengwainton in Cornwall the gardens were converted wholly to food production, with three land girls and two boys working the soil. Where there had been lawn there were tomatoes – 2,500 lbs in 1941 – and where there had been tennis courts there were vegetables. More than 5 tons of leeks, potatoes and onions were harvested and sold in 1944. This was a pattern repeated in every corner of Britain.

Eunice Reed (now Smith) was a member of the Women's Land Army employed on the Earl of Jersey's estate at Osterley Park in Middlesex:

I lived in a turning off the Jersey Road. My mother had died and I had to look after my father, so I got special permission from the WLA to work in Osterley Park. We used to start [at] 7.30, finish at 5, with breaks in the bothy ... We did a variety of work, trying to tidy up the neglect from when the men had gone into the army: weeding, growing vegetables and fruit ... It was not like an ordinary farm – everything for the family had to be washed... The surplus was sold to the local people who came into the walled garden to buy.

Some others had life easy – and they resented it in the context of the nation's emergency. Joan Chapman worked as a private gardener for an elderly friend of Vita Sackville-West:

Nothing we grew was ever sold or went to help the war effort. At the time it worried me terribly. I spent my days picking raspberries for dinner parties, pruning espalier fruit trees – instead of growing food for a country at war.

Land girls at their hostel at Pamphill Manor on the Kingston Lacy estate in Dorset in 1944. The owner of the photograph, Molly Andrew, is pictured on the back row, second from the left. Most of this group were originally from London

The land girls, however, were for the most part young women, doing their bit for the war effort and frequently far removed from the constraints of family and upbringing. As a teenager, Marion Ricketts saw a contingent of the Women's Land Army arrive in the Dorset estate village of Pamphill:

Pamphill Manor was commandeered for the Land Army. They took the good windows out so they wouldn't get broken – a good thing they did, for the Land Army girls were in and out of those windows all night. The goings-on. The poor warden came down to my mother tearing his hair out, he didn't know what to do with them.

Not every land girl had the chance – or the energy – for partying but most seem to have taken the opportunity whenever they could. 'If it had wheels on it and it stopped, we would hitch a lift on it,' said one. Local women at dances often resented their fit and hearty Land Army sisters, but were cheered by the thought that the land girls usually had to leave early because of the need

to be up at dawn. There were always those who had greater misfortune in the dance-hall stakes than others.

Joan Chapman recalled a local Land Army girl who became pregnant by an American soldier:

The opinion at the time was that they were an American's leavings … As far as this girl was concerned, the popular opinion was that she had been silly – but she didn't deserve twins!

The proof of the change in agriculture was recorded by the Wiltshire novelist Edith Olivier in her wartime memoir. Weather and work combined successfully in the late summer of 1942:

Practically the whole of the man- and woman-power in the country had already been taken into the war effort, either on the battlefield, on the ocean, in the air or in the factory. The farms were terribly short of labour. Farmers took off their coats and worked harder than ever. Old men came back into their own, proud to know that the fields where they had worked

He danced a few rounds with each

Village social life continued with men in uniform lending their presence to any occasion. Rex Whistler, who drew this illustration for Edith Olivier's *Night Thoughts of a Country Landlady*, was tragically killed by an enemy mortar in Normandy in 1944 when trying to free one of the tracks of his tank

'from a boy' were still in need of their feeble but experienced hands. Land girls and schoolboys brought youth and gaiety to the harvest fields … It was little short of a miracle that the harvest of 1942, worked by emergency staffs, and temporary staffs, and amateur staffs, should have been a 'record' one.

The particular contribution to the war effort made by the Women's Land Army cannot be underestimated. The land girls recognised it themselves, as they sang:

Back to the land, we must all lend a hand,
To the farms and the fields we must go.
There's a job to be done,
Though we can't fire a gun
We can still do our bit with the hoe.
When your muscles are strong
You will soon get along
And you'll think that the country life's grand;
We're all needed now,
We must speed with the plough,
So come with us – back to the land.

The front line at home had two dimensions – the ability to make do and mend, to eke out meagre rations and find substitutes for the food that no longer came from overseas, and the readiness of the population to withstand attack and invasion. Rationing was introduced in January 1940. The Minister of Food, Lord Woolton (after whom the wartime staple of the vegetable pie was named), declared that his duty was 'to see to it that everyone received the minimum amount of proteins and vitamins necessary to ensure good health under hard working conditions'. The ration book, with its coupons to be exchanged together with money for food, and later for clothing and other necessaries, became a defining symbol of wartime Britain. Bananas were a fast-fading memory for most and, as the official ration diminished in size through

Slogans and posters from the Ministry of Food were everywhere, urging war on waste and disease as well as on the common enemy

periodic cutbacks, so were other once-common commodities. At its worst point in 1942, consumers had to make do each week with a shilling's worth of meat, half an egg, four ounces of bacon, half a pint of milk and half a pound of sugar. The wholesale slaughter of animal herds in 1940 was one of the contributory factors to the enduring shortage of milk. Dried milk and dried eggs became a staple part of the diet. There were extra sugar rations in jam-making and fruit-bottling seasons – 'Every pound takes us one step further towards defeating Hitler' – and in 1940 the Women's Institutes and Women's Voluntary Service made three million pounds of jam.

In the countryside, there was always a greater chance of supplementing the official ration with home-grown produce. Marion Ricketts, in Pamphill, Dorset, recalls that once war was declared:

People started to talk about rationing, and that came. The baker came and asked Mother whether she wanted half a hundredweight of sugar before rationing started. This she kept upstairs in a cupboard – I doubt she ever used it. She was too afraid to. We had chickens. Mum made do. We had a garden with vegetables so we never had an empty table ... In the villages we used to have shilling hops, dances for the troops who came in. They were wonderful times we had. I can remember my mother making pancakes over an open fire, running down the road with these pancakes for the dancers to eat, then running back and making more. We had plenty of milk and eggs, so it was all right to do that.

Sylvia Howard, who was the cook at Calke Abbey in Derbyshire, relied on the estate produce:

We were rationed, but they were self-supporting here. They killed the deer, brewed their own beer.

Food, they said at the time, is a munition of war. Meanwhile, once bombing began, real munitions rained from the sky – not only on cities and towns but on the countryside as well. Some were phlegmatic. Henry Baker, son of the architect Sir Herbert Baker, recalled at Owletts, the family home in Kent,

Then the war came. The parents still lived here and carried on here more or less as they had done before. They didn't move down to the cellars, they stayed in their own bed ...

At Emmetts, also in Kent, where Gladys Leigh was a housemaid, the family took rather more precautions:

We had all the cellar made [up], we had all the beds down there and we used to sleep down there. So the wine cellar got all used up ... One night there was a raid on, one of the first over Ide Hill, and it was alight with incendiary bombs, and I can remember standing at the front crying my eyes out, thinking that my home was getting all burnt up ... When they dropped the first bomb on Toys Hill ... my sisters and I and my mother all trying to get into this tiny little pantry, because the bombs were dropping and suddenly we realised it was war. How we thought this little larder was going to keep us from getting killed, I wouldn't know.

Audrey Harvey (now Carr), the chauffeur's daughter at Emmetts, was still young when the raids began:

Witley Common in Surrey was another precious landscape that was put to the plough to grow food. Fortunately it has since recovered from being used for farming and is a good example of Surrey heathland and scrub with woodland fringes

It was extremely frightening at the height of the bombing … We used to take shelter in the cellars under Emmetts, and for some particular reason we came up from the cellars, came outside and looked up. The sky was absolutely black with bombers. It seemed to be thousands of them – I suppose it was hundreds really, but it was the most amazing experience to see them going over like that towards London. When we got over our surprise we promptly went back down into the cellar and stopped there.

Not only households made ready. Throughout Britain, the armed forces took precautions – often badly needed – to protect the population. Stan Hollingdale at Saddlescombe Farm saw good farmland given over for munitions and means to repulse the enemy:

We had the army in here all the time. Canadians, New Zealanders, a few Australians. They commandeered part of the old [farm]house, had their offices in there. They had sentries posted because they had all the gun carriages out in the lane here. They had Howitzers down in the lay-by. When they were trying them out they used to come up here to tell us to open our windows, otherwise our windows would be shattered. Used to be a hell of a bang. They used to fire them right out to sea … There's one field, we still call it the Searchlight Field now … There was a hell of a lot of shells and so on lying around. Barbed wire everywhere – up on to Devil's Dyke. Only us farmers were allowed to use the road up there, everyone else had to take the lower road into Brighton.

Fears of invasion meant that in many vulnerable areas the coast was totally out of bounds, as James Lees-Milne observed on a visit to Norfolk: 'All along the [north Norfolk] coast to Cromer there is a great structure of iron barricading, covered with barbed wire in defence against the invaders, if they should come this way.' A generation lost the opportunity to build sandcastles (although in locations like Alderley Edge in Cheshire there was the opportunity to fill sandbags to protect buildings in Manchester).

The threat of invasion – and later the prospect of invading the Continent – led to extraordinary measures: directional signposts were removed from main roads and country lanes, whole settlements were cleared in Dorset and Norfolk, and in 1942 Lees-Milne was told that plans were being made for wholesale evacuations on a massive scale:

Below: Soldiers from the searchlight battery in the grounds of Chirk Castle in Wrexham, Wales along with castle staff. The photo was taken at the Castle Home Farm in August 1941. The buildings in the background are now the National Trust Visitor Centre

Below right: Photograph taken in 1941, showing accommodation for the soldiers manning the searchlight battery housed in Chirk Park with the castle in the background

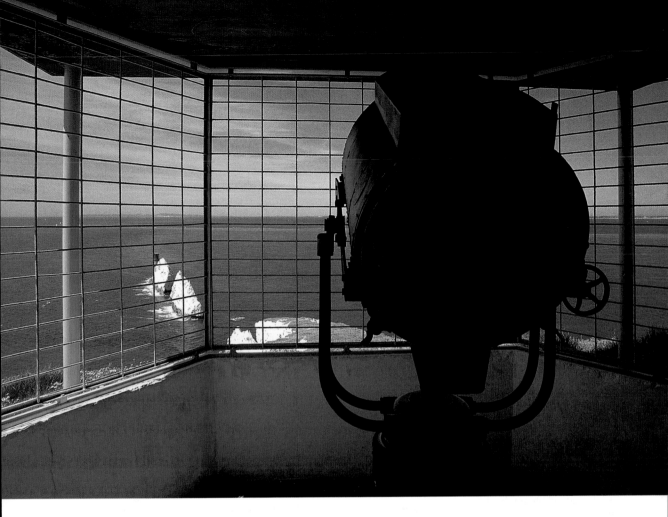

Di [Murray, a family friend in Chelsea] tells me that every preparation is being made for the evacuation at twenty-four hours' notice of the south coast towns to London, presumably to make room for troops with which to invade the Continent. She is on an Evacuation Committee to receive the unhoused. She also says convoys of barges are to be seen taken down the roads to the south coast.

The searchlight in the Battery looking out over the Needles on the Isle of Wight to guard the strategically important approaches to the Solent and Southampton and Portsmouth dockyards

The countryside was littered with various defences. Pillboxes – concrete machine-gun posts with firing slits – were built everywhere, especially within easy reach of the coast. The pillbox to the south of Bodiam Castle in Sussex was a modern version of that ancient deterrent against enemy invasion. Three pillboxes survive at Loe Bar in south-west Cornwall, overlooking the pool that had timber booms placed across its surface to deter enemy seaplanes. The Royal Military Canal in Kent, dug in the early 19th century to deter Napoleon from invading, was refortified in the mid-20th century to deter Hitler.

As part of the anti-invasion precautions, the order was given on 1 June 1940 to remove all signposts to make life difficult for German agents. This meant that anyone asking for directions in the country-side was treated with suspicion

Cities and precious historic sites were protected by searchlights, gun batteries and even more exotic forms of defence. Brownsea Island in Poole Harbour, Dorset, had a coastal defence battery, and was a bomb-decoy pyrotechnic site to protect Poole and Bournemouth. The decoy system on the western side of the island, designed using the skills of Shepperton Film Studios, was a framework incorporating lights and flares. These 'Starfish' sites, as they were known, were based on the idea of lighting huge fires outside cities and towns once a bombing raid was under way. German planes would drop incendiary bombs as markers for bombers to follow, so firing up a Starfish site could put the enemy off-track and divert them away from the town. The opera-tors (naval on Brownsea) would also have a manoeuvrable light resembling the light of an aircraft that was meant to attract the

attention of the enemy pilot. The pilot would attack, and the decoy men in their shelter would manipulate the lighting display. There were about 250 of these decoy airfields, of various sizes (there were other Starfish decoy sites at Godrevy Point in Cornwall and Lyme Park, Cheshire).

Pepperbox Hill near Salisbury in Wiltshire, was the site of a searchlight battery to protect the ancient cathedral city. Badbury Rings, on the Kingston Lacy estate in Dorset, was the site of the direction-finding for the airfield at nearby Tarrant Rushton. It was also a launch site for gliders at D-Day and the Arnhem landings; before D-Day, army vehicles and soldiers sheltered under the immense beech avenue leading to Kingston Lacy house.

In Somerset, Brean Down, the site of an old Victorian fort, was a coastal-defence battery, and also the site for experimental

weapons testing on the headland and Brean Sands. The ancient Cadbury Camp's role was to protect Bristol. It had a searchlight and anti-aircraft battery, and itself came under direct attack. The camp was also used as a place to explode undetonated bombs brought in from elsewhere in the region.

The St Anthony Battery on the Roseland peninsula in Cornwall, first fortified in 1805 and last used in 1918, was recommissioned in 1939. Manned by Territorial gunners, the battery together with the fortifications at Pendennis Castle and St Mawes defended Falmouth from attack. A searchlight scoured the sea and sky. When they were off duty the troops had their own 'Dig for Victory' garden to tend. At Treligga, near Tintagel, the air-to-ground and air-to-sea firing range – staffed wholly by Wrens (Women's Royal Naval Service, WRNS) – was also remodelled towards the end of the war as a Japanese-held island. Complete with tanks, a convoy and a bridge, it was a convenient training ground for the final push in the Pacific.

Daphne Woosnam, an evacuee at the Cornish house Lanhydrock, was struck by the scale of the ammunition dumps ready for use, especially after the USA joined the war in 1942:

From here down to Bodmin there were like open-ended Nissen huts with about two soldiers to patrol the whole lot. Also in the park there were British Tommies there in camp, with tents. The Americans took over the Duke of Cornwall's Light Infantry in Bodmin. I had a chaperone, one of the young housemaids, so we could join the cadets and it was all right if I wanted to go anywhere.

There was evidence to be found everywhere of the destruction that preparing for the enemy could wreak. James Lees-Milne surveyed a number of National Trust properties where military incursions had taken their toll:

… In the rain [I] proceeded to Baggy Point [on the coast of north Devon]. Talked to our farmer who complained of the damage done by the American troops who use it as a range for every sort of explosive,' he wrote in April 1945 and later, in September:

Clouds Hill, T.E. Lawrence's cottage, is in the middle of Bovington Heath, which is a blasted waste of desolation, churned feet-deep in mud by a thousand army tanks.

Fields were filled with lines of old vehicles, trenches were cut – even in historic monuments such as the recently uncovered Anglo-Saxon burial mounds at Sutton Hoo in Suffolk – to deter enemy invaders and prevent gliders from landing. Many of these forms of home defence were traditional, and they were often located where defences had been situated for centuries. But there was one line of defence that was entirely novel: radar. Developed in the 1930s, notably on the Suffolk coast at Orford Ness, and refined both there and elsewhere, radar was critical to the eventual defeat of enemy air power over and around Britain. Twenty Chain Home stations with masts 300 feet high were built around the coast, supplemented in mid-1940 by twelve Chain Home Low radar stations to detect lower targets.

Watson Watts' radar tower and accompanying derelict buildings at Orford Ness in Suffolk. These radar installations, amongst others, provided early warning of air raids. This meant that fighter squadrons had advance warning to intercept German aircraft and the civilian population had time to seek refuge

Downhill in Northern Ireland was one important radar site; Ballard Down, strategically situated above Swanage and Studland Bay in Dorset, was another. Between May 1940 and May 1942, the principal radar research station was located at Swanage (it was then to move to Malvern College in Worcestershire). A series of inventions by the assembled boffins extended radar's capabilities: airborne radar for night fighters, a pinpoint target system, and 'the most brilliant of the infants of radar', a magic eye that enabled pilots to pick out ground features in the dark. This was a significant aid to night bombing, one of the main forms of attack on Germany in the later years of the war. Unfortunately, on Ballard Down the tractors that were being introduced by the 'War Ags' tended to interfere with reception, while local children like Cyril Upshall and David Sales were able to collect as souvenirs the strips of tinfoil that German planes dropped in an attempt to jam the radar. 'In the early part of the war,' David Sales recalls,

the radar mast on top of the hill was a target for German bombers. They used to drop bombs across the village and across the heath trying to destroy [it]. I can recall the bombs going off in the middle of the night quite plainly.

People just came to expect noise. In her wartime memoir Edith Olivier contrasted the quiet of the pre-war village with current experience:

Now we think that our nights are distinctly noisy, and they remind us that even here, in the depths of the country, we are at war. When the Germans raided the Midlands – Coventry, Birmingham and other industrial towns – all through the night we were being taught (as we had never been taught before) that, geographically, we were on the direct route from Berlin to the English Black Country ... On other nights, a convoy of tanks or military lorries passes through the lane. These convoys can truly be said to make night hideous, and it is quite impossible to sleep as they go by ... 'Of brazen chariots rag'd; dire was the noise.' That is what a tank regiment sounds like as it passes down a country lane.

Local people also took the opportunity themselves to rally to the cause of domestic defence, enrolling in a range of official and semi-official bodies. Those too young or too old to fight formed themselves with pride into the Local Defence Volunteers. Established on 14 May 1940, they were soon to be renamed the Home Guard and affiliated to the county regiments of the army. A quarter of a million men volunteered on the first day. Cornwall's Local Defence Volunteers were drilled on the parade ground in front of Trerice, below the county flag bearing the chough, the county bird. The Trerice unit became renowned throughout the Home Guard and took its nickname from that very bird. The first of the newer Home Guard units was established at Osterley, the Jerseys' house in Middlesex that was taken over by the banking firm of Glyn, Mills. The bank clerks and estate employees lined themselves up in serried ranks.

The madding wheels of brazen chariots

The noise of the war is encapsulated by Rex Whistler in his illustration accompanying Edith Olivier's *Night Thoughts of a Country Landlady* (1943)

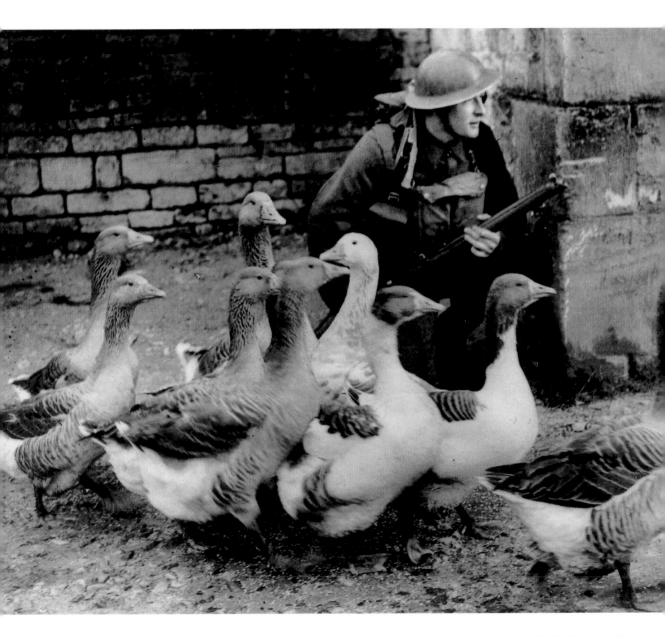

Geese in a farmyard happily ignoring a Home Guard soldier and his rifle. Not all such encounters passed off without incident

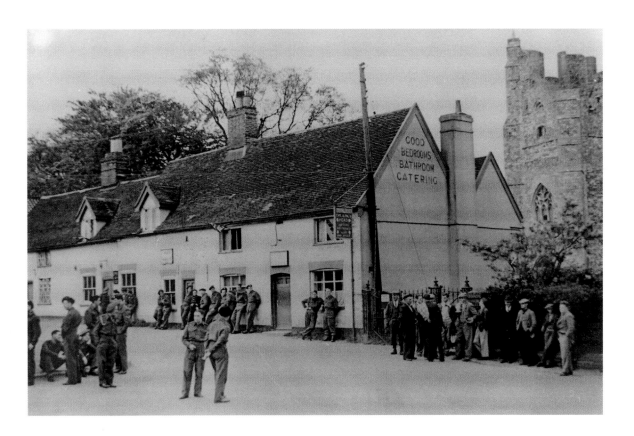

Anti-aircraft gun crews and locals mingle outside the King's Head at Orford Ness in Suffolk. The anti-aircraft guns protected the vital bombing ranges that the RAF used for practice and testing

In Studland village Cyril Upshall witnessed some of the lighter moments of Home Guard activity:

Was the Home Guard really like [the television comedy series] Dad's Army*? Exactly like! An old retired colonel started the Home Guard … When he got a revolver he was going to demonstrate it on Ballard Down. It was like the Pied Piper – all the kids followed on behind. They got up there, were ages setting up, and when he decided to fire he put the bullets in. He didn't realise it was an automatic. Brrrrr. All six bullets were gone. So they marched down the hill again … When [the Home Guard] got a rifle it had a hand-grenade launcher. So they fired the grenade into the heath. They were going to retrieve it and fire again – but they lost it. A week later they marched up, did the same again, and lost the other one.*

My father was in the Home Guard. He was the first aid man – but if he cut his finger at home he'd faint, so I don't honestly know what he'd have done.

John Field, who has known the Maidenhead and Cookham Commons in Berkshire all his life, was also witness to some eye-opening episodes with the Home Guard:

Cockmarsh was the place where the Home Guard used to go and do its firing exercises. Being an open space and liable to be used by invading Germans with their gliders, it was covered with barriers such as old cars. On a most dramatic occasion one Sunday morning, our gunner who was using the marvellously-named Blacker Bombardal Spigot Mortar achieved a direct hit on an old car – and up it went in flames.

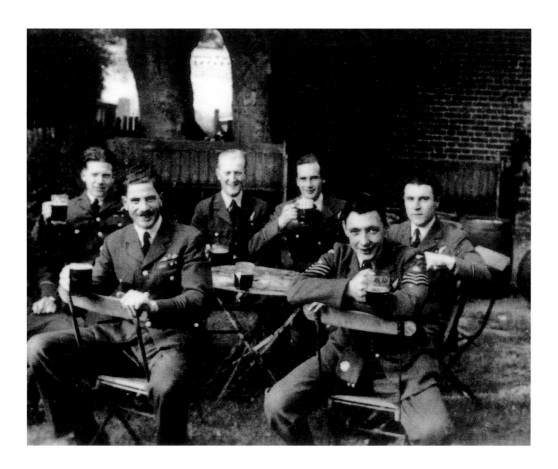

RAF crews enjoying their tankards of ale at Blickling Hall in Norfolk, the home of the sergeants' and officers' messes for nearby RAF Oulton

Never in reality called upon to defend their homeland, members of the Home Guard spent many hours devising ever more fiendish and dangerous ways to confront the enemy. There were occasions when they did more to endanger than protect the people they were trying to preserve. In the spring of 1943 at Blickling Hall in Norfolk, James Lees-Milne almost met an early death:

After tea in the officers' mess [Christopher] Birkbeck and I looked at the recently burnt-out part of Hercules Plantation. We found another fire burning and put it out by stamping, beating. I was sadly deficient in this respect, alas, Birkbeck doing most of the work efficiently. The exertion gave me sciatica. When the fire was put out I came upon a scorched wooden board on the ground, raised it and lo! it was a trapdoor over a Home Guard bomb dump, from which smoke was pouring. I looked down into the pit bravely, but refused to descend to see what the smoke issued from.

Others in country districts joined bodies like the Women's Voluntary Service (WVS), the Auxiliary Fire Service (AFS), the Royal Observer Corps (ROC) or the Air Raid Precautions (ARP). Almost everybody everywhere made a personal contribution to the war effort. Marion Ricketts, from the Dorset village of Pamphill witnessed the excitement and boredom of 'doing your bit ':

My mother joined the ARP. Every time a siren went, all the wardens had to go to the church hall and wait until the all clear. They never had any

The Jacobean east front of Blickling Hall

bodies – so they used to practise on anybody who came in. We did have one bomb, though. The siren went, and the bomb dropped in the middle of the village green.

William Harvey, the chauffeur at Emmetts in Kent,

joined the AFS [Auxiliary Fire Service] before war was actually declared; they wanted to keep a team of five firemen at least with a pump, ladder etc. at Emmetts. Mr Boise [the owner of Emmetts] allowed us to use the Buick, one of his cars, for a towing vehicle. We used that throughout the whole of the war. I also had a complete crew of women AFS fire girls at Toys Hill, which adjoined us. Had there been a fire in that vicinity they would always have been a backup crew for whatever firefighting was needed. We also had a barrage balloon down near the stables, and the balloon boys were – in the early days – billeted and fed at Emmetts. When they got established they had their own quarters down there, until the war's end …

Audrey, his daughter, played her part too:

When I was old enough, I joined the [fire service] gang. My duties used to be on the telephone and as a driver. The main calls were to plane crashes, of which there were a lot in the area. Most unpleasant and unsettling. Men used to come home with the most ghastly tales of what they had seen and found … We had happy times as well; we used to be friendly with the Westerham firemen, and used to have dances ….

On the home front, the population endured privation, rationing, noise, bombing raids, compulsory requisitioning, the building of defences, yet nevertheless played their part large or small. And everywhere there was knitting and sewing: socks and balaclavas for the troops, blankets, camouflage nets. They knitted in Derbyshire. At Sudbury,

… The girls started to knit sea-boot stockings for the sailors. The boys got a little bored so we taught them how to knit! Later we were to weave coloured strips into camouflage nets.

They knitted in Cornwall, at Lanhydrock as well as in farmhouses and cottages:

We used to make camouflage nets on the lawn, the nets that covered the guns that my [future] husband Jack used to fire in the war. They used to smell terrible, it was the material you wove into the nets … And we knitted socks and balaclavas. We wound the wool, we sat there and wound it.

They even knitted at West Wycombe, the Buckinghamshire house of the Dashwoods that was the temporary home for the National Trust's officials and other paying guests of distinction. James Lees-Milne confided in his diary on 8 February 1942:

After dinner I took up my knitting … Cecil [Beaton] had hiccoughs he laughed so much. Eddy [Sackville-West] took up his knitting, an endless khaki scarf. We were sitting side by side on a pair of upright Chinese Chippendale chairs before the fire, Eddy wearing his blue cloak with silver buckles, and his red velvet waistcoat with the Sackville coachman's gold livery buttons. I suppose we were an odd spectacle. Still, I wish Helen [Lady Dashwood] would not call us the two old bombed houses.

Girls of the Pay Corps at Antony House Cornwall, or *HMS Raleigh*, as it was known. In 1939 the naval shore establishment of *HMS Raleigh* was established near Plymouth to provide training for new entrants to the Royal Navy

NAAFI staff from Orford Ness relax by paddling in the sea on the Suffolk coast

The countryside was most directly affected by two particular military events of the Second World War: the Battle of Britain, in which German and British aircraft fought for supremacy of the skies in the summer of 1940, and the preparations for the landings in Normandy on and after D-Day in 1944. The south-eastern corner of England was the most important area for the first of these events and those living at many of the National Trust's properties had direct and frightening experiences.

The prelude to the Battle of Britain was the German advance into the Low Countries and France. The defeated British Expeditionary Force (BEF) was evacuated from Dunkirk in the last days of May 1940, in a daring plan overseen by Vice-Admiral Bertram Ramsay from a base within the White Cliffs of Dover. A total of 338,000 men, of whom 120,000 were French, were taken off the beaches at Dunkirk by ships of every type and size. Trains took exhausted soldiers to all parts of the country. Military huts were built in the Carvannel Valley on the north-west coast of Cornwall to receive evacuated troops. Penrhyn Castle in north Wales took in others to recuperate.

Tony Gould was ten in 1939. As the first year of the war passed, events began to speed up in the Dorset village of Studland, just as they did elsewhere:

The German seaplanes used to come in at dusk, and drop magnetic mines into Poole Harbour. Then France fell, the troops came in by ship to Poole Harbour, one was hit – had its bows blown off – and the troops swam ashore together with a very large Alsatian dog, their mascot. We had troops living in the village, some in our garage, until the army rounded them all up. Things went fairly quiet until the Battle of Britain. A Junkers 52, painted black, would come over the dunes every night. It would just cruise up and down. Somebody was signalling to it – the soldiers never actually caught them. Then it stopped. In the Battle of Britain, things hotted up day and night.

Once France had fallen, Britain stood alone. Winston Churchill broadcast that Hitler would have to 'break us in this island or lose the war'. German invasion was expected, but a successful invasion required air superiority. On 10 July 1940 German aircraft began to attack shipping in the English Channel and German bombers then began to strike at airfields of the RAF's Fighter Command. British aircraft – notably Spitfires and Hurricanes – engaged the Luftwaffe in aerial combat, right over the heads of the population of Kent and Sussex. Fred Jones was one of them, a young gardener in his first job:

Life at Owletts right up to the war was fairly peaceful and then along came 1939. And I was working in the garden there right through the Battle of Britain, which took place right overhead – I'm afraid it was a bit dicey at times, never seemed to worry me then because I was only eighteen years old. I thought it was marvellous, but thinking about it now it wasn't quite so clever.

Gladys Leigh, who worked at nearby Emmetts, recalled,

Churchill giving his famous V-salute, which was invented by a Belgian lawyer named Victor De Laveleye in the early 1940s. De Laveleye was unhappy about the use of the letters 'RAF' being scrawled on walls in Belgium to insult the Nazis. He hit on the idea of V for Victory because it worked in many different languages. After his initial broadcast, proposing the V, the BBC mounted a highly successful propaganda campaign employing the Morse code symbol for V (dot-dot-dot-dash) and the opening bars of Beethoven's Fifth Symphony. It was after this that Churchill took up the sign and used it publicly at every opportunity. Nazi propagandists became so alarmed at the success of the symbol, that they started their own counter-project, but it was too late

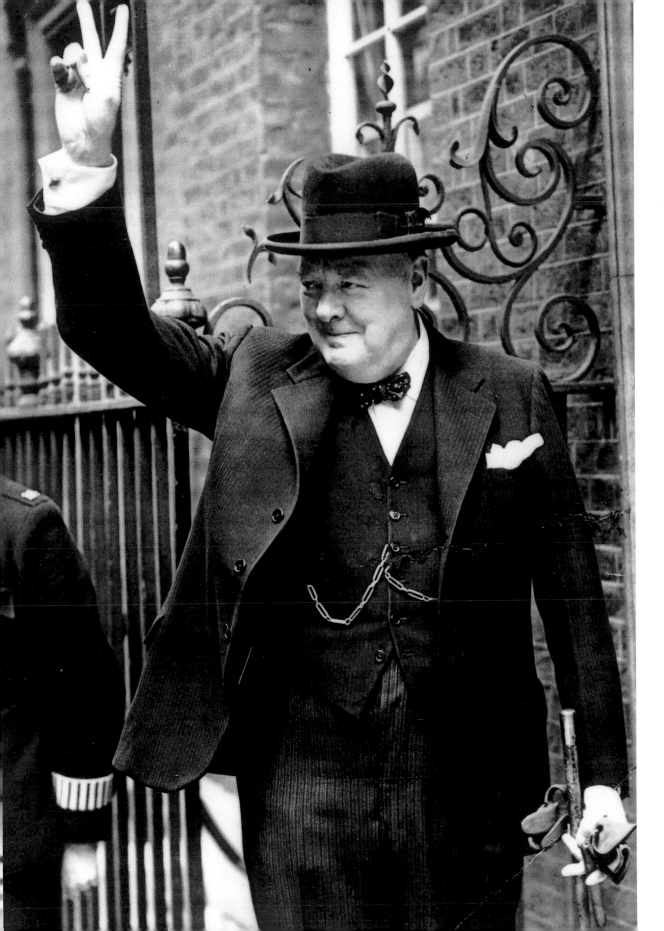

We were right in the middle of the Battle of Britain as well. I saw an airman come down – alight – one day. All black he was. It was awful.

Her fellow-employee, William Harvey, knew that the Boise family who owned the house took a very direct interest in the battles in the air:

Mr Boise during the war bought two Spitfires – Emmetts 1 and Emmetts 2. I remember they did their job quite well. They were both shot down eventually.

In his diaries, Harold Nicolson recorded the progress of the Battle of Britain that was being waged in the skies above the castle at Sissinghurst:

18 August 1940

A lovely day ... While we are sitting outside, the air-raid siren sounds. We remain where we are. Then comes the sound of aeroplanes and, looking up, we see thin streamers from the exhausts of the German planes. Another wave follows, and we see it clearly – twenty little silver fish in arrow formation ... [Soon] there is a rattle of machine-gun fire and we see two Spitfires attacking a Heinkel. The latter sways off, obviously wounded. We then go on with our luncheon.

2 September 1940

There is a tremendous raid in the morning and the whole upper air buzzes and zooms with the noise of aeroplanes. There are many fights over our sunlit fields ...

Vita Sackville-West, Nicolson's wife, took a poet's delight in the beauty amidst the carnage. She wrote to Harold a few days later:

There was a most lovely sight: ten white machines climbed absolutely sheer, leaving perfectly regular white streaks of smoke like furrows in a cloudless blue sky, while a machine lower down looped smoke like gigantic spectacles before shooting up to join its friends. We saw one catch fire and fall.

The area of Kent near Dover and over the White Cliffs was popularly known as Hellfire Corner, so intense was the fighting there. Barbara Morris, a land girl employed on a farm directly above the cliffs, won a special badge for her courage for working on with air battles continuing overhead, although even her bravery wavered at times.

It was harvest time and I remember hearing a terrific screaming sound as a plane seemed to be coming down on top of me. I just ran and ran to the edge of the wood nearby but the plane fell some distance away ... We did not pay much attention when planes fell some way off, we were too busy ... At the height of the battle we saw many planes shot down.

The aerial combat, although concentrated in the south-east, extended across southern England. 'We had a Heinkel bomber come down in the village,' Cyril Upshall from Studland recalls:

The gunner was killed and was buried in the churchyard. We were in the air-raid shelter at school. The lady teachers, in charge of thirty or forty of us, were far more scared than we were. They were in the shelter, we were looking out of the door – and when we saw the plane go by with smoke pouring out, we were out of the shelter and ran until we got to it.

The garden front of Chartwell in Kent, home of Winston Churchill. The house, which commands sweeping views of the Weald of Kent, has been preserved by the National Trust as it was in the pre-war years. However, during the war years it was mothballed as it was considered unsafe for use due to its conspicuous and well-known location and consequent vulnerability to attack by German bombers

Between 10 July and 31 October, the Luftwaffe lost 1,294 aircraft. The RAF lost 788. Britain was on its knees, but the advantage of fighting over home territory was that British pilots who parachuted to the ground and survived could fight again whereas German pilots were captured. The turning point came in September: Goering, commander of the Luftwaffe, decided to divert his air resources to the bombing of British cities instead of attacking British airpower, and Hitler then postponed his plans to invade Britain. 'Never was so much owed by so many to so few,' Churchill said of the RAF, a sentiment echoed especially in south-eastern England.

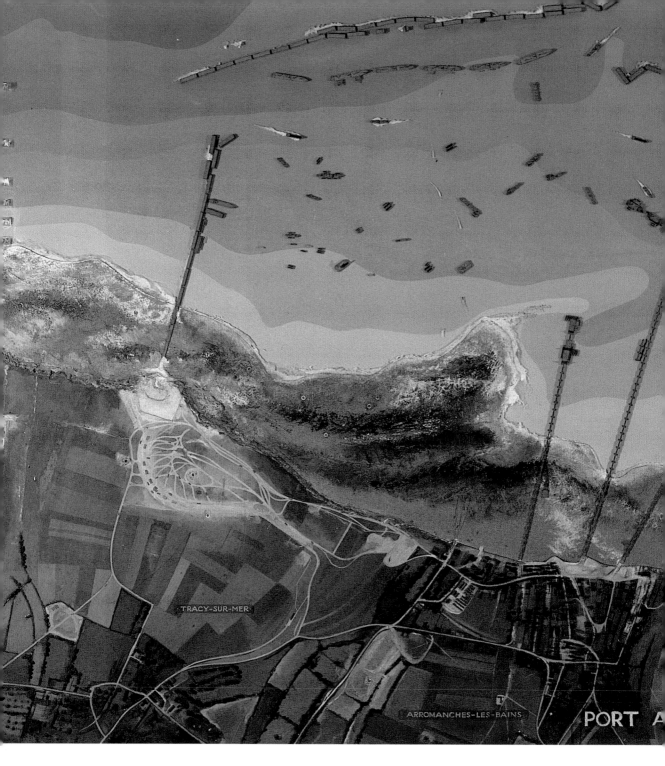

Relief map of the Mulberry Harbour at Port Arromanches, Normandy as it appeared on D-Day plus 109 days, 23 September 1944. The map is set amongst the bookshelves in the Library at Chartwell. The Mulberry Harbour that was assembled at Arromanches was made up of concrete quays floated across the Channel to

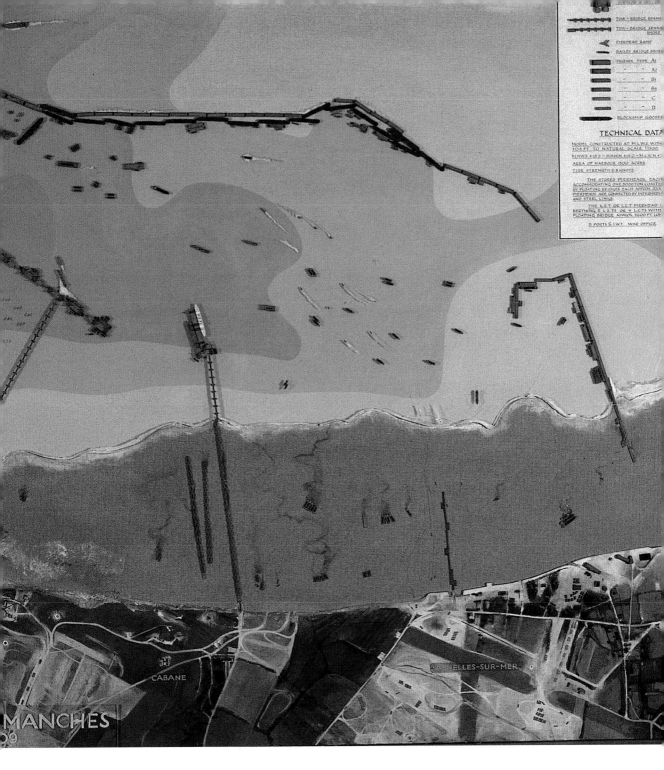

TOW-BRIDGE SPANS

TOW-BRIDGE SPANS SHORE

PIERHEAD RAMP

BAILEY BRIDGE SHORE

PHOENIX TYPE · A₁

— · A₂

— · B₁

— · B₂

— · C

— · D

BLOCKSHIP GOOSE

TECHNICAL DATA

MODEL CONSTRUCTED AT M.L.W.S. WITH
+05 FT. TO NATURAL SCALE 1/1200

M.H.W.S. +15·0 — M.H.W.N. +11·0 — M.L.W.N. +

AREA OF HARBOUR 1500 ACRES

TIDE STRENGTH 2·3 KNOTS

THE STORES PIERHEADS, EACH
ACCOMMODATING ONE 5000 TON COASTER
BY FLOATING BRIDGES EACH APPROX. 3500
PIERHEADS ARE CONNECTED BY INTERMEDIA
AND STEEL LINKS

THE L.S.T. OR L.C.T. PIERHEAD
BERTHING 2 L.S.TS ON 4 L.C.TS WITH
FLOATING BRIDGE. APPROX. 5000 FT LON

B PORTS G.(W.T. WAR OFFICE.

CABANE

ARNELLES-SUR-MER

MANCHES

enable the Allies to disembark troops and materials quickly once troops had established a beach-head in France on D-Day. The artificial port has been so durable that sections of it remain and are visible from the cliffs overlooking the town

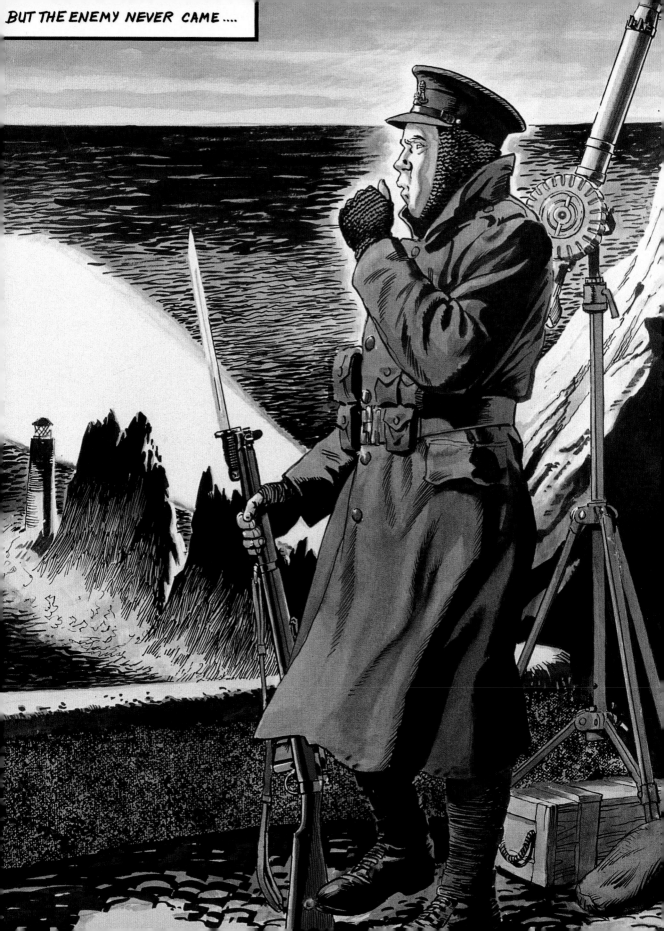

D-DAY

From the end of 1941 Britain no longer stood alone, joined by the mighty USA after the Japanese attack on the US Navy at Pearl Harbor. Gradually the tide turned. The Atlantic convoys were getting through. Allied bombers flew deadly raids over Germany in 1943; the Allies advanced through Italy in 1943 and 1944. The scene was set for one of the most audacious ventures in military history: the D-Day landings on the coast of Normandy on 6 June 1944.

Planning began in 1943, when it was quickly established that the Bay of the Seine offered better prospects – despite its greater distance from the English shore – than the Pas de Calais where the Germans expected an invasion to occur. Throughout Britain and often amid top-level secrecy, preparations for the re-invasion took place, from the fabrication of the floating harbours that would be towed across the Channel to training troops on beaches and terrain closely matching that in Normandy.

In November 1943 the people of the South Hams in southern Devon began to remark on the greater numbers of officials inspecting the beaches at Slapton and Blackpool Sands, to the north of Torcross. Then an order was given that by 20 December the area behind the beaches, six parishes covering some 30,000 acres (12,000 hectares) where 3,000 people lived, was to be evacuated. One Women's Voluntary Service worker involved in the hasty evacuation wrote:

This is a tremendous undertaking and helpers have come from far and near to help forward the evacuation. One feels that these villages will be forever inscribed in our memory – the appalling muddy lanes made worse by an ever-growing fleet of lorries and numerous Voluntary Car Pool cars. The pathetic sight of the old and infirm at the bureaux, seeking advice, the RSPCA vans disposing of pets that cannot be taken away, are all heart-rending. The only consolation is that were the enemy invading all personal belongings would have to be left behind.

Johnnie Luxton was a land girl who was one of the few civilians permitted to enter the evacuated area; her task was thatching ricks:

We were picked up every morning by lorry from our hostel in Totnes and driven out into the country. We were dropped at a particular gate and directed to the ricks. It was self-sown corn, which had grown from the grain that dropped from the drying stooks at the previous harvest. It was poor quality but because it was wartime it was needed ... It was double summer time then and so it was still light at eleven o'clock at night. We never saw anybody, except, occasionally, if we were high up on the rick, an American jeep going past, usually with coloured servicemen in it. It was so quiet it was eerie. There were no animals, no farmers, no sound. I don't even remember birds singing. As we walked to the gate at dusk, the only thing you'd hear were the crickets.

Then disaster struck in April, during exercises rehearsing beach landings, when nine German E-boats evaded British patrols and attacked the rehearsal ships. One ship was torpedoed, and there was huge loss of life. The catastrophe was not officially recognised for many years to come.

A mural in the guardhouse of the Needles Old Battery on the Isle of Wight. Geoff Campion's mural is one of a series depicting how the battery was used in the First World War (see also page 20)

At the same time, George Brown was a gunner at the Needles Battery on the Isle of Wight, serving there from 1941 to 1944:

No shipping traffic at all was allowed to go through from the Needles to Portsmouth. That was all shut off, out of bounds to all ships including the Navy … Where our guns traversed across the sea, that was a secret box. No shipping or aircraft allowed there at all … Once you heard 'Action Stations', you dropped everything and ran to the gun. Number 1 and Number 2 gun – there used to be three guns in the '14-18 war, but one was worn out and they didn't replace it. The next order: 'Take Post', 'Load', 'Make safe'. The gunner would receive orders on the telephone from the signal station at Old Needles. 'Fire'. Our fire commander, assisted by a naval officer for identification of shipping, would attend duty there. Every day, every day … With a stopwatch I have timed them, from fifty-one to fifty-nine seconds between 'Action Stations' and 'Fire'. You could definitely see the shell go!

On one occasion two enemy E-boats were sighted. They turned out to have been among those that had fired on the troops at Slapton Sands. They were caught by the radar station. Some shots were sent out … We sunk one. The next day the radio said the Royal Navy had caught one in the English Channel – it was actually the Needles Battery but they couldn't say that.

Throughout southern and western England, troops were marshalling in readiness for the invasion. Jetties were built at Turnaway Point on the River Fal in Cornwall, in preparation for troop embarkations at D-Day. Raymond Nash lived near Moorside Common, one of the Cookham and Maidenhead Commons in Berkshire:

The invasion was about to take place, and the Americans took over [the Common] to build a camp. Massive great place. Portable wooden huts, thousands of them – only there a short time because they were on their way to the D-Day landings.

Some of the most extensive preparations – and the most secret, except to those who lived there – were made at and near Studland in Dorset. Troops massed and experiments were undertaken. Cyril Upshall was one of the local boys who observed – and often took part – in much of what happened:

We had our own troops, then the Suffolk Regiment, the Welsh Regiment stationed in the village … Then the Canadians came. We called them the mad ones. They came to do the work – built Fort Henry, a concrete lookout (which is still standing). Churchill and all the big noises came to watch the practices for the D-Day landings. The Americans came after, and they were something else. They say everything of theirs was bigger and better – it really was, lorries and tanks and all. When they arrived, there was the first black man I had ever seen. He seemed so big, and looked so much bigger than anyone I had ever seen. They were so friendly and generous …

When they practised for the main D-Day landings, there'd be maybe a hundred boats, firing ammunition into the bay, on to the Big Beach. The noise was terrific … There was one almighty practice including live ammunition all during the night. But it was now just run-of-the-mill. We got so used to it all happening.

David Sales, another local boy, was also able to watch:

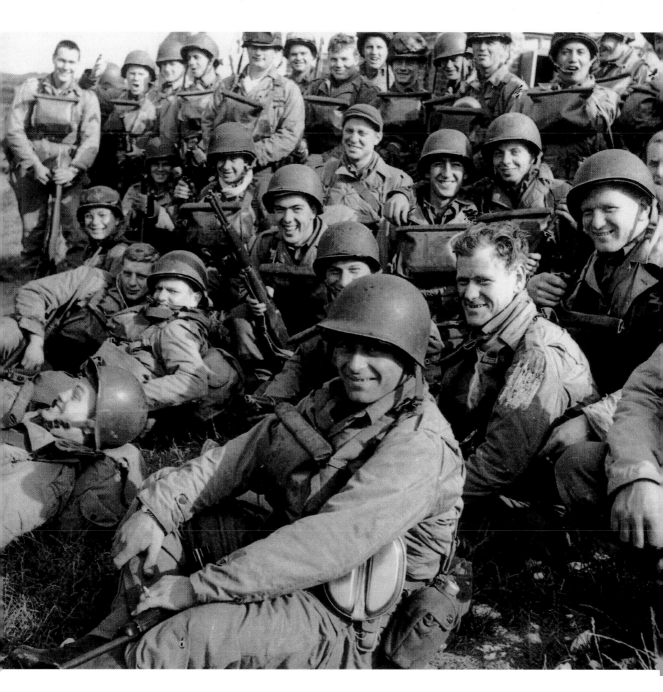

A scene repeated at many locations along the south coast of England; American assault troops massed at the embarkation ports for the forthcoming invasion of Normandy, June 1944

They were making practice runs for landing on the beaches. These were full-scale affairs, and we as children were able to observe them from the Mount, which is a bit of high ground behind the village, seeing it in all its reality. The bombers, fighters, tanks landing and what have you.

... An experimental rocket-firing ship used to come into Studland Bay frequently, firing rockets up on to the beach and the heathland. With one of the Canadians, I went with him along the beach in his lorry, and all these rockets were sticking out of the beach like a pincushion.

Tony Gould also witnessed the manoeuvres.

They did a creeping barrage, a quarter of a mile ahead of the troops as they went inland. We heard afterwards there were quite a few casualties, and some were killed.

Cyril Upshall picks up the story:

They had burning oil on the water for sea defences ... They had massive tanks buried in the woods, they'd pump the oil out into the water and ignite it. There was thousands of gallons of burning oil. When Churchill and Montgomery came, they had a scaffold tower built on top of the cliffs ... Whenever we saw a staff car, we knew it was somebody important so we'd run to follow it. They'd climb up the top of the scaffold to see what was going on. We'd climb up just below them and watch as well. Only when our parents told us did we realise who they were.

'There was one rehearsal at Studland Bay and another at Hayling Island,' former Private John Chalk recalled, 'involving Navy, Air Force and artillery firing over our heads.' The gently sloping sands at Studland proved the perfect training ground as it matched some of the projected landing beaches across the Channel in Normandy. Yet even those who were intimately involved with these exercises did not know at the time how many disasters befell the troops in training.

Sergeant Major Jack Vilander Brown was serving with the 147th Essex Yeomanry when his group of men was summoned to prepare for the second front, the Allied invasion of mainland Europe. After training with the Navy in Scotland, the men were issued with their equipment and transferred to Bournemouth to be trained on landing craft:

Practically every day we went out on these exercises on these [landing craft]. We used to start more or less from the Needles and go towards Studland Bay. We used to land on Studland Bay, fire live ammunition, all sorts of things, then trundle with our tanks back through Bournemouth, waking people. We were supporting the Sherwood Rangers' Yeomanry, who were equipped with DD tanks [pioneering amphibious tanks], which were all very hush-hush. They were using the swimming tanks on exercises but they were always kept very close, in the inlets around Sandbanks and

Children watch the top-secret rehearsals for the D-Day landings that took place at Slapton Sands in Devon. Tragedy struck during one rehearsal when German E-boats attacked in April 1944 and caused much loss of life

Poole, and whenever they moved they always tried to keep them hidden. Still, we could never understand why spies and people didn't see us, why the Germans never picked us up.

The DD tank was intended to be one of the major surprise weapons of the Normandy landings – it was a floating tank that would roll on to the beaches with, it was hoped, devastating effect. General Sir Robert Ford describes the device:

Its flotation was achieved by means of a collapsible canvas screen fitted to the tank's hull just above the running gear. This screen was erected by a combination of compressed air pillars and struts, and they enveloped the vehicle completely above the tracks. The watertight canvas walls provided extra displacement to discount the total weight of the tank and thus enabled it to float. On landing, the screen could be instantly collapsed by a quick-release device and the tank was then ready for action.

At first there were some ribald comments about the curious appearance of this swimming tank. With its screen erected ashore it looked like a mobile field latrine. When it was afloat only about three or four feet of the screen showed above the water line, and it seemed to be transformed into an innocent canvas boat with no hint of the lethal weapon beneath … It was intended that the tanks would land at H minus five, that is, five minutes ahead of the infantry. In the first instance it was imagined that the whole squadron – sixty tanks – would land in a line abreast. Ideally, all canvas screens would be deflated at the same time and the enemy would be confronted by sixty tanks on a beach, firing like mad.

That, at least, was the theory. Exercise Smash One at Studland, on 3-4 April 1944, tragically displayed some of the shortcomings.

The weather suddenly deteriorated … No orders came through not to launch, and so, at the appropriate time, in the dark, we launched. Within ten minutes the wind increased and the waves grew bigger, beating against the screen and sloshing over the top. It was soon very clear the pumps could not cope.

Seven tanks and most of their complement of men were lost on the exercise. Some men escaped, like Sir Robert Ford, and Jack Thornton who was on another of the amphibious vehicles.

We didn't say a lot … The driver was the only one inside the hull of the tank. The rest of us were on top wearing Mae Wests [inflatable life jackets]. As the water rose up to my waist I thought we were going down, so I prepared to put the escape apparatus on. The water was quite deep. I hit the beach, luckily. I deflated the screen, hopped out of the tank on to the beach, looked behind – and there was nobody following me. The tanks had disappeared that were behind me. But before I could do anything, the CO drove along the beach in a jeep and told my sergeant who was up in the turret to put me on a charge for not wearing a steel helmet.

… My friends were out there, and it hit me hard, very hard. But we had to get on with it, get the tank off the beach and back to base. They kept us busy, we weren't allowed to linger and think about it … My particular friend … I was put on a train and I had to tell [his wife] that her husband was dead, drowned. I couldn't tell her how he'd drowned. That was still a secret.

Beneath the prophetic lettering on the canvas of his tent ('This is IT'), Private Clyde N. Dunkle from Pennsylvania cleans his rifle in preparation for the forthcoming D-Day landings in Normandy

Finally, on 6 June 1944 (postponed from the previous day because of weather conditions), D-Day came. The logistics were

and are barely credible: transporting men, machines, weapons and a floating harbour across to France and still maintaining the surprise. It was a surprise too for the children like Cyril Upshall who had seen the build-up:

Before D-Day, Studland Bay was absolutely full. There were so many boats in the bay, you could have walked from one to another and right across. We got up the next morning to look at them again, and they were all gone. But the sky was full of planes, towing gliders.

Nadine Shiner, who lived in a children's home near Poole, was another witness to D-Day in this southern part of Dorset:

I heard voices outside the window, so I got out of bed and peeked out. There were men there below, talking in low voices. I tugged at another girl's blanket. 'It's started,' I said. She knew just what I meant – we all knew the invasion was going to happen. Over here, everyone knew – the amazing thing is it came as such a surprise over there. Troops were stationed all over the place – and suddenly they were gone.

In the morning we had to go to school. But all the army vehicles were on the roads, nose to tail, and we just could not cross the road. There was the school on the other side, but we couldn't get to it. Eventually an officer in a jeep slowed down and asked us if something was wrong. So he stopped the convoy, and we ran into school.

Later that day, the gliders set off. From where we were you could see for miles – out to sea, and on a fine day back as far as Badbury Rings. And the sky was black, filled with these planes going out to France.

The scene was replicated across England. At Sissinghurst in Kent, Harold Nicolson wrote to his sons:

[The skies are] literally dominated by aeroplanes. All night they howl and rage above us. It is like sleeping in the Piccadilly Underground … Then in daytime there is also much activity: great fleets of bombers floating slowly above us in the empyrean, their drone being a throb all round us and not a definite noise coming from a definite object. And then the fighters at a lower level swishing along at enormous speeds. So far that is all that Sissinghurst has seen of the invasion. Otherwise the trains run the same, the papers come the same, everything is the same.

Even in eastern England, 200 miles away, the picture was similar. The Hon. Mrs Caroline Partridge lived at Belton House in Lincolnshire. At the start of the war she had been evacuated to Shropshire because there were so many air bases – and hence likely targets – in her home county.

When D-Day came we were back at Belton because the threat of invasion was now not great … We saw all the gliders going over, the Lancasters towing them. There were so many aeroplanes. My father [Lord Brownlow] … looked up and said a tiny prayer as we came out of church, seeing all these tiny aeroplanes going over. I knew something major was afoot.

This proved to be the beginning of the end of the Second World War and, although the threat from German-occupied Europe continued in the form of flying bombs, within a year Germany had surrendered.

Studland Bay in Dorset with Brownsea Island and the entrance to Poole harbour on the horizon. Studland was used for training exercises in the run-up to D-Day because of its similarity to some of the beaches in Normandy

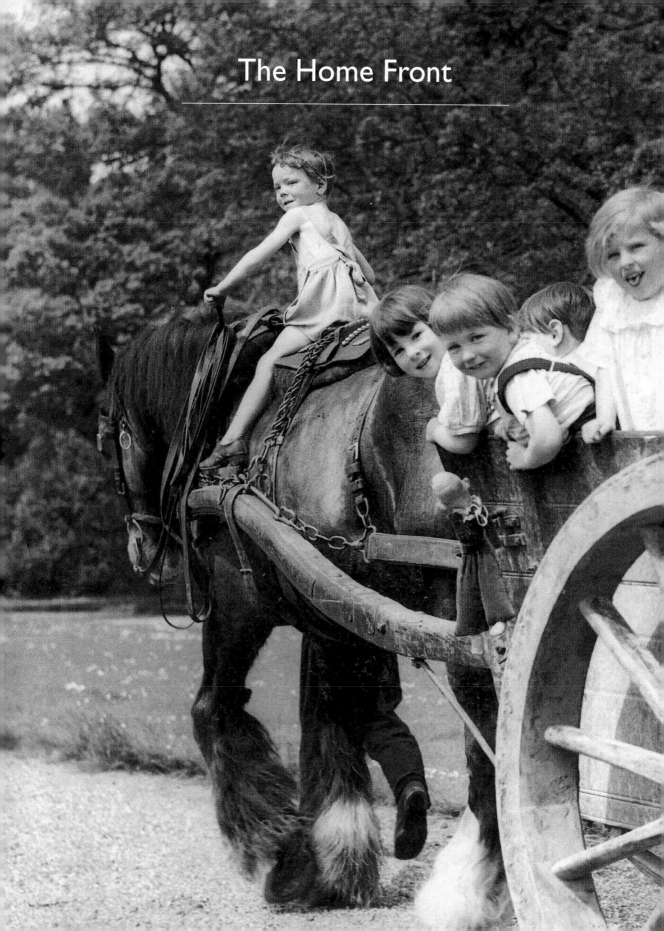

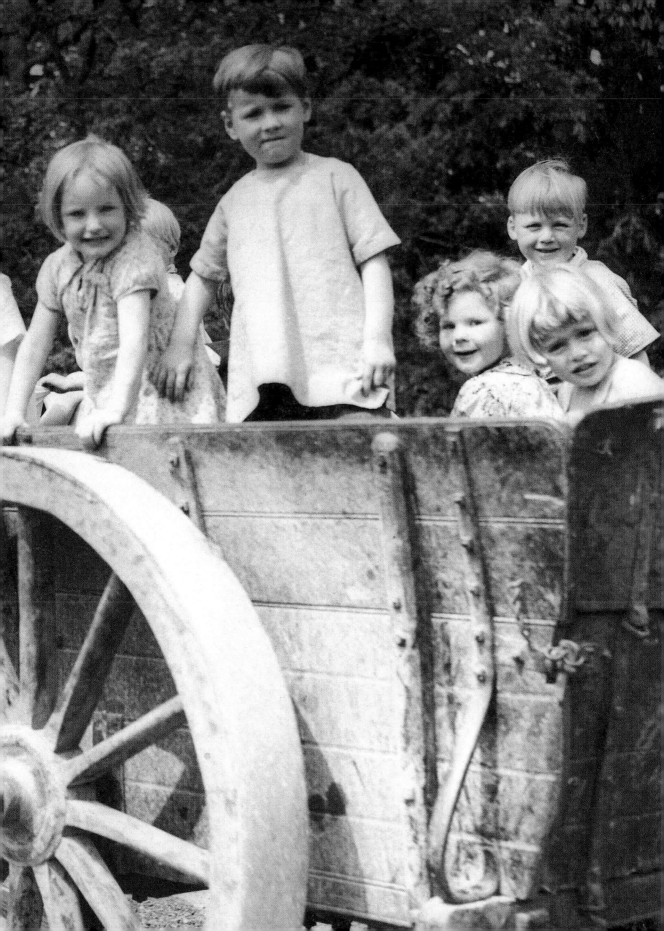

W H E N the 5th Earl of Mount Edgcumbe died at his beautiful Cornish house of Cotehele in 1944, a newspaper obituary recorded not only the passing of his lordship but also what seemed to be the passing of a way of life:

… war, and the death of the master, has broken up the big household just as it has done many another … The London house in Belgrave Square has been closed since early in the war … The pleasure gardens of the estate in Cornwall are taken over by the military … The yacht has been laid up since the war [began] … The kitchen garden is producing food which is marketed … The woodmen are carrying out their work for the government.

The writer could have added that the Earl had been forced to move to Cotehele having been bombed out of his principal house, Mount Edgcumbe.

Guidebooks often have a line or two somewhere towards the back referring to the wartime history of a country house: 'It was requisitioned for the war effort and became a hospital/army camp/school/military HQ for the duration.' It is still apparent that the rich and varied history of country houses and estates in the Second World War has barely begun to be written. Yet the extent to which the larger houses were used and the degree to which they were mobilised was enormous.

Houses and estates had a variety of uses: as stores, as military bases, for secret war work, as hospitals, as schools. It is difficult today to imagine the experiences many of these places had in the war years. Historic gardens and landscapes were turned into assault courses. Ancient woodlands were felled for pit props and sleepers. Lorries churned up woodland rides into deep-rutted muddy racks. Nissen hut encampments sprang up in parks directly beside great houses. Barbed wire and sentry posts were erected to keep some out, others in. Secret decoding work was carried out in sedate and aristocratic surroundings. The sick might be tended in corridors that formerly held rows of ancestral portraits, schoolchildren might sleep in dormitories that had been state rooms or servants' wings. Particularly in the build-up to the 1944 invasion of Europe – and especially in southern England – few country houses escaped the attention of the war planners.

In some cases, the occupants 'for the duration' treated their temporary homes well. In other cases, houses and parks fared badly, some never to recover. The war of 1939-45 was a turning point in the history of country houses, as it became apparent that the old ways of life that had previously supported them were fast disappearing. Demolition, conversion, and bequest or sale to the National Trust were all potential solutions. A trickle of difficulties turned into a flood of problems. By 1955, the worst-recorded year for the destruction of country houses in Britain and ten years on from the end of the war, eleven country houses were being demolished every month.

The wartime use of country houses and estates for evacuated children and mothers from the major towns and cities was a theme of the first chapter. In those cases, the big houses were usually closely aligned with smaller properties in the neighbourhood, with everybody taking in their share of the urban visitors.

Previous pages: Evacuee children enjoying a cart ride

Saltram House near Plymouth in Devon was one of many country houses that had to take precautions to protect itself against bomb damage. This consisted of digging trenches for air-raid shelters (above, right) and bricking up doors and windows to protect the treasures within from flying shrapnel (below). Even so, Saltram was hit by incendiary bombs (some of the ones that did not explode are shown above, left), and more serious damage was avoided as a result of the fire-watching activities of the 4th Earl of Morley and his brother, both in their sixties

For other purposes, the larger country houses and estates stood apart, whether that be as stores for Britain's art treasures, as military accommodation and training space, as locations for secret war work, as auxiliary hospitals or as substitute schools.

SAVING THE NATION'S TREASURES

On the very eve of war, at dawn on the Sunday morning of 3 September 1939, a special overnight freight train was unloaded in Bangor, North Wales. It carried probably the most valuable single cargo ever to be transported on a British train: the treasures of the National Gallery. Other rail and road consignments went out in August and early September 1939 from the great national institutions – the British Museum, the Victoria & Albert Museum, the National Portrait Gallery – bearing further priceless consignments. A variety of country houses had been selected as suitable repositories, away – it was believed – from the dangers of falling bombs. The great pictures from the National Gallery were destined for Penrhyn Castle. Many treasures from the Victoria & Albert Museum went to Montacute House in Somerset.

When Montacute was being assessed as a repository, the vice-chairman of the Advisory Council on Air Raid Precautions, Lord Ilchester, made much of the fact that it had already been rejected for evacuees as being in too poor a condition. 'Empty houses were the very place for evacuated children,' he said, 'but if Montacute is not safe for them it is certainly not safe for the V&A treasures.' He was overruled (not least because he was clearly lobbying for his own house, Melbury Court in Dorset, to be selected for the purpose). Although Montacute had stood empty for some fifteen years and had no proper services, the Long Gallery on the upper floor was deemed suitable. Problems remained: an army searchlight battery had been set up in the park, with the men operating it billeted in various outbuildings. There were delicate negotiations with the National Trust, as being peacetime it was still open to the public and the house also had a sitting tenant. With terms satisfactorily agreed, in August 1939 precious articles were dispatched to Montacute.

As early as 1933 the National Gallery was making plans to transfer its own precious holdings of works of art well away from London if war should ever come again, and various likely locations in Wales were identified.

Penrhyn Castle was one, and it was duly offered by Lord Penrhyn for the purpose (and at a price). The castle was a place capable of housing the largest works the Gallery owned, notably the Van Dyck of Charles I on horseback (for which special cases and even special railway trucks needed to be constructed). The Old Dining Room, the largest room in the house, had particularly tall doors through which the paintings could pass, while a set of garages was fitted up for smaller works.

It was swiftly apparent that this move had been a mistake. Liverpool, Cheshire and north Wales were soon to experience the Blitz. Penrhyn came within enemy bombing range after the fall of France gave the Luftwaffe access to airfields close to the English Channel, while fears were also voiced of civil unrest occurring in

Above left: Penryhn Castle, now in Gwynedd, which was temporarily used as a depository for some of the most precious works of art from the National Gallery in London. The castle was considered safe from enemy bombs until a nearby raid changed opinions and the paintings were removed in late 1941 to a slate quarry in north Wales. The castle also served as a billet to troops and as offices to the Daimler Motor Company

Below left: The National Gallery's portrait of Charles I on horseback by Van Dyck being unloaded at Penrhyn Castle. This picture measures 3.65m x 2.89m (12ft x 9½ft) and Penrhyn was one of the few places that could accommodate such a huge work

the event of an invasion. Moreover, Lord Penrhyn was very difficult, not least because he was often drunk, did not care for the pictures in the agreed manner and was prone to sudden changes of mind. On 9 July immediately after Dunkirk, Martin Davies, the National Gallery's representative in the region, wrote, 'A thousand troops back from Flanders are being sent to Bangor to rest. Lord Penrhyn, without consulting me, has agreed to receive them at the castle. For sentimental reasons I do not feel inclined to veto the billeting of the troops, though I maintained ... I could have done so.' He felt that Lord Penrhyn was clearly trying to make more money – it seemed he was also considering housing an evacuated girls' school. 'You will see that one after another,' Davies wrote, 'our country house owners are thinking of ways of making money out of us. They seem to forget that we have saved them the great inconvenience of compulsory evacuees planted on them. Their willingness to make sacrifice in war does not seem to be great.'

The pictures were subsequently transferred to a more secure location in north Wales, the Manod slate quarry, in August and September 1941. Lord Penrhyn meanwhile had offered the use of Penrhyn Castle to the Daimler Motor Company, as it was transferring its business to Wales from Coventry after the devastating raids on that city. The Rothschild collection from Waddesdon Manor in Buckinghamshire and the Bearsted collection from Upton House in Warwickshire were among many other important art collections that were transferred to Manod for safety. In August 1941 most of the Montacute items were also moved, along with other treasures, to Westwood Quarries near Bradford-on-Avon in Wiltshire, another secret underground location that offered more stable environmental conditions and far greater security.

Up and down the country, large historic houses were being used as grand storerooms for national treasures. Parts of the Wallace Collection were transferred to West Wycombe in Buckinghamshire, where the National Trust staff and other paying guests

Right: Montacute House in Somerset, which was used to house treasures from the Victoria & Albert Museum, London

Far right, above: Women at West Wycombe Park in Buckinghamshire doing their bit for the war effort by knitting, darning and mending. Clothes had to last longer as they were rationed, like food

Far right, below: Offices of the National Trust at West Wycombe, crammed into the entrance hall in 1941. James Lees-Milne commented on their cramped nature in his diaries

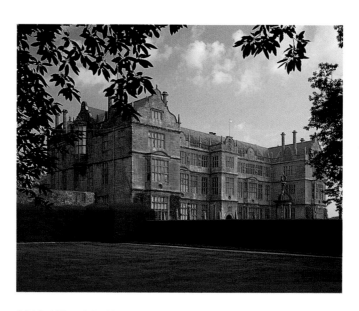

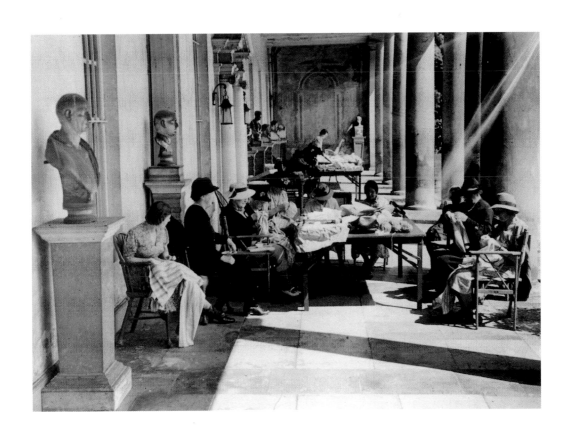

Above, left to right: Some of the 300 tons of Public Records Office being unloaded in August 1941 at Clandon Park in Surrey. Documents were piled high in the vast and ornate Marble Hall with a banner featuring the Onslow family arms hanging above

Below, far right: Noel Blakiston, Assistant Keeper at the PRO, working in his temporary study (the Earl of Onslow's dressing room) in August 1941

were also temporarily housed. (The rest of the collection went to two other Home Counties houses, Hall Barn and Balls Park.) On 1 May 1942, James Lees-Milne and others staying there were treated to a sneak view:

The guardian of the Wallace Collection (its pictures are stored in the house for the war) got out some of the Watteaus and Fragonards for us to look at. He arranged them in a row in the saloon. We had a perfect view of the lady incising a large S *on a tree and the* scènes champêtres, *all of which suit the particular elegance of this house and park.*

Rufford Old Hall in Lancashire was one of the sites used for storing the Walker Art Gallery's prized medieval collection from Liverpool; Packwood House in Warwickshire, was used for storage of paintings from Birmingham City Art Gallery. Some of the most precious pieces of York Minster's stained glass were kept in the stables at Nunnington Hall in North Yorkshire – while a thousand baby respirators were also piled in the smoking room there. Tattershall Castle in Lincolnshire was one of twenty sites used for the relocation of the Natural History Museum collection. On a less elevated level, the vast vaults of Dunster Castle, on the north Somerset coast, were used as champagne stores for Berry Bros.

The Public Record Office was similarly dispersed and Clandon House, the Onslows' seat in Surrey, became one of the principal repositories. The 5th Earl of Onslow sent a telegram to its director in 1941: CLANDON EMPTY NOW YOU SHOULD REQUISITION IMMEDIATELY OR OTHERS WILL. The house was empty because its twenty evacuee children had found the accommodation in the basement cramped and damp, so moved to cottages in the locality. The Earl surmised that the house would be safer as a repository for public records than as a hospital or army billet. Three hundred tons of documents duly arrived. James Lees-Milne visited in the summer of 1942 and again a year later to find the Assistant Keeper of the Records ensconced with his family.

The war in Europe over, the 6th Earl and Countess of Onslow returned to Clandon. Noel Blakiston and Lady Onslow are sitting on the marble steps. Noel's wife, Georgiana, stands behind her husband next to the Earl who has a cigarette in his hand

I walked from the station to Clandon where Noel and Gina Blakiston are living among the stored documents from Noel's Record Office. Otherwise they and the two children have this enormous house to themselves...

The Blakistons seem perfectly content to live in this vast, dust-filled house, in a makeshift manner. They are not in the least deterred by lack of domestic comforts and what are termed the minimal amenities ...

By the closing months of the war, the documents had become tempting morsels for rats. As they were seemingly impervious to poison and traps, Noel Blakiston finally resorted to shooting them from the window. The 5th Earl died a month after the war in Europe ended, so he never had a chance to reclaim Clandon. Boxes of archived documents were cleared out of the Speakers' Parlour so that his coffin could lie in state there.

When war was over, the pictures and documents all began to travel back to their rightful homes. The works from the National Gallery were moved from Manod quarry almost immediately; most of the Victoria & Albert collection left Wiltshire in 1946. Few items from these stored collections had been lost or damaged beyond repair in the process, whereas if they had remained in their respective sites, many would have been destroyed by enemy action. This evacuation had been a resounding success in the end, although country houses had not proved the best solution in every case.

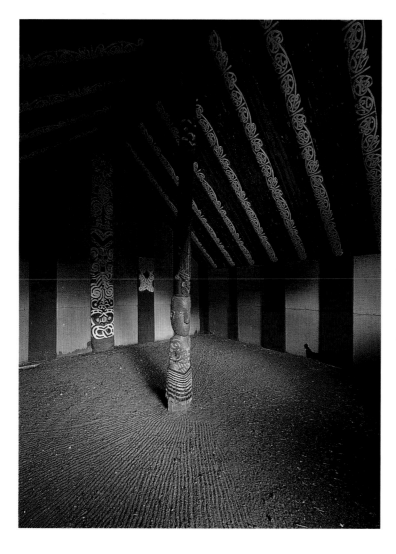

Above: Noel
and Georgiana
Blakiston sitting
in front of
Hinemihi, the
Maori *whare*
(meeting house)
brought to
Clandon in 1892
by the 4th Earl of
Onslow, a former
Governor of New
Zealand

Left: A modern
view inside
Hinemihi showing
the decoratively
carved *poutoko-
manawa* (centre
post) and painted
haiwhai (rafters)

Jim Moore and his brother Peter relaxing by the lake at Blickling Hall in Norfolk where Jim, while on active service, was privileged to stay on two occasions with two different squadrons

While some owners willingly offered their properties to the authorities for the war effort, others were forced to hand over their house or estate. Elaborate lists were drawn up as various interested parties in government and the Civil Service eyed up properties they considered appropriate. The great majority of houses now in the care of the National Trust performed some official – and usually military – function during the course of the Second World War.

The Marquess of Lothian's great Norfolk house at Blickling was requisitioned as the Officers' Mess for RAF Oulton. Lothian had been a member of influential pro-German political groupings in the 1930s (and von Ribbentrop, Hitler's ambassador to Britain, had stayed at Blickling in 1934), but that link was largely forgotten by the time war had broken out. Jim Moore recalls:

It was on 3 April 1941 as a 20-year-old I first saw Blickling Hall. At that time I was a Sergeant Wireless Operator/Air Gunner in 18 Squadron, which was equipped with the twin-engined medium bomber, the Blenheim Mk IV. We had moved from the airfield at Great Massingham to Oulton, a few miles away. The squadron remained at Oulton until 13 July, during which time we lost fifteen aircraft and had forty-three aircrew killed.

The Sergeants' Mess was at that time situated in what is now the Stewards' Room … The main entrance and the staircase were not accessible to us but the remainder of the Hall and all of the grounds were our home … We were under a great deal of stress and the peace and tranquillity in which we found ourselves was an ideal setting in which to unwind … It was quite a pleasant summer and we regularly swam in the lake under the disapproving eye of the resident swan. We had no licensed bar, so the Buckinghamshire Arms became our local if we didn't have the desire to sample the fleshpots of Norwich or Aylsham.

In June, my 19-year-old brother Peter who had just qualified as an electrician was posted to the squadron. He also worked on the flight with which I flew and it must have been very traumatic for him when we were flying on operations … In August 1942 he re-mustered as an Air Gunner, losing his life on his first operation on 28 May 1943.

Blickling was a happy place in spite of the tragic deaths of so many young airmen:

There was a good relationship between all ranks and there was a sense of belonging. Considering our losses, it may seem illogical but it is true. I was to return to the Hall on 30 September 1942 as a newly commissioned Pilot Officer to join 88 Squadron equipped with the twin-engined Douglas Bostons Mk III. The Officers' Mess was located in the east wing of the Hall. Our circumstances were more luxurious than on my previous stay … By this time the outlook for our nation was looking considerably brighter.

The major operation in which the squadron took part was on Sunday 6 September when we led eighty-six medium bombers on a daylight raid on two Philips' valve works in the centre of the Dutch town of Eindhoven. The raid was successful despite the loss of fourteen aircraft (but none from our squadron) … Before the end of the war I was to complete three tours of operations and fly ninety-two operations, yet the summer of 1941 is the period which will be forever imprinted in my mind. It was the most

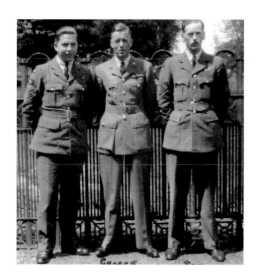
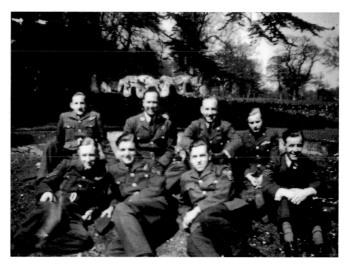

Jim Moore and his fellow RAF airman at Blickling Hall

Twin-engined Douglas Boston Mk IIIs from 88 Squadron in 1942. It is possible that Jim Moore was in one of these aircraft

The 18th-century mausoleum in the park at Blickling. This was broken into during the war by those hoping to find the Countess of Buckinghamshire's jewels

exciting yet frightening time, contrasting to the peace and beauty provided by Blickling Hall.

Not all the RAF personnel were quite as appreciative of their surroundings. When James Lees-Milne visited in May 1942, meeting Miss O'Sullivan, the custodian of the house and the late Lord Lothian's secretary,

On arrival at Blickling we are greeted by a sea of Nissen huts in the park in front of the Orangery, and a brick Naafi construction opposite the entrance to the house. The sudden view of the south front takes the breath away ... The RAF are in Miss O'Sullivan's bad books for they have needlessly broken several window casements, and smashed the old crown glass. They have forced the locks of the doors into the staterooms out of devilry. This sort of thing is inevitable.

Others had forced an entry into the pyramidal 18th-century mausoleum in the park, in the hope of finding the Countess of Buckinghamshire's jewels inside. Perhaps they had not read the inscription on the house saying the jewels had been sold to pay for its rebuilding. Lord Lothian had allowed the RAF officers to use some of the more comfortable historic furniture, just before his death in 1940 in Washington DC, where he was British ambassador. Lees-Milne, when he came back in 1943,

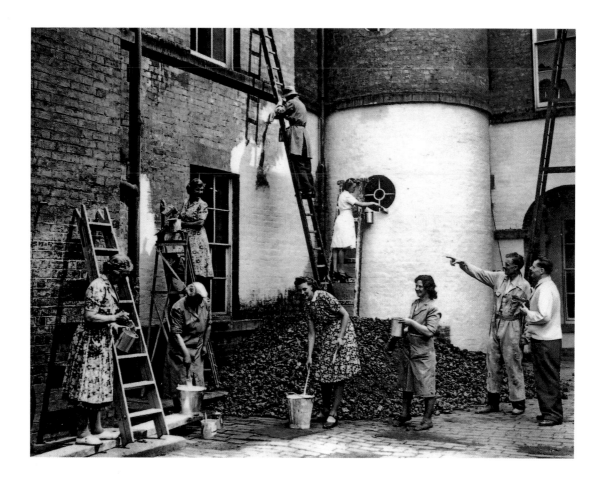

… spent the morning going round the house with [Miss O'Sullivan]. We decided to remove a number of good eighteenth-century bedroom pieces of furniture which Lord Lothian had lent to the RAF. Many of them had been badly spoilt … [Blickling] is a sad, lonely, unloved house with a reproachful air. I dare say it will be burnt down before long.

Members of the Women's Institute decorating the courtyard of Attingham Park in Shropshire

Blickling survived to become a loved house once more. Lord Lothian had bequeathed it to the National Trust in 1940, under the terms of the Country Houses Scheme that he himself had piloted through parliament in 1937. At the end of the war, Margaret Lockwood came to Blickling to star in the feature film *The Wicked Lady*, one of the famous Gainsborough Studio period dramas that provided escape from the grim reality of life.

Blickling was by no means the only house that became a residential centre for service personnel. In 1942, whilst visiting the Berwicks at Attingham Park in Shropshire, James Lees-Milne found that wartime occupation had considerably restricted the family's domestic arrangements:

They inhabit a fraction of the east wing. The WAAFs [Women's Auxiliary Air Force] occupy the rest of the house. The Ministry of Works has at my instigation protected the principal rooms by boarding up fireplaces and even dados …

Helen Samain was based at Petworth House in Sussex during the war years, working in the sort of office arrangements that were to be found at many country houses. Also based there, at a separate time, was the man she subsequently married; the couple only realised the coincidence later:

The house was in use at that time as the headquarters of Commando Group. The park, beyond the lake, was the site of a sizeable tented camp for Commando troops. As a young WRNS [Women's Royal Naval Service] officer I was based at Petworth for several months, as personal assistant to the GOC [General Officer Commanding] Commando Group, Major-General Robert Sturges. He was in overall command of four Commando brigades, two operating in north-western Europe from D-Day onwards, one in Italy and the Balkans, and the fourth in Burma.

Only the ground floor of Petworth House was used for HQ purposes – although the entire house had been previously stripped of paintings, sculptures etc. and was inevitably rather bare. The General had his office in part of the Turner Room, and I had a small partitioned office adjoining. There were other partitioned offices for staff officers, plus two or three other Wrens who worked as general office assistants and clerks. I did not live in Petworth House personally. I was billeted in a pleasant cottage in the nearby village of Duncton. A staff car used to transport me to and from Petworth daily.

Although there was much coming and going of senior and staff officers, frequent meetings with the General and so on, life at HQ was rather quiet – certainly a good deal quieter than life for our Commando troops who were away on the battlefronts! During our spare moments several of us managed to form a drama group and put on a performance of George and Margaret, *a popular family comedy of the day. Most of our time, however, was spent working – paperwork, letters, appointments – and all of it secret.*

Shortly before D-Day I was posted back to Combined Operations HQ in London … My husband, a young Royal Marines subaltern, returned from operations in Normandy in September 1944, camping in the Commando 'marshalling area' in Petworth Park. The Brigade, which had been fighting in Normandy since D-Day, had come back to the UK for a 'refit'. After some weeks at Petworth and further training … the Brigade went back to north-west Europe to fight in Holland and across northern Germany – right up to VE Day.

Melford Hall, in the Suffolk village of Long Melford, was requisitioned by the army; the Hyde-Parker family moved out, initially to a house on the green. As a small boy, Sir Richard Hyde-Parker watched as the north wing of the house burnt down. The fire was the result of over-enthusiastic partying by the military personnel living there:

My strongest early memories go back to when I was nearly five watching the house burning in the distance and that afternoon, walking hand in hand with my father to a scene comparable at my age to a burnt-out box on a bonfire. I later learnt that on the following day my father marked the timber to be felled for rebuilding. The fire gutted the north wing, destroying adjoining roofs, and water from the hoses caused extensive damage to important surviving interiors and subsequently dry rot …

I continued to grow up in a world where the trappings of war divorced

Wartime photographs from albums of Petworth House in West Sussex (three pictures above), and Melford Hall in Suffolk (five pictures below). The Petworth children were from the Chelsea Day Nursery. They slept in the servants' block, while their nurses had quarters right at the top of the main house. Phillip Reeves, a young RAF officer billeted at Melford, is shown with his dog

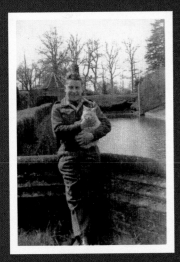

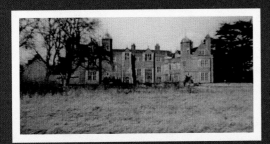

from serious action were delights to a small boy living in the hub of military activity, when Wrigley's spearmint [gum] and B-17 bombers made the greatest impression on boys of my age in my village.

The Hyde-Parkers moved for a time to a place far removed from Suffolk – to Hill Top, the Lake District cottage belonging to their cousin Beatrix Potter. This house was already beloved by generations of children from the illustrations in her books. Tom Storey, Beatrix Potter's shepherd, recalled:

There was just one bedroom [at Hill Top] with the old four-poster. That's the only bed there was there, bar when Sir William Hyde-Parker was there in wartime. It was fit up for him and his wife and two little kiddies and Nanny. That was the only time it had beds in it.

Meanwhile, military occupation of the Hyde-Parkers' Melford Hall continued. Men from twelve successive battalions from nine regiments lived in the house and Nissen huts in the park, until finally the 1st Battalion The Royal Hampshire Regiment were inspected by King George VI at Melford Hall before going into action as spearhead troops in the assault on Gold Beach during the Normandy D-Day landings. Phillip Reeves was among those quartered at Long Melford in 1945:

I had joined the RAF and continued in the RAF until VE Day after which the need for a large European-based air force no longer existed. At that stage – and I understand this is not widely known – many air-force personnel (including myself) were transferred to the army to be trained as gun fodder for the war against Japan. Long Melford was a kind of distribution point where we were accumulated awaiting dispersal to a variety of regiments. We were billeted in the servants' rooms up in the roof, but had the use of the whole Hall.

An American army camp occupied the park at Erddig, near Wrexham in Wales. The increasingly eccentric owner, Simon Yorke, stayed at home: at the onset of war, he had not distinguished himself as a soldier, first by losing the steamroller of which he had been put in charge, and then by getting wood splinters in his one good eye leading to his being invalided out.

Down in Devon, Saltram's park was taken over by the US Army in the build-up to D-Day. Antony House in Cornwall was requisitioned for the war by the Wrens [Women's Royal Naval Service], who were accommodated there from nearby Plymouth. The city was subject to some of the most devastating air attacks of the war, and Antony itself was almost burnt down during an air raid but was saved by the prompt action of the Wrens. In another corner of Cornwall, Cotehele's gardens were occupied by the military, while the house took in the many members of the Edgcumbe family who were made homeless when their principal seat, Mount Edgcumbe, was bombed in 1941. The 5th Earl of Mount Edgcumbe brought with him one of his proudest wartime possessions, a long-handled Redhill shovel designed to remove burning incendiary bombs which had failed to save the big house but might yet save Cotehele.

The house at Attingham in Shropshire was requisitioned by the Air Ministry and occupied by the WAAF [Women's Auxiliary Air

A modern view of Melford Hall in contrast to Phillip Reeves' wartime snapshot from the same position (see page 97)

Group of RAF servicemen in front of Melford in 1945, awaiting dispersal to the war in the Far East

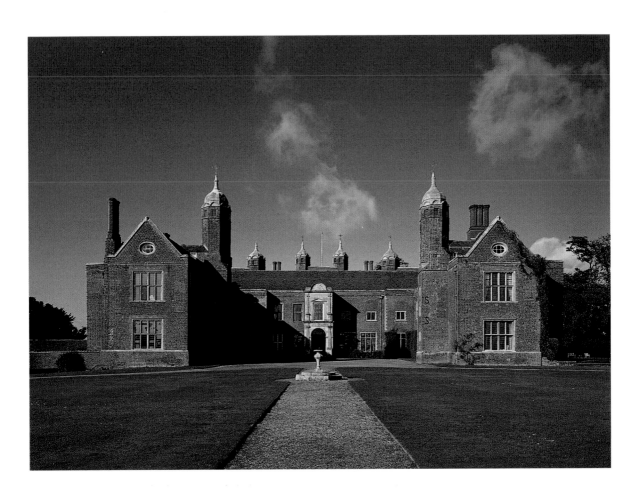

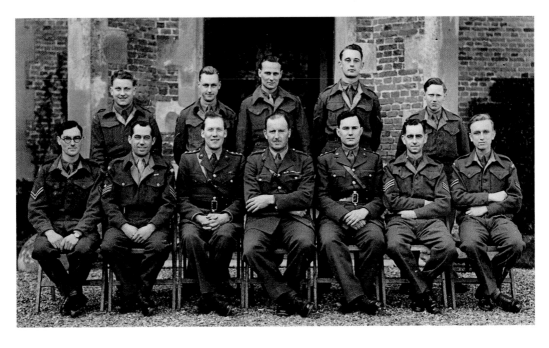

Above: US army soldiers relaxing under the trees at Saltram House in Devon. The vehicles in the background are camouflaged to prevent enemy aircraft from spotting them. Scenes like these were typical across the whole south coast in the run-up to D-Day in 1944

Above right: US trucks under what cover was available at Saltram

Below right: Battalion 4 of the Home Guard at Attingham Park in Shropshire

Force], while the parkland became a vast airfield. Beningbrough Hall in North Yorkshire was taken over by the airmen based at nearby Linton-on-Ouse: the top two floors were used as accommodation while their mess occupied the ground floor. The Royal Artillery used Nostell Priory, also in Yorkshire, as a training base for new recruits, with the stable block and servants' quarters as their barracks. A secret unit took over the late medieval Norfolk house of Oxburgh Hall as a temporary headquarters, after earlier groups of soldiers who had camped all around the house moved out. Many properties, like the park at Dunham Massey in Cheshire, became German prisoner-of-war camps. Geoffrey Mander MP was Parliamentary Private Secretary to the Air Minister; he and his wife retained part of Wightwick Manor in Wolverhampton while the army took over the remainder as an officers' mess and operations centre. Greenway in Devon, which had housed evacuated children in the first part of the war, was the officers' mess of the 10th US Patrol Boat flotilla just before D-Day. One of their number painted the frieze which is still above the fireplace.

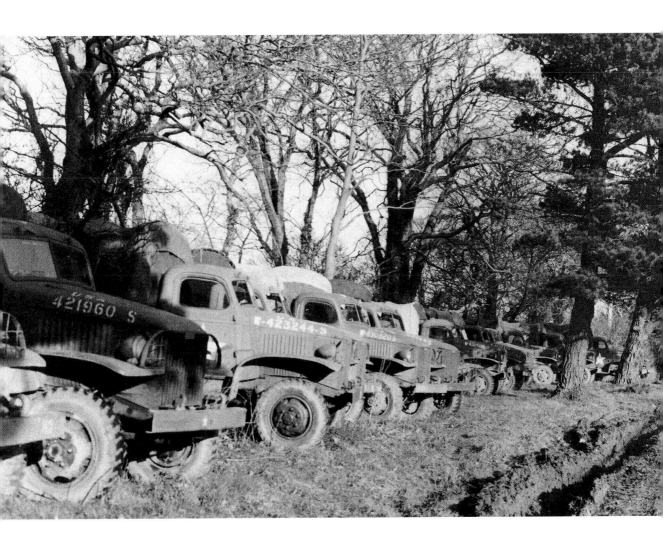

Hardwick Hall in Derbyshire was home to the 1st Parachute Brigade, formed in 1941. Men undergoing training (above left and right)

Right: A dramatic landing. All the parachutists involved in the D-Day landings had passed through Hardwick Hall

Hardwick Hall in Derbyshire, Bess of Hardwick's Elizabethan prodigy house, was used by the RAF as the headquarters of the School of Airborne Forces. The 1st Parachute Brigade was formed there in 1941. Every airborne participant in the Normandy landings went through initial training at Hardwick. In Cheshire, Tatton Park was also used for parachute training. Tatton was the dropping zone for No. 1 Parachute Training School – and in the course of the war years, it also operated as a reception camp for men evacuated from the Dunkirk beaches, a Satellite Landing Ground, a Starfish decoy site, an aircraft dispersion store, a tracked vehicle store; it provided the Auxiliary Fire Service for the locality, and employed and accommodated land girls who worked on the estate.

The park at Knole in Kent was another historic landscape dotted with military camps. In February 1944, the fears of many who loved the house were realised when a bomb aimed at the encampments exploded. James Lees-Milne recorded a curiosity of the event:

The windows of the west front of Knole have been blown out by a bomb in the park. The heraldic beasts on the gable finials turned round on their plinths and presented their backs to the outrage committed. What proud and noble behaviour!

The vast Cambridgeshire house of Wimpole Hall was considered to be inadequately serviced for even the least discriminating army personnel, so the house was not commandeered, while the Professor of Botany at Cambridge put in a plea to save the

precious landscape. An American army VD hospital was however built in a section of the park, and troops were quartered in the stable block. The great avenue of trees, the principal glory of the park, was itself a landmark to help guide returning bombers back to base, and the tree canopy was used to hide aircraft stationed at nearby Bassingbourn. This proved not to be as closely-guarded a secret as the authorities may have hoped, as Lord Haw-Haw specifically mentioned it in one of his radio broadcasts from Germany. Other great gardens did their bit for the effort. Sheffield Park in Sussex was the headquarters of a Canadian armoured division before D-Day, and then became a prisoner-of-war camp. Canadian soldiers were stationed in the garden at Sheringham on the north coast of Norfolk.

Of all the parklands that are now in the care of the National Trust, some of the most extraordinary wartime sights were in Nottinghamshire, hidden beneath the trees at Clumber Park. The house of the Duke of Newcastle had been dismantled just before war came, and the authorities commandeered the park to make it one of the principal ammunition depots of the Midland counties. John Alcock lived at Clumber Park from 1931 until 1960. As a ten-year-old, he saw the first troops arrive soon after war broke out:

The park was known as 24 ASD – Ammunition Supply Depot. Under the trees a pair of Nissen huts was erected, a tarpaulin at each end. And it was all packed with ammunition. The area around our cottage was all phosgene gas. [Elsewhere] it was all ack-ack and naval shells. Stood about four foot high! The thing was controlled by the Ordnance Corps. They extended the platform at the halt between Retford and Worksop so they could take the munition trains. The ammunition was transported into the park on Bedford trucks driven by ATS [Auxiliary Territorial Service] girls. They were bloody fantastic – some were only teenage girls, driving these bloody great trucks filled with ammunition, night and day. They were worn out, dead on their feet …

It got to be the whole park became one big ammunition dump. It was a good job the Germans never found it, or it would have been the biggest bang you've ever seen. With the phosgene gas, it was all very dodgy … It was marvellous from my point of view. The estate was like a jungle… the paths were all overgrown.

George Merrill also lived at Clumber Park, and he worked at a local cordite factory as well as being a member of the Auxiliary Fire Service at Worksop. An explosion at the Clumber ammunition stores was their principal fear:

When this place was full of ammunition, and I mean full, we were priority number one. We had a machine and fire pump here, and we were not allowed to go anywhere. There was a big anti-aircraft gun and a searchlight opposite. A German aircraft went over and was caught in the light – but the anti-aircraft gun was not allowed to shoot in case the camp blew up.

The open and accessible spaces together with extensive tree cover that many parks offered made them ideal for military use. At Ashridge in Hertfordshire the main house became an Emergency Medical Hospital. It was principally the out-of-London location for University College Hospital and Charing Cross

Above: Aerial view of Clumber Park in Nottinghamshire, which served as a massive ammunition dump. This photo has been retouched extensively to highlight roads and buildings

Left: General Eisenhower in his role as Supreme Commander of the Allied Expeditionary Forces inspecting the XIth Hussars at Ashridge Park in Hertfordshire on 24 February 1944 in the build-up to D-Day

Hospital, established in the expectation of mass civilian casualties in bombing raids. In the event, the largest number of casualties treated there was the wounded of the British Expeditionary Force after the evacuation from Dunkirk, although bombing victims from London were subsequently brought there in considerable numbers. Rows of huts in the park provided accommodation for doctors and nurses as well as medical support services.

Large tracts of woodland on the Ashridge Estate had been bought by the National Trust in the late 1920s, and these were used throughout the war by many army regiments as a training base, practising manoeuvres and preparing to go overseas. Frank Mayling, who was born locally in 1931, recalls Ashridge as an area designed for playing in, war or no war:

Before the war we children played in the woods, made camps, climbed the trees and did all the other things boys do. When the army took over the woods, we were not allowed into the woods because throughout the war one regiment or another was camped there. But in the evenings and at weekends us children would go and help clean the tanks, lorries or whatever was parked under the trees just off the road. That was as far as we were allowed to go but we still had plenty to do.

The XIth Hussars and the 51st Highland Division, fresh from the North African campaign and preparing for D-Day, were both based at Ashridge, as were Polish, Dutch and American troops. Young soldiers far from their homes in the USA carved the names of their home states – Texas, Tennessee, Virginia, North Carolina, Michigan, New York, Illinois, South Dakota – into the trunk of a beech tree in the Ashridge woods a month before D-Day. Almost certainly, some never saw their homes again.

HUSH HUSH

Other properties served equally vital but secret functions, secrets to which only a few were privy. Visiting Hughenden in March 1944, the Buckinghamshire house that had originally belonged to Disraeli, James Lees-Milne found that most areas were out of bounds to him:

The main part of the house is at present used by the RAF for target spotting, and cannot be entered ... I was delighted with Hughenden. It is deliciously hideous.

Hughenden – codenamed Hillside – was in reality being used for much more than target spotting. As the Survey Production Centre it was a hive of activity for making maps and plans that the RAF could use on their missions into Europe. Every part of the house was in use, from drawing offices in sitting rooms and bedrooms, to cameras in the ice house and the Intelligence Department in – appropriately – the library. When the war in Europe was over, the Commanding Officer, Major Quaife, wrote to the staff to congratulate them for their efforts.

Old beeches on the Ashridge Estate which had been bought by the National Trust in the 1920s. Large parts of woodland like this were used by the army for training exercises and manoeuvres

Hughenden Manor in Buckinghamshire, described in 1944 by James Lees-Milne, Historic Buildings Secretary of the National Trust as 'deliciously hideous'. Code-named 'Hillside', the house played a vital and secret role as a centre for map production

It should be a matter of personal pride to each one of you that Hillside has been closely associated not only with the Allied Bombing Forces through the production and distribution of target material, but also with the highly important work which has been done in connection with special objectives. Amongst those which may be recalled with particular satisfaction are the production of maps and charts for the destruction of the Sorpe and Mohne Dams, the airborne landings on D-Day and after the Arnhem affair, and the destruction of the Tirpitz. There are others which even now cannot be named for security reasons.

A cartoon in the *Hillside Herald*, the staff newspaper, shows that Major Quaife in fact bore a striking resemblance to Disraeli. A description in the newspaper of the assembled corps at lunch suggests that they did not always take their recreation time quite as seriously as their war work:

Yes, without a shadow of a doubt, these people were the cream of Hillside. Then, 'PLOP', a large ball of wool landed bang in the centre of my plate, smashing gravy in every direction. This was followed by a chortle from the Flight Sergeant. 'Bull's eye', sniggered Sgt McQueen. 'Oh, good show!' tittered Sgt Coppin. 'Would you mind passing my wool back?' asked Miss

Lunnon, a wrathful gleam in her eye. I wiped the grease from my tie and jacket. Mr Bignell did likewise to his forehead and right eye. Gingerly I lifted the ball of wool from my plate and passed it over to its owner. The next moment the ball was floating over to the other corner of the room. 'Catch, Gibby...' Once again the ball floated over our heads, to land with a squelchy thud on the wall behind Rowe. An ominous stain appeared on the wallpaper. It was fortunate that at that moment a diversion appeared in the form of sweet being served.

Equally secret was the work that was done at Coleshill, the Oxfordshire house that had hosted evacuees from the East End of London in the first months of the war. The Pleydell-Bouveries were in occupation, desperate for the National Trust to take the property on but hamstrung by the complicated terms of a family will. Again, James Lees-Milne visited in April 1944 to see what could be done:

The Army is in partial occupation of the house, and has through an explosion destroyed one of the gate piers and part of the wall at the office entrance. The elder Miss Pleydell-Bouverie, who is kindly, shy and stooping, looks as old as her mother seemed to be in 1936. The younger, also

Kedleston Hall in Derbyshire from across the lake. Kedleston was occupied by the army and functioned as a wireless monitoring station, listening and transcribing German signals

unmarried sister lives in a cottage in the park, and is a potter ... The sisters are very poor.

Miss Doris Pleydell-Bouverie, the elder of the two sisters living at Coleshill, later recounted why the army was there and how it came to be so destructive, for reasons that even she did not know at the time:

The whole of this last phase of the Coleshill story is how it was a centre of potential resistance for then the army came. It was introduced by Mike Henderson, [Lord] Faringdon's brother at Buscot. We thought they were training the Home Guard – throwing Molotov cocktails about, and all that – but this was a very, very special assignment. Had Hitler arrived, had he landed, these were special trainees to harry the Germans. It was terribly, terribly secret. It was called ASU, Auxiliary Special Unit, part of SOE [Special Operations Executive, the wartime undercover agency]. Lots of people like poachers got into it, they knew the countryside so well, and they were trained how to harry the Germans.

The 1942 handbook on sabotage by a Captain Tallent was called The Countryman's Diary 1939*! This was going on under all our noses,*

and none of us had the slightest idea of it. In the official history it has the Germans' list of all the people they were going to shoot off at once in England ... and you found most of your friends there.

When D-Day came, certain of [the ASU] were collected and taken to the Isle of Wight – it was thought that after the invasion the Germans would try to make some landings on the coast. They weren't dismissed until 1945.

In the very last days of the war, James Lees-Milne went to Kedleston Hall in Derbyshire, on another of his visits for the Trust. The house, designed by Robert Adam in the 18th century, was a stunning sight, marred by the disrepair into which it had evidently fallen and the unsightly evidence of military occupation. Lord Scarsdale had offered the house to the War Office as soon as war broke out in September 1939. It had been used as a mustering point for the ill-fated British Expeditionary Force – with troops coming to Derbyshire from as far away as India and the Middle East – and then as an army training base, before the Auxiliary Territorial Service [ATS] moved in during 1942.

Down the long drive there suddenly bursts upon the vision the great house, best seen from the Adam bridge ... What can these unfortunate people do? Theirs is a tragic predicament. I notice that the portico has lost swags and wreaths. When the sun comes out, the sharp shadows give the south front the movement Adam intended. This visit has made me sad. I am convinced that this wonderful house is a doomed anachronism.

At the entrance to [the] gates is a series of army huts with a little sub-urban garden in front of each. Again, all over the park are unsightly poles and wires, something to do with radio location ...

The 'something to do with radio location' was in fact another of the well-kept secrets of the war. Joyce Jones was in the ATS at Kedleston in 1944 and 1945:

I was a Special Wireless Operator in Y Service, Royal Signals. We were the humbler arm of the complex operation which produced the code-breaking successes of the cryptographers at Station X, Bletchley Park. In isolated monitoring stations around the country [like Kedleston], hundreds of girls kept [their] round-the-clock vigil in front of radio receivers, tran-scribing German messages from Morse code into four-letter groups, hastily scribbled on printed 'red forms' spirited away to Bletchley by despatch rider.

... We lived in hutted accommodation. The Hall itself was shuttered and silent, but we were allowed to keep bicycles in the stable block and visit the small church beside the house, filled with the marble tombs of the Curzon family. The setting, of course, was superb. Coming off watch in crumpled battledress after a long night shift, we were greeted by the mag-nificent classical building and the morning mist rising from the lake.

Shortly after Lees-Milne's visit, a new dawn broke:

One morning we were informed that during the previous night's watch we had unwittingly been logging messages signifying the surrender of the German army. VE Day followed.

With the end of the war in Europe, the outstation at Kedleston closed down and we were removed to less idyllic surroundings.

Across the water at Downhill, the County Londonderry estate built a century and a half before by Frederick Hervey, 4th Earl of Bristol and Bishop of Derry, even more secret operations were underway. Flight Officer Marion Dunn, now Marion Kelly, went there in 1943:

It was very much a secret operation, and when I say secret I mean Top Secret, as associated with radar in the Second World War. Officially it would have been very difficult to identify what was going on at Downhill. It was an RAF station – RAF Downhill – which was part of 60 Group, a group totally committed to radar, within Fighter Command of the RAF. These radar stations were placed on strategically important elevated sites, so clearly the cliff at Downhill was very important ... As a Wing Head-quarters engineering officer and commissioned in Special Signals Radar, I came out [from Inverness] ... to inspect and consider the maintenance of stations in Northern Ireland ...

Rays were radiated from aerial curtains and they would pick up echoes from moving aircraft, which would be received at the station again, and the radar operators could then identify by the speed with which the radar wave was returned to the station the distance and approximate position of

Mussenden Temple, a folly on the Downhill Estate in County Londonderry, Northern Ireland. Downhill served as one link in the chain of radar sites round the country giving early warn-ing of potential enemy activity

*that plane. It was part of a very important chain of communications …
an important link for coastal command planes. It would not have had a
great number of personnel, but those personnel would have been for the
most part very highly trained, and would be fully appreciative of the import-
ance of their work. Some people say that if we hadn't been able to keep
ahead with radar, it's very unlikely that we would have won the war …*

Even in the best-run operations, accidents happen:

*I've already stressed this was a highly secret operation, and every docu-
ment relating to the operation would have been so labelled, and in every
instruction manual, on every page, it would have been quite clear that it
should be kept under strict guard and therefore quite often would have
been carried by a senior [officer]. If you visualise Downhill and the cliff,
and imagine an officer or other carrier of secret documents moving out of
the shelter of a dwelling to go across to the radar aerial, and the wind
blowing with great force, and somebody stumbling carrying a collection of
loose documents – well, this happened. They scattered down the cliff side,
and it was a big operation to make sure that every single bit of paper was
retrieved and put back in.*

As in the other locations, the secrets were kept.

HOSPITAL WARDS

Of the other vital functions that country houses performed, one
of the most significant was their use as hospitals. Berrington Hall
in Herefordshire, for example, was a convalescent hospital run by
Lady Crawley, who herself held a prominent position in the
British Red Cross. The Beale family at Standen in West Sussex had
been intimately involved with hospital work for generations. The
Queen Victoria Hospital at East Grinstead, which the family had
endowed, became the centre for pioneering work in plastic sur-
gery on airmen who had been disfigured by burns, while Standen
itself took in patients from the hospital and from the armed forces
just as it had done in the First World War. The garden meanwhile
was almost wholly converted to vegetable-growing to feed the
patients. Helen Beale made her personal contribution to the war
effort by giving up her prized Irish wolfhounds to be regimental
mascots. The house at Tyntesfield in Somerset, became a field
hospital, with the women of the Gibbs family helping to nurse
injured servicemen. Pupils from Clifton Girls' School also stayed
in the house; the billiard table served as the desk for one class.
Dunster Castle, also in Somerset, was used as a convalescent home
for wounded naval officers. The women of the Drewe family at
Castle Drogo in Devon provided shelter for babies made homeless
by the London Blitz. Knightshayes Court, again in Devon,
received convalescing American airmen, who lived in the stables
that had been specifically converted for their use.

In other cases, whole new medical establishments were built
beside the houses themselves. One of the biggest was begun in
March 1943 when the War Department requisitioned the park-
land at Kingston Lacy, the Dorset home of the Bankes family. A
year later a hospital complex of more than a hundred buildings
had been built there for American troops, for the expected huge
tally of casualties following the Normandy landings. One of the

This aerial view of Kingston
Lacy in Dorset shows the extent
of the hospital complex that
was built to the south of the
main site. It is interesting how
various areas have been
retouched in white, and some
even blanked out, possibly to
hide secret installations

Right: Corfe Castle in Dorset. US Army Captain George Kremelberg, medical officer and general surgeon at Kingston Lacy Hospital looking around the ruins

Far right: Anton Sohrweide, an American dermatologist at the Kingston Lacy Hospital, sitting on the steps at Kingston Lacy

army surgeons, Major Ted Applegate, wrote almost daily to his family in the USA from there, the 106th General Hospital, US Army. Dorset seemed a long way from home, and the physical separation was often increased by the emotional and cultural distance. Soon after his arrival, Applegate wrote to his family to describe his surroundings:

We are quite near to that very lovely estate I told you about ... and we are among these great old trees, rolling hillocks abound and green, green grass is everywhere. It is lovely.

Three months after D-Day, the war was still taking a very heavy toll. Fleets of ambulances met the trains that came to the nearest stations every day, with 300 wounded men on each train. Slowly, the ambulances navigated the country lanes and into the park carrying their pained and mutilated passengers. In the last five months of 1944, nearly 4,000 patients were admitted, and as many again in the period January to July 1945. In the early months of 1945, there were almost 1,300 patients at Kingston Lacy at any one time, some of them in tents:

I do see many bad cases but it doesn't bother me one whit. I have been well prepared for what I knew the situation would be. It is most piteous, shocking, unless you know what war is. This is the aftermath, the seamy side of war. War is the most inhumane, the most senseless curse of mankind.

Major Applegate was a sensitive and serious man, and deeply aware of the heavy responsibilities placed upon him and others as the end of the war approached:

I live only from day to day, my dear, and they are passing. As an Englishwoman who talked to us a night or two ago said, 'We had our yesterdays, we will have our tomorrows so why worry about today?' This lady ... is in British intelligence. She escaped the Nazis in Belgium and France by the skin of her teeth in 1940 and has been working as liaison between the British and the underground movements in those countries the last four years ... She could and did supply some of the homely little touches which

Anton Sohrweide in front of hospital buildings in the park at Kingston Lacy

brought the horror of war closer to us. How I did thank God I had done my duty and for many thousands of men and for the British who have all stood up and been willing to give their lives that you and our daughters would not have to be subjected to the tortures and indignities, pain, cold and hunger that untold millions of poor defenceless women and children have had to bear. My load is easier for hearing people like her ...

Others helped lighten the load too. The fifteen girls in Betty Hockey's touring concert party based in Bournemouth regularly entertained the troops at Kingston Lacy and at other remote locations throughout the southern counties. *Wait for it!*, the posters cried. *A bigger kick is coming.* And on Christmas Day 1944 the residents of a nearby children's home were given a feast to remember by the US Army. Sixty years on, the gifts and even the menu cards are treasured possessions for some who were there and who, like Nadine Shiner, 'went round the wards showing the sick men there all the lovely things they had given us,' men the children had previously 'cheered as they went through on the

hospital train, and we picked up the chewing gum and chocolate that they threw out to us', before Father Christmas arrived by jeep. Apart from these memories and ephemeral survivals, almost nothing is left of the hospital that once filled a large corner of the Kingston Lacy parkland.

If your house was not to be used for military purposes, the chances were that it would become a school. Girls' schools were often preferred to boys', but up and down Britain a surprising roll of houses opened their doors to schoolchildren. Some did so willingly, but many did not.

Hinton Ampner in Hampshire was Ralph Dutton's pride and joy in 1939. He had just finished remodelling the house in the best Georgian taste when he was given an official ultimatum: take in forty evacuees or hand the house over to a school. He chose the latter as the better option and the Portsmouth Day School for Girls was duly billeted on him. Being close to the Royal Naval Dockyard, their existing premises were a vulnerable target. First came a hundred iron beds. Then came the telegram giving Ralph Dutton forty-eight hours notice to leave. The house's treasures were swiftly packed away and on 1 September, two days before war broke out, the schoolgirls arrived. They rushed into the house in a state of excitement, but for Dutton:

It was a moment of intense bitterness: just as many months of work and effort had reached their culmination, all was snatched from me. Nowadays one is more accustomed to the buffets of fortune, but in 1939 I found it difficult to comprehend that I was being turned out of my own house. However, the situation had to be accepted and, picking up my suitcase, I left.

In the event, Hinton Ampner fared well under the new school regime, and the house was there to be reclaimed six years later (although not before the Royal Observatory had considered taking it over as its new base away from the light pollution and smog of London).

These transfers were taking place in all the vulnerable parts of Britain. In 1940 the girls of Ancaster House School exchanged the potentially dangerous East Sussex coastal location of Bexhill-on-Sea for the Oxfordshire acres of Buscot Park, Lord Faringdon's house. The search for suitable premises had taken a few months, but for Felicity Hancock and her friends the choice of Buscot proved a happy one, if at times exhausting:

Bananas were unknown, oranges only for babies and lemons unseen. So we were sent out to collect hips from the hedges and pick up potatoes from the fields. Some games times had to be sacrificed to our wartime contribution, when lorries took us off to nearby farms. Potato-picking was back-breaking, and cold and muddy, but we had a lot of fun too.

Looking back, it was a privilege to live in that beautiful house – less appreciated then. The furniture had been safely stored away but we lived with the pictures. The delightful Burne-Jones Sleeping Beauty paintings adorned the gilded saloon where we danced on a gorgeous floor … There was a plot among us heroically to rescue the Rembrandt portrait in case of fire. The large nude male statues in the entrance made a startling entry to a girls' school!

Evacuee schoolchildren at Nymans in West Sussex, helping with the upkeep of the garden (above) and drying herbs in the wood shed (below)

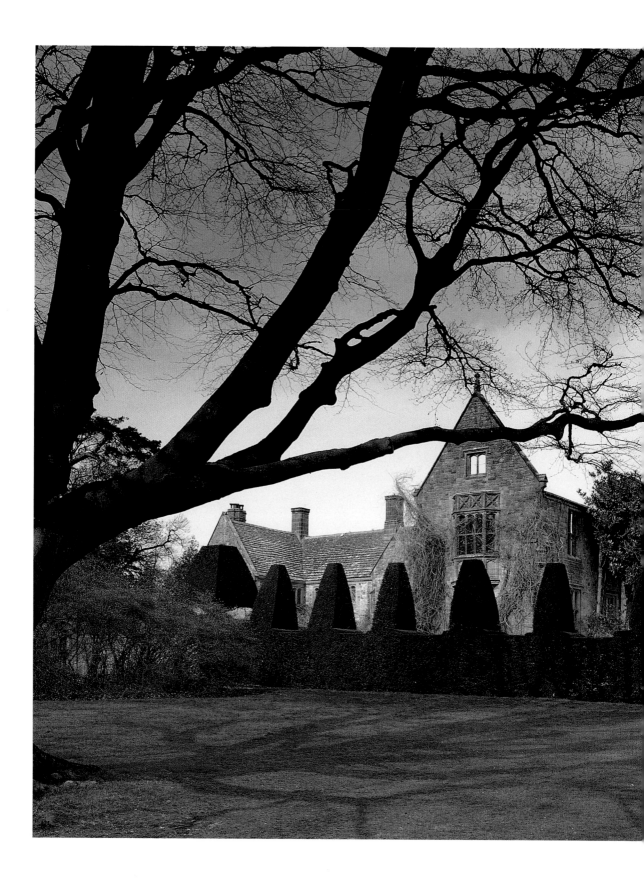

Left: The remains of the manor house at Nymans, one of several houses that survived the war and the attentions of the school evacuated there, only to fall victim to a later fire

Below: A game of skittles on the lawn at Nymans

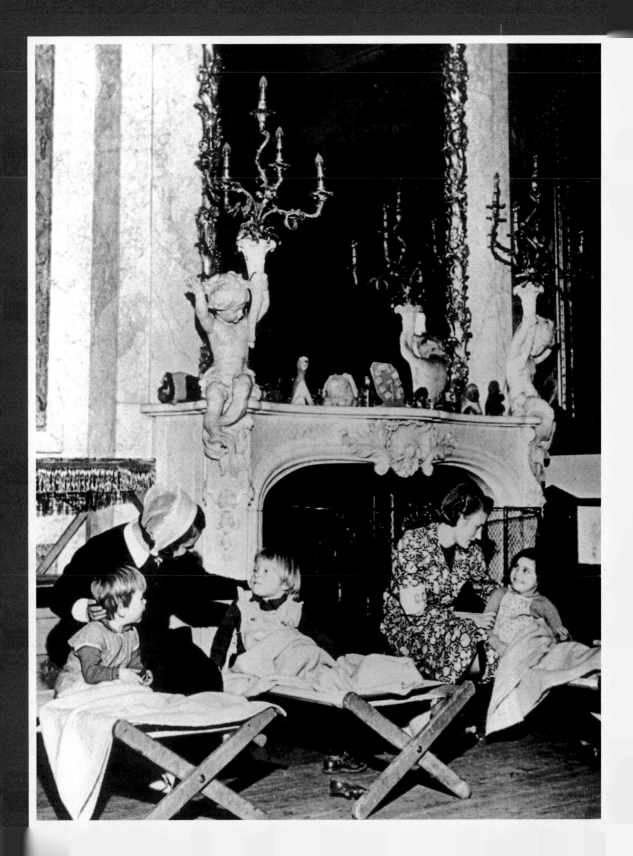

Above: Girls from Battle Abbey School, East Sussex, doing physical jerks, sitting on the house steps, and preparing for music practice at Killerton in Devon

Below right: Hatchlands Park in Surrey, set in beautiful grounds designed by Humphry Repton. During the war it was occupied by a convent school

Previous pages, left: Group photographs showing some of the schoolchildren and their masters who stayed at Nymans during the war. In the picture above, they are joined by Leonard Messel, his wife Maud, their daughter Anne and her husband, the Earl of Rosse

Previous pages, right: Waddesdon Manor played host to many displaced people, and space was sometimes at a premium. Here the dining room is used as a dormitory

Molly Donovan (now Gibson) was one of the convent schoolgirls who moved into Hatchlands, the Surrey home of the architect H. S. Goodhart-Rendel, a Colonel in the Grenadier Guards. Occasionally he brought parties of guardsmen to the house for a weekend's relaxation from the rigours of duty:

These visits were marked – or marred – by our performing plays for the men, and in the evening a piano was brought out on to the lawn where the guardsmen danced with us. They were, of course, all six-footers and some of us were only ten years of age at the time, so we were somewhat ill-matched.

The girls did not always appreciate that there was a different imperative in wartime:

A group of us adopted rabbits as pets. They lived in hutches at the back of the stable block. They were bought by Father Beenker, a Dutch priest who said Mass for us and who lived in a flat over the courtyard. I think he had intended them to supplement the meat ration, but after they had been adopted …

Battle Abbey Girls' School was evacuated to Killerton, the Aclands' house in Devon, together with a prep school for boys. Sylvia Priestley was a pupil there:

The two schools were kept remarkably separate … I cycled the three miles to school. I was one of the few day girls. A small school, there were ten in my class.

Killerton was so light and airy. I loved the way the light shone through the arched windows. Logs burned in the open fires in winter. We were allowed unlimited plain bread with our mid-morning milk. Usually we consumed this while performing our obligatory walk to the gates and back, but if it was too rainy we stayed indoors and toasted our bread by sitting slices of it between logs – the ash added to the flavour.

One morning I was stopped on the way to school. I was so worried, it was end-of-term exams, so they let me through – but an aircraft had crashed in the grounds. All very hush-hush. We did the exams.

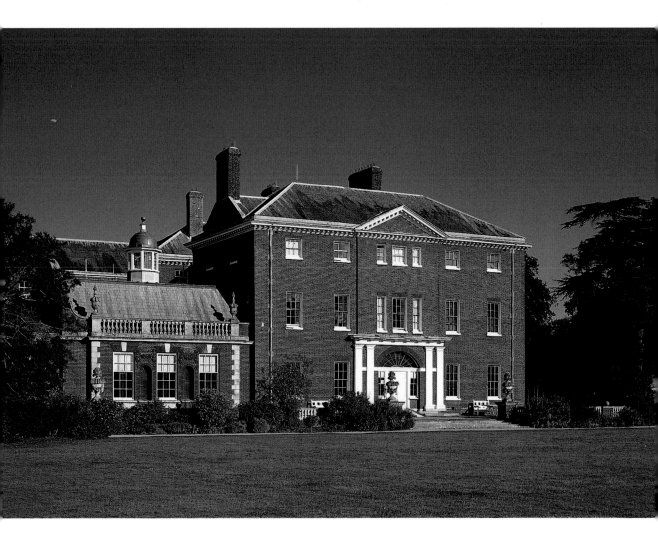

Girls from the Welsh Girls School, originally based at Ashford in Middlesex, were evacuated to Powis Castle in Powys. One of the girls is shown mounted on 'Fame riding Pegasus', an eighteenth century statue by Andries Carpentière. The lead split under the horse, so the rearing majesty had been lost, possibly even from the time when the schoolgirl mounted it. The statue now stands fully erect, back to its former glory (far right)

Scotney Castle housed boys from Rochester School, located in a rather more dangerous corner of Kent, and Nymans in West Sussex took in boys from a school in Westminster. A boys' preparatory school from Deal was evacuated to The Vyne in Hampshire. Children from Campden Hill in west London were evacuated to Lacock in Wiltshire, where they used the South Gallery of Lacock Abbey as their schoolroom. Margaret Gray was a pupil at the Welsh Girls School from Ashford in Middlesex, which relocated to mid-Wales and very different surroundings:

Following the declaration of war, the Welsh Girls School was given two weeks' notice to vacate the building in order that the army could take it over. The Earl of Powis, as a governor of the school, invited the school to Powis Castle and, having delayed the first day of term for two weeks, the staff moved books, small furniture and other items in as many cars as were available. They went back and forth until their time was up. The school remained in Wales until 1946, when we returned to Ashford to a much-battered school.

As a senior pupil who spent the first term in the girls' new home at Powis Castle before leaving school, Gwyneth Hutchinson remembers the sharp transition:

We lived near Hull. I remember the long cross-country [journey] from Yorkshire to Powis. We arrived in Welshpool to be taxied to Powis Castle,

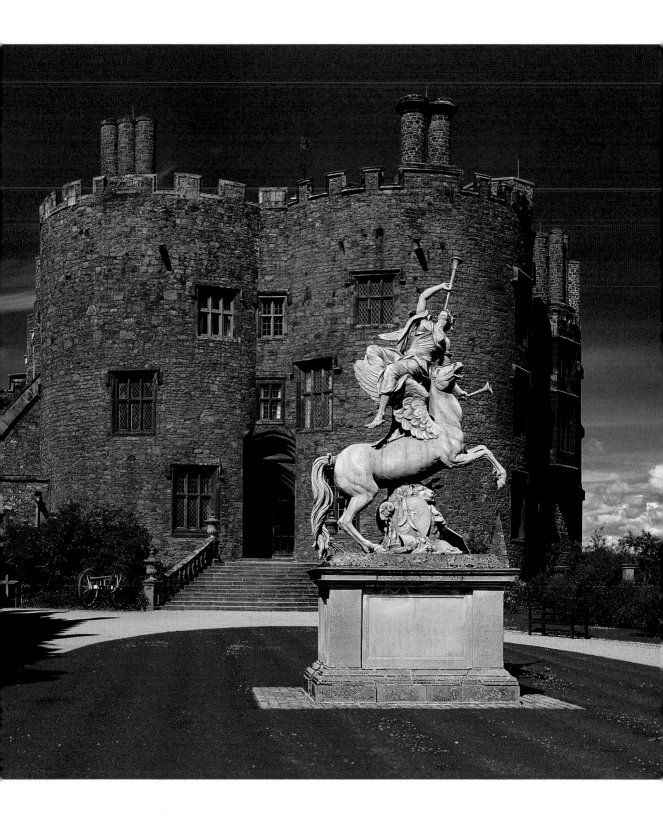

only to find that some of us had to sleep in the bothy which had previously, I imagined, been used for the sheep. I had asthma most of the term and spent weeks in the Dairy House sanatorium knitting squares for the war effort. The beautiful autumn weather, the rutting of the deer in the park, the very steep hill to the castle ... these are vivid memories, and so are those of the daring escapes to the Pola Cinema.

SALVATION AND DESTRUCTION

The uses to which larger houses were put were legion. Osterley Park in Middlesex, as mentioned earlier, became the banking headquarters of Glyn, Mills. The Earl of Jersey, a director of the bank, offered his family home and rows of desks and calculating machines filled the main rooms in the house and a series of wooden huts built in the park. The Petroleum Board leased Clevedon Court in north Somerset from Sir Ambrose Elton. He had always refused to have electricity, and although the Petroleum Board installed electric lights in the parts of the house they used, Sir Ambrose continued to live by gaslight until his death in 1951. William Morris's Red House at Bexleyheath, then in Kent, was painted brown and filled with stocks of ration books for the National Assistance Board. Many other houses, including Polesden Lacey in Surrey, were host to the Women's Land Army.

One of the remarkable features of wartime use is how few major casualties there were, despite bombing and requisitioning, and how many places survived – at least into the immediate post-war years. There was one house that was most certainly threatened, and was only saved from destruction by a timely appeal to the National Trust. In March 1943, James Lees-Milne went to see Gunby Hall in a remote corner of Lincolnshire:

It was built by the Massingberds and is full of their portraits, including two Reynoldses. Now the Air Ministry is threatening to fell all the trees in the park and demolish the house, both in direct line of a runway which they have constructed without previously ascertaining the proximity of these obstacles. If the threats can be averted with our help, the Mont-gomery-Massingberds are ready to make the property over to the Trust straight away. They are such dear people that even if the house were worthless I would walk to the ends of the earth to help them.

Eight months later, Lees-Milne could report success:

A huge steel structure like the Eiffel Tower with a beacon on top has been erected on the tennis court, close to the house, as a guide to pilots and a safeguard of the house. I am overjoyed that the Trust has been largely instrumental in preventing this dear old place from being razed to the ground in order to extend the runway.

What the Trust had also preserved, at least for the time being, was a way of life that remained curiously unaltered in spite of the war. The Montgomery-Massingberds, observed Lees-Milne,

live in easy austerity, no wine, but good, solid food, and enough of it. They have a butler, his wife the cook, a pantry boy, two housemaids, a chauffeur, and lead a feudal existence on a modest scale.

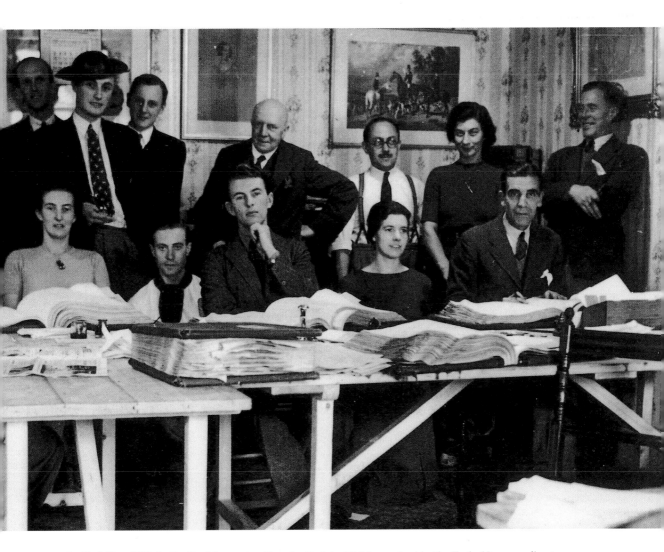

Staff of Glyn, Mills & Co. Bank housed at Osterley Park in Middlesex, lent by the Earl of Jersey, a director. The bank had been acquired by the Royal Bank of Scotland in the summer of 1939, but retained an independent board of directors and services until it became part of the parent company in 1970. The bank played an important role in the war as it paid the men of the armed forces

Gunby Hall in Lincolnshire, dating from 1700; one of the few houses to survive the war intact, mainly through the efforts of the National Trust

When James Lees-Milne visited Stourhead in Wiltshire the previous year, he had discovered the Hoares – who were to give the house and gardens to the National Trust almost immediately after the Second World War – were not always quite sure which war this one was:

Lady Hoare ... said to me, 'Don't you find the food better in this war than in the last?' I replied that I was rather young during the last war, but I certainly remembered the rancid margarine we were given at my preparatory school when I was eight. 'Oh!' she said. 'You were lucky. We were reduced to eating rats.' I was a little surprised, until Sir Henry looked up and said, 'No, no, Alda. You keep getting your wars wrong. That was when you were in Paris during the [1871] Commune.'

Places like Gunby and Stourhead survived. Neither experienced the indignities that houses like Coleshill suffered from military occupation. Post-war workmen achieved what the army had been unable to do and Coleshill burnt down in 1956, soon after it was acquired for the National Trust. The story of neglect, wear and sometimes of vandalism in military use was repeated across the country, and became even more depressing as the end of the war approached. James Lees-Milne, surveying Trust properties and potential acquisitions, recorded two such episodes in April 1945, first in Wiltshire and then in Pembrokeshire:

Returning to Salisbury, we called at Dinton. The American camp immediately in front of Hyde's House is a real desecration. I have never seen

anything so disagreeable – concrete roads, tin huts with smoking chimneys, in short a hideous shanty town in what was a beautiful park ...

Slebech is actually on the creek, and more romantically situated than Picton. We went over this delightful house. A fresh unit of troops was trying to clean up the appalling mess left by the last. Since January water has been allowed to seep from burst pipes through the ceilings and down the walls. Most of the stair balusters have disappeared. Mahogany doors have been kicked to pieces. Floorboards are ripped up. All rooms mottled with and stinking of damp. I imagine dry rot has set in everywhere ...

Some houses were lost. Others emerged renewed and reinvigorated. One of the best-known examples in the Trust's care where a vandalised house was brought back from the brink of ruin is Basildon Park in Berkshire. Lord and Lady Iliffe purchased it from Mr George Ferdinando in 1952. The army had requisitioned the house from him at the beginning of the war; ironically, this happened soon after the family had reclaimed the property and it had been refurnished. By the time Ferdinando took possession again in 1950, Basildon had been wrecked, as he recalled nearly thirty years later:

During the war, the library caught fire. It was the sergeants' mess of an English regiment at the time. The Canadian engineers came first, then our own engineers followed. They threw bridges over the Thames for practice. The Canadians had gone over to France with the first lot, and had fairly heavy casualties. Then after that came the Service Corps, and a number of others ... Towards the end of the war, the American 101st Airborne Division came here, until they went off for the D-Day landings. I met some of the officers when I was on leave. After D-Day the Ministry of Transport took it over. Their own watchman sold the lead off the roof (he was later sentenced to two years' gaol). When I came home, there was an inch of water or more on the floor. The rain came straight through ...

The military previous to that had been fairly careful as to which rooms they used, because they didn't need all of it all the time. The Canadians were trigger-happy and loved to shoot things out; they had a party or two and shot windows out. The glass could be replaced. The clock downstairs; its face was used as a target. Some of the soldiers pulled down a summerhouse in the park. 'Somebody build a house like that, they must have wanted to hide something there.'

By the time Lady Iliffe saw Basildon in 1952,

To say it was derelict is hardly good enough; no window was left intact, and most were repaired with cardboard or plywood; there was a large puddle on the library floor, coming from the bedroom above, where a fire had been stopped in time; walls were covered with signatures and graffiti from various occupants ... It was appallingly cold and damp. And yet, there was still an atmosphere of former elegance, and a feeling of great solidity.

James Lees-Milne also described property after property in his journals that war, the military and genteel poverty were apparently destroying. At Ham House in Surrey, inhabited by the decrepit Tollemache family:

The grounds are indescribably overgrown and unkempt. I passed long ranges of semi-derelict outhouses. The garden is pitted with bomb craters

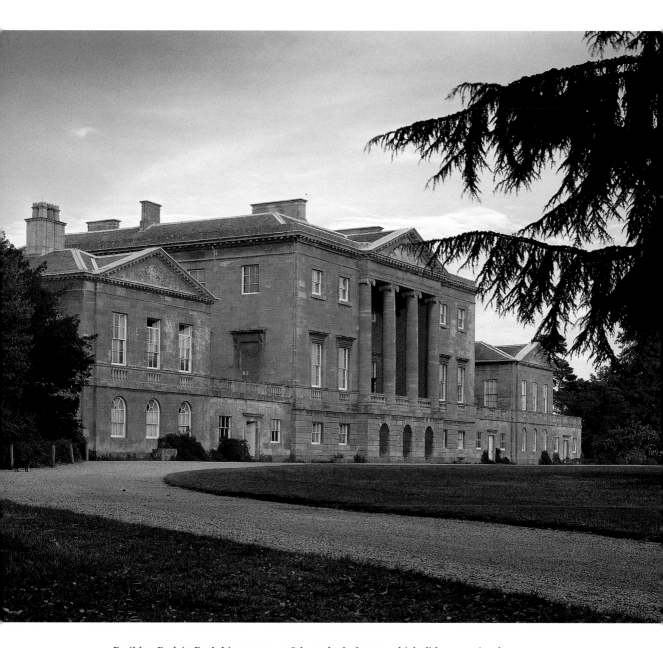

Basildon Park in Berkshire was one of the unlucky houses which did not survive the war
undamaged. George Ferdinando described some of the destruction (see left); Lord and
Lady Iliffe oversaw its restoration in the 1960s

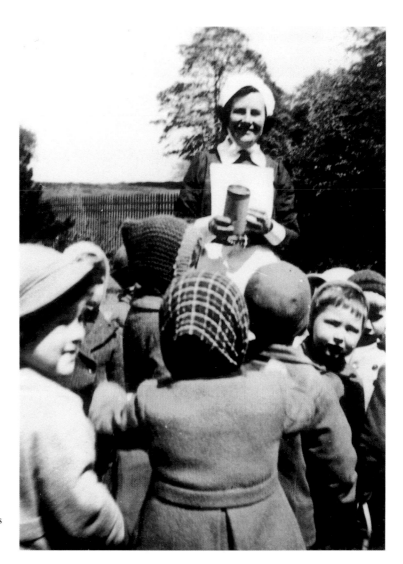

The sweet ration being handed out to eager evacuees at Lyme Park in Cheshire; a rare treat!

around the house, from which a few windows have been blown out and the busts from the niches torn away. The garden and the front door looked as if they had not been used for decades.

Again in 1943, at Lyme Park in Cheshire:

... There were forty evacuated children in the house, but they have now gone. The park is cut to pieces by thousands and thousands of RAF lorries, for it is at present a lorry depot.

The following year,

... to Osterley. What a decline since 1939! Now total disorder and disarray. Bombs have fallen in the park, blowing out many windows; the Adam orangery has been burnt out, and the garden beds are totally overgrown. We did not go round the house which is taken over by Glyn, Mills bank, but round the confines of the estate. There are still 600 acres as yet unsold ...

The courtyard at
Lyme Park in
Cheshire. A group
photograph of
children and their
nurses (above),
and as seen today,
some 60 years
later (below)

Not long after that visit, Lees-Milne lamented the debilitating effects of war:

... motored to Lacock ... [Miss Matilda Talbot] has a number of lonely, white-haired octogenarian ladies lodging with her ... The pictures in the Abbey are in a deplorable condition; so is the furniture, stacked together without dust sheets. The English have become an untidy as well as a grubby people ...

Yet all these houses – Basildon Park, Ham House, Lyme Park, Osterley Park, Lacock Abbey – lived on. There were also wartime examples of country house owners having the foresight to put protective measures in place in the finest rooms, as at Attingham Park in Shropshire, safeguarding what they had inherited in order to pass it on when the danger had receded. For every story of wartime destruction and needless decay, there is also a story against the odds of ingenuity and preservation.

Bernard Shipman was agent to the 6th Lord Brownlow at Belton House in Lincolnshire. This was one of those houses that seem to have escaped requisitioning and wartime depredations, but from the outset no chances were taken:

In the early part of the war there was considerable fear that Hitler would invade England ... There was always the prospect of bombing and Belton House would be a good target to aim at ... This exercised Lord Brownlow's mind. What to do with all his valuable possessions, especially the silver? He hit upon the good idea of hiding it in the underground passageway in the servants' quarters ... All the silver was packed up, wrapped in baize, brought down and stored. The door and frame were taken down, the hole blocked up with bricks, plastered over and the whole passageway whitewashed so you couldn't see where the storage place was.

The silver was taken out when the war was over – all tarnished and black, but it cleaned up.

The other big trouble was the paintings in the house ... and [Lord Brownlow] came up with the idea of sending out to each of the principal farmhouses on the estate two or three paintings, and asking the farmers to look after them for the period of the war. These went out to twenty or more different farms. The very biggest pictures couldn't go, of course. Nothing happened to any of them, and they all came back safe and sound. I had two in my house – the Mercier of Viscount Tyrconnel and family on a swing, the other an Italian, thought then to be a Canaletto, sold many years ago. The Mercier is one of the prize exhibits of the house now.

Portrait of the Tyrconnel family by Philippe Mercier from Belton House in Lincolnshire.
As described (see left), the painting was housed in the home of Lord Brownlow's agent for
the duration of the war

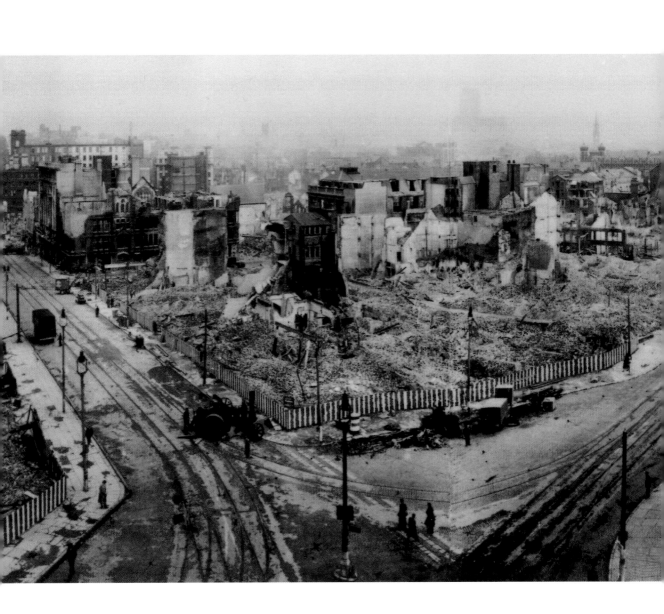

The End of a World

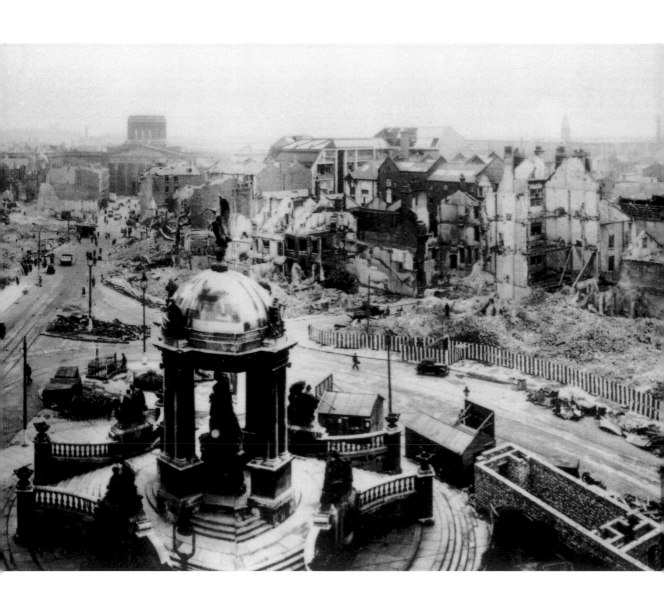

FROM Belton House to Blickling Hall, from Lanhydrock to Lyme Park, nobody could forget there was a war on. There were few parts of the countryside that escaped the effects of wartime, whether by taking in evacuees, being overrun by military personnel or experiencing bomb blasts, but the brunt of it was borne in towns and cities. These were the places from which millions of children and their mothers were evacuated, whether from potential or actual danger, and here civilian deaths and physical destruction were concentrated. Some 60,000 civilians were killed by bombing in the Second World War, most of them in urban areas. A further 270,000 armed forces personnel and 35,000 merchant seamen died in wartime service, more than two-thirds of whom came from towns.

When war broke out in September 1939, it was widely predicted that Germany would begin aerial bombardment straight away, accompanied by deadly gas attacks. Hence the strict blackout precautions at night, as any chink of light might help guide the enemy from the air. Hence the evacuation strategy that, for all its organisational success, failed in many ways, as evacuees returned to the cities and towns (often leaving behind their unused gas masks) when homesickness prevailed and it was apparent that the danger of bombing had been exaggerated. Or rather, the danger had been overstated for the time being. When the bombers finally arrived, they came with a vengeance.

BLITZ

Saturday 7 September 1940 was a beautiful day in a long Indian summer. For weeks the Battle of Britain had continued to rage in the skies over south-east England. Then, at 5 o'clock in the afternoon, almost before the warning sirens had begun to wail, the first concentrations of bombs fell on London. The nation's fears were finally being realised. The writer and publisher Desmond Flower described the first attack on the Surrey Docks, on the south side of the Thames:

Suddenly we were gaping upwards. The brilliant sky was criss-crossed from horizon to horizon by innumerable vapour trails. The sight was a completely novel one. We watched fascinated, and all work stopped. The little silver stars sparkling at the heads of the vapour trails turned east. This display looked so insubstantial and harmless; even beautiful. Then, with a dull roar which made the ground across London shake as one stood upon it, the first sticks of bombs hit the docks.

Hundreds of German bombers with their fighter escort had taken Britain by surprise and broken through the air defences. All the London docks were set alight. Oil, sugar and pepper warehouses burned with particular intensity. The flames guided new waves of bombers towards their targets in the East End. They kept coming until 4.30 the next morning. Houses collapsed, hospital wards were destroyed, whole streets were set on fire. Fire engines and cars converted as makeshift fire appliances raced through the streets. High up on St Paul's Cathedral, one of the volunteer fire watchers was recorded as saying, 'It is like the end of the world,' to which another replied, 'It is the end of *a* world.'

Previous pages: The ruins of Liverpool city centre from Derby Square in 1941. Because of its strategic value, Liverpool was the target for sixty-eight German bombing raids between July 1940 and January 1942, more than any other British port apart from London. The worst attacks occurred in the 'May Blitz' of 1941. Although the docks were the main target, most of the city, including residential areas on both sides of the Mersey, were virtually destroyed: 4,000 people were killed, 4,000 seriously injured and 10,000 homes completely obliterated

Right: Damage to the high altar of St Paul's Cathedral after a bombing raid on the night of 10-11 October 1940

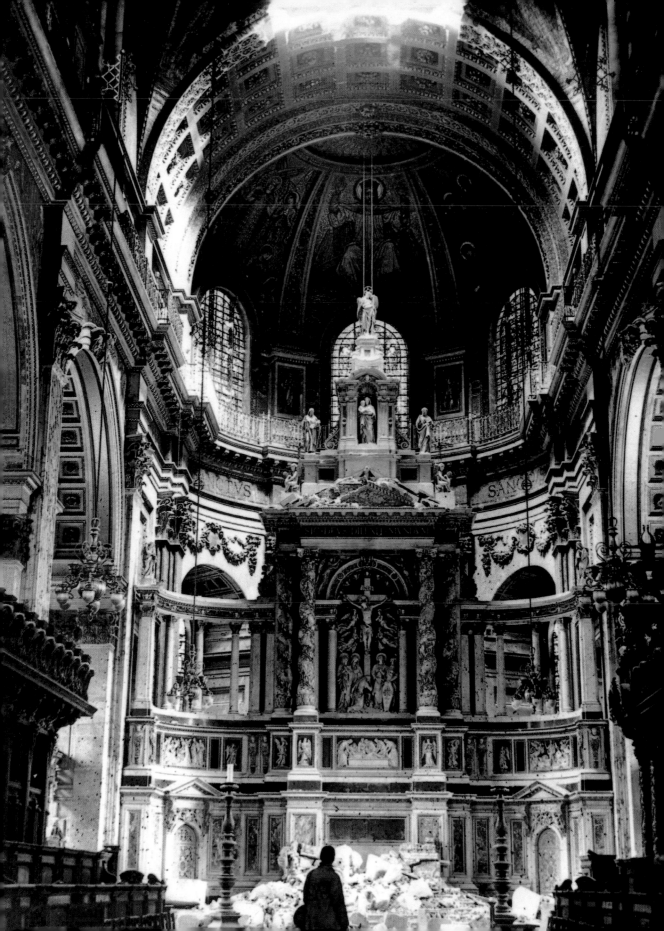

The glow in the sky could be seen by people living thirty miles away, but as the deputy chief air-raid warden for Poplar in London's docklands said,

They could not see stick after stick of bombs dropping into the flames and hurling burning wood, embers and showers of sparks hundreds of feet into the air; they could not see gangs of ARP workers clearing earth from buried Anderson shelters and bringing the occupants, dazed and half suffocated, out … they could not see the [ARP] control staffs, perspiring, exhausted, foodless, endlessly ordering out fresh parties, nor could they hear the gasp of the telephone girl taking the air-raid message dealing with her own home.

That night, 430 civilians died, and thousands were made homeless. Just after eight in the evening, the bombers came back. Another 400 were killed on that second night. On Monday night the bombers returned once more. With the exception of 2 November, when the raiders were turned back by adverse weather conditions, London was bombed for seventy-six consecutive nights (as well as much of the daytime).

When the prime minister, Winston Churchill, broadcast to the nation on 11 September, he invoked history. The fear was that these bombing raids were the prelude to invasion. Intelligence showed that barges were waiting at the Channel ports for troops to embark, and the British codeword for preparedness to repel invaders – Cromwell – had gone out. The week to come, Churchill said, ranked in Britain's island history 'with the days when the Spanish Armada was approaching the Channel, and Drake was finishing his game of bowls; or when Nelson stood between us and Napoleon's Grand Army at Boulogne'. As it turned out, RAF Fighter Command averted the threat by continuing to inflict heavy losses on German fighter aircraft in the last stages of the Battle of Britain, and eventually German plans to invade were cancelled because the opportunity had been lost. The bombing raids continued unabated; morale had been hit heavily in the opening nights, but the public spirit reasserted itself: 'Britain can take it.' Bomb-damaged shops put up signs, 'Business as usual' or, for the more phlegmatic, 'More open than usual.'

ARP warden outside Ernö Goldfinger's Modernist house at 2 Willow Road in Hampstead, London and (right) the house at night, as it would never have been seen during the war. One of the duties of the ARP wardens was to ensure that the blackout was maintained so that enemy aircraft were not helped in finding large concentrations of lights

Once the attacks began on London, other cities – especially ports – felt the wrath of German bombers. By mid-1940, Norway, Holland, Belgium and France had fallen to the German Army, allowing the Luftwaffe to use airfields in each of those countries. It was from these bases, especially in northern France and Belgium, that German bombers would fly to the industrial and port centres of Britain, even as far as Glasgow and Belfast. The bombers followed special radio beams, the *Knickebeine*, that directed them to their target, although British scientists managed on occasions to jam or bend the beams.

Right: Mendips in Woolton, Liverpool where John Lennon lived after the war, away from the destruction of the city centre caused by mass bombing

Far right: Rubble of buildings in Liverpool city centre in 1941 looking towards Canning Place

Among the cities to be attacked again and again was Liverpool. The most important British port outside London, it was a vital route for military equipment and supplies. Heavy bombing had reduced London's port facilities to rubble, so the Mersey became even more vital to the British war effort. The docks were also home to important munitions factories. In February 1941 Western Approaches Command headquarters were transferred north to Merseyside from Plymouth, large areas of which had been obliterated the previous March. In deep underground bunkers, Western Approaches Command received intelligence from the Admiralty and the Air Ministry, and was responsible for protecting supply ships as they entered the port.

Most bombers approached Merseyside and the docks from the Welsh coast, and they could check their position by the lights of neutral Dublin.

On 9 October 1940 a baby was born during a heavy air raid, at Oxford Street Maternity Hospital. Named John Winston Lennon, his middle name in deference to Britain's wartime leader, the boy John lived with his mother in Wavertree, Liverpool through the war. His father was away at sea. Soon after the war was over he went to live with his aunt at 'Mendips', a suburban house in Woolton. He was following a route that many had already taken

Liverpool city centre looking towards the River Mersey in 1941, showing the scale of the damage inflicted by German aerial bombardment

out of the damaged and war-torn city centre.

John Lennon survived. Many Liverpudlians did not. Between August 1940 and January 1942, almost 4,000 people were killed and 3,500 were seriously injured in German air raids. One distraught woman said early in September 1940, 'For the last week we have not been in bed before 4 am, and sometimes after, through the air raids. We have no shelter, so get under the stairs as the safest place.' The worst periods of bombing were yet to come: the devastating Christmas Raids of December 1940 and the even worse May Blitz of 1941. But nothing could quite measure up to the impact of the destruction of Coventry, attacked for ten hours on 14 November 1940. The cathedral was gutted, a third of the city's houses were rendered uninhabitable and a hundred acres of the city centre were destroyed. On Sunday 29 December came the 'second Great Fire of London', when the City of London was struck. Some 1,400 fires were started, but the River Thames was at a low ebb and the firefighters could not cope.

Over the Blitz period of 1940 and 1941, Plymouth, Birmingham and Liverpool were hit hardest after London, with eight major raids on each. In early 1941 Germany decided to regroup its

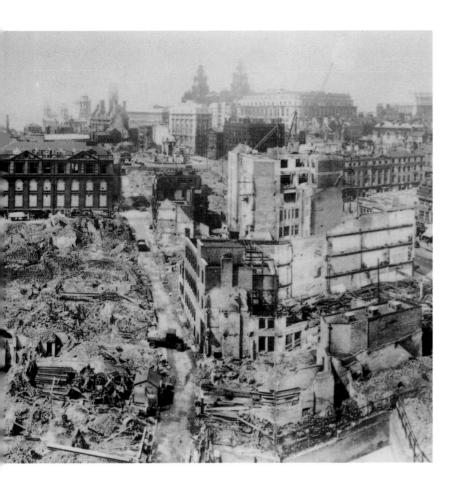

forces in preparation for the large-scale assault on the Soviet Union that was planned for the summer. Before it turned eastwards, the Luftwaffe increased the force and frequency of its attacks on British ports, building up to the heaviest in the first week of May. In the May Blitz, Dorothy Laycock's memories of Liverpool were that the city

... was alight night and day. There was no day, there was no night, it was one continual light day, all fires. The whole city was on fire. No ambulances, no hospitals, there was too many dead, too many injured.

... When you're seven and you're looking at bodies, arms, legs, blood, you don't really know, do you? All you're doing is running after your mum – she had a baby in her arms and he was two, my brother Brian. We used to run, and I mean run, because the bombs were coming at us like raindrops falling all over the place...

So in the May Blitz they blasted, they killed us, they threw everything at us and we sheltered and yes – I came out of it. Thousands came out of it, thousands were killed in it. I never want to go through a war again, never. And you're looking up and you look at these bombs, they're coming down like raindrops at you all over the place. Bombs dropping and you know when they drop, they'll kill, they'll explode ...

Overleaf: Many of the thousands of service personnel who passed through Liverpool in the course of the Second World War went to the studio of E. Chambré-Hardman at 59 Rodney Street to have their portrait photograph taken. Clockwise from top left:

Assistant Section Officer Wetton. A woman officer of the RAF in full uniform

C. R. Harrison dressed in military uniform with Caubeen Field Service Cap

Flight Lieutenant Hilton in full RAF dress uniform, including sword, helmet and gloves

A. D. Miller wearing full Scottish uniform

Mrs Saunders, of the ATS

Pilot Officer J. R. Atherton in full RAF uniform

2nd Lieutenant Robin Campbell in full Scottish military uniform

Chief Petty Officer F. Dawson dressed in full naval uniform

The End of a World [147]

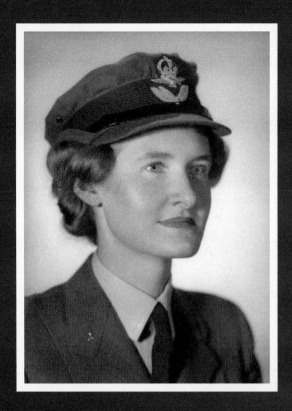

Divis Mountain and Belfast city
viewed from Lisnabreeny. The
mountain was used by the citizens
of Belfast as a refuge from air
raids

More than 1,700 people were killed between 1 and 7 May 1941,
in the most concentrated series of air attacks on any British city
outside London.

Cities' defences were mounted principally by the RAF and the
Army. The RAF put up huge, hydrogen-filled barrage balloons
above the docks and at sites in the surrounding area. These usu-
ally deterred the raiders from attacking below 5,000 feet. They
also lit decoy fires on the sands of the Dee estuary, close to the
Wirral shore, to confuse the enemy. Army anti-aircraft guns and
searchlights targeted enemy planes flying above the barrage bal-
loons. From 12,000 feet upwards RAF fighter aircraft attacked the
bombers. The fighters defending Liverpool were based at Speke,
on the outskirts of the city, and throughout north Wales and the
north-west.

Many urban families decided that they should flee. Large num-
bers of children and mothers had been evacuated in 1939, but had
drifted back home during the 'phoney war'. Now there was a sec-
ond wave of migrants to the comparative safety of country billets.

Other families moved shorter distances but still away from the
centres of enemy action. After the first bombing raids on Lon-
don, thousands moved to camps that sprang up in Epping Forest.
Women and children tramped out of a devastated Plymouth into
the fields, taking with them the few belongings they could sal-
vage. Belfast's citizens took to the hills to escape the bombard-
ment; Divis Mountain being one of the places where they
camped out. Around 10,000 homeless were sent from blitz-torn

Liverpool to new homes in Lancashire, Cheshire and north Wales. Many of those were children who had been orphaned during the attacks. It was estimated that only a quarter of Portsmouth's population remained in the dockyard town, and most of those who stayed on – judging by a survey undertaken at the time by Mass Observation – would have left too had they not had vital jobs in the city.

John Francis McEwan's father was home on leave in Liverpool in October 1940:

… He heard sirens and the blackout was on. He made his way home expecting to find my mother and the three children in the air raid shelter. When he went to the shelter we weren't there. He then went to the house and my mum was under the kitchen table, or under the dining table, with the three children. Obviously my dad was very concerned about this. I don't know exactly what went on other than the fact that the decision was made to evacuate us. My mother was also pregnant at the time …

The three children were evacuated to Southport in Lancashire.

As part of the preparations for war, householders were encouraged to build shelters for air raids in their gardens. Many urban households did not have gardens, but some, like the back-to-back houses in the court on Inge and Hurst Streets in Birmingham, had cellars offering some protection. The most common was the Anderson shelter, named after the then Home Secretary; by the time the Blitz started a quarter of all households had one. Consisting of curved pieces of steel that had to be bolted together, the shelter was then dug into the ground and covered with three

feet of soil. The shelters were small and damp, but offered a degree of protection away from the house. Many householders relied upon the stoutness of a table or a cupboard beneath the stairs. In London, the deep tunnels of the Underground stations housed approaching 200,000 people every night. It was another world below ground.

Sleeping in a shelter became a regular part of daily or, rather, nightly life throughout Britain, in many parts of the countryside and particularly in towns. Morgan Wood's family in Liverpool had their own air-raid shelter, but other neighbours preferred the fun that was to be had in communal shelters:

[Ours] wasn't an Anderson. It was a brick air-raid shelter, with a concrete roof, a concrete base. The walls, they were about eighteen inches or two foot. And I remember the escape hatch was made with wedge-type bricks so they fitted in to the hole of the two-foot by two-foot escape exit … So that was the air-raid shelter arrangements for me in my own back yard. There were occasions when I did use them, just to satisfy my ma, stop her from moaning, because she would do nothing else only moan. Sometimes I'd just refuse to come out of my bed to go into a damp air raid shelter, because that air raid shelter of ours was terrible. It was really damp and cold. Imagine them thick walls, it was ice cold. Eventually we got a little paraffin oil lamp. It gave us a bit of light, but not much heat … I knocked up a couple of bunks so that we could be reasonably comfortable …

… At the top of Elswick Street there'd be queues of people to get in that shelter. And the reason being, earlier on in the day there'd be somebody loading off a couple of crates of ale, you see. And then in the evening, apart from the ale, there was a couple of people with guitars and accordions. Accordions were very popular in them days, and they'd be having a [party] in the shelter. It built up a reputation and people would come from all the streets around, prepared to wait in the queue even though no air-raid sound had gone off. But they'd be prepared to join in, to get a space in that air-raid shelter, that's how popular it had become. I never sampled it, but that was a fact …

For those who were bombed out of their homes – and that meant one in every six Londoners by May 1941 when the main Blitz period came to an end – the problems had only just begun. Shelter for the night could be found at rest centres run by volunteers (usually the Women's Voluntary Service). They tended to be schools and church halls, containing beds and little else. These centres were meant to be temporary, but the homeless often had nowhere else to go so returned night after night. Essentials such as blankets and washing facilities were limited, by official decree, discouraging people from spending long periods there. When it came to finding new homes, ration cards, identity papers or clothing, there was no central office while public transport was often damaged and severely disrupted. The search on foot was worst for those who had managed to rescue some belongings or had several children in tow. Travel vouchers were available for the homeless – if they could find the right place to collect them – to go to relatives and friends outside the area.

Pearl Cartwright recalls picking through the remains of her Liverpool home:

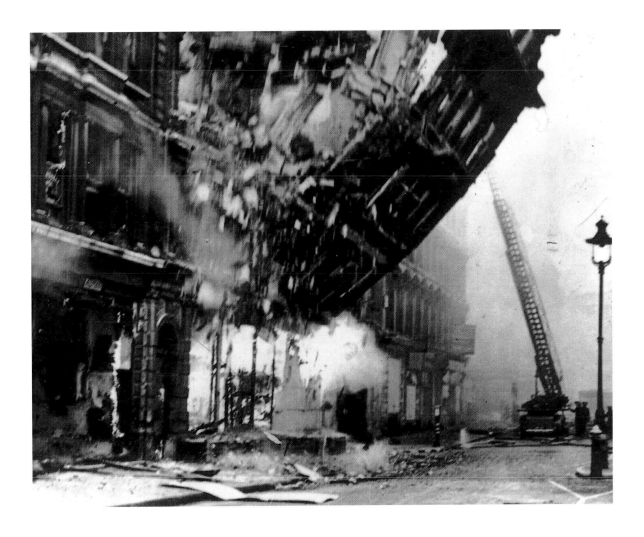

I stood on the top of the hill and just watched. Looked down at my home and the tears were trickling. And they were digging like mad because they had seen this thing, you see. And I said, 'What are you looking for?' 'There's someone in there.' I said, 'There's nobody there because it's my house.' It was this doll they'd found. It looked like a body, you know. I said, 'This is my house and those are mine too,' and it was a sachet of handkerchiefs. I had this big sachet – because there were no tissues, we had handkerchiefs – and they were perfectly ironed, all in this pouch of material, a pretty thing. I was looking for my stuff. It was all gone. Oh, it was terrible and the tears, the tears, well, they wouldn't stop …

In May 1941, the writer and commentator J. B. Priestley broadcast one of his regular radio talks. There had been almost nine months of continuous bombing. 'We are not civilians who have happened to stray into a kind of hell on earth,' he said,' 'but soldiers who have been flung into battle, perhaps the most important this war will see.' By the autumn of 1942, more civilians had been killed and injured in the war than had soldiers. This truly was the home front.

No building was safe from the bombs; this dramatic photograph captures the exact moment when the Salvation Army London headquarters at 23 Queen Victoria Street collapsed on 11 May 1941

The Blitz on Britain came to a temporary end in the later months of 1941, and the bombardment was now being turned on Germany by the British. None the less, limited bombing campaigns and heroic attempts at sabotage, German industrial output continued to boom. Desperate measures were needed to curb German production so as to harm the Nazi war economy, to reduce the scale of armaments manufacture and to attack the morale of workers. The answer seemed to be in blanket bombing, mainly of German industrial targets. Sir Arthur Harris, who led Bomber Command from February 1942, decided to strike at a moderately-sized industrial target, Lübeck on the Baltic coast. Lübeck was also a beautiful and historic city. The attack occurred on 28 March, and half the town was destroyed. German revenge came swiftly: Hitler ordered the so-called 'Baedeker' raids, that set out deliberately to target towns that were of historic rather than strategic importance, allegedly selected on the basis of star ratings in an old guidebook.

Since air attack had essentially come to an end in the summer of 1941, town-dwellers had learnt to go about their routines again. Now, between late April and late June 1942, the beautiful cathedral cities of Exeter, Bath, Norwich, York and Canterbury were pounded by German aircraft, some on several occasions. Four hundred people died in Bath during two nights of bombing. Among the wrecked buildings were the Assembly Rooms, epitome of the spa town's Georgian elegance. At the end of April, when the news of Bath's plight reached him, James Lees-Milne wrote with intense sadness:

It has upset me dreadfully that so beautiful a building, hallowed by Jane Austen and Dickens, should disappear like this in a single night ... There were no defences, no AA [anti-aircraft] guns were heard, and the Germans dived low and machine-gunned the wardens and ARP workers in the streets. This is a reprisal for ours over Lübeck. Both raids are sheer barbaric bloody-mindedness, anti-culture and anti- all that life stands for.

The attack on Bath was a major blow both to the beautiful town and to national pride, and Harris sent bombers to Rostock over four nights, killing or wounding nearly 6,000 in deadly retaliation. The terror bombing of civilians had become policy in both Britain and Germany, principally as a way of undermining morale. In Exeter, which was attacked on 24 April and again on 3 May, the city centre was virtually destroyed, with nine historic churches among the casualties, and the cathedral was also hit badly. These towns were weakly defended, and the potentially morale-sapping nature of the onslaught meant that news of the scale of the raids was censored.

In the aggregate, the numbers of aircraft and bombs used in these or indeed any of the raids on Britain fell far short of the power that was unleashed on Germany in the bombing campaigns of the latter part of the war. Meanwhile, however, the deep outrage that these proud and ancient places were not legitimate targets was felt very keenly.

Above right: Air raid damage to Canterbury Cathedral after a 'Baedeker' raid on the night of 31 May 1942. In this raid, about a fifth of the city of Canterbury was destroyed by fifty bombers dropping approximately 6,000 bombs in about three hours. Much of the damage was caused by incendiary bombs which set fire to many of the timber-framed houses of the historic city

Below right: Remains of Coventry's beautiful cathedral; on 14 November 1940, the cathedral was one of the targets hit by large numbers of incendiary devices from Luftwaffe bombers

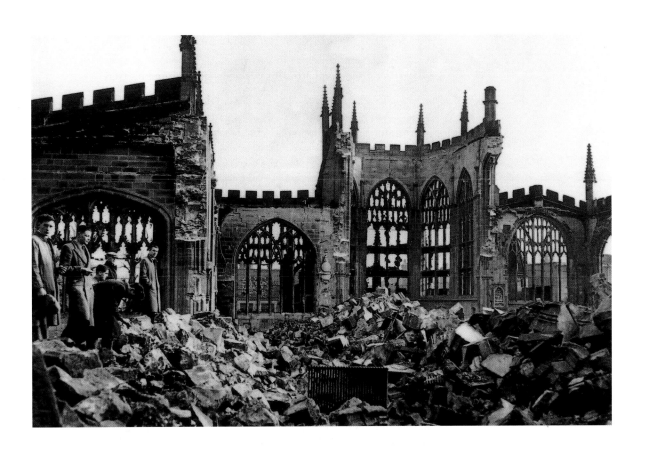

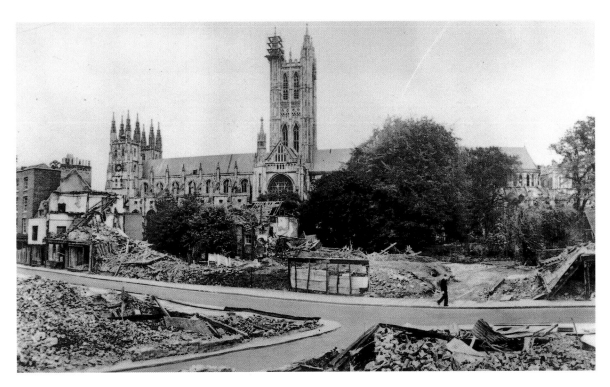

Although the emphasis was always on how much British agriculture could provide, everybody – in town or country – was exhorted to do his or her bit in producing food. 'We want not only the big man with the plough, but the little man with the spade to get busy this autumn,' were the words of the Ministry of Agriculture in 1940. 'Let "Dig for Victory" be the motto.'

At the super-Modernist house 2 Willow Road in Hampstead, London, Ernö Goldfinger's carefully contrived garden was turned over to vegetable-growing. The semi-detached houses of Blyth Grove in Worksop, Nottinghamshire not only produced the fruits

of the land but also, through the business of the Straw brothers who lived there, helped provide seeds for local farmers and gardeners to sow. Everywhere, people were digging in. One of the benefits of Double Summer Time, when clocks went forward two hours rather than one, was that during the growing season, householders could spend longer in the evenings cultivating their plots. Lawns became vegetable patches. Wasteland, railway embankments, sports pitches, town squares and bomb sites were all dug up and planted. By the mid-point in the war an estimated 1.4 million public allotments were being tilled. The Ministry of Information had a slogan for everything: 'Turn over a new leaf – eat vegetables daily to enjoy good health.' 'Dig harder to beat the U-boat.' 'Never mind the worms, just ignore their squirms.'

Many more townspeople than before the war kept chickens; a householder with fewer than twenty hens could keep the eggs they laid. With eggs rationed to sometimes one a fortnight, this was a considerable bonus. Some, like the ARP wardens in London's Hyde Park, joined forces to have a Pig Club, saving every

Above: A painting by Picasso on display at Ernö Goldfinger's house, 2 Willow Road in Hampstead. This exhibition was held to raise funds for the Red Cross Aid to Russia campaign in 1941, after the German invasion

Left: The garden at 2 Willow Road, dug up and used to grow vegetables as part of the 'Dig for Victory' campaign, with Henry Moore's statue looking on. A very different scene from the garden today (far left)

scrap they could to feed the porker, which could only be slaugh-
tered when it had reached exactly a hundred pounds in weight.
Beekeeping became another urban pursuit to an extent that had
never existed before.

In town as in country, the rationing system became ever more
stringent, and townspeople usually had fewer opportunities than
their country cousins to supplement their diet. Pre-war memories
of good food were almost always just that – memories. There were
always substitutes, as the Ministry of Food's Food Facts reminded
housewives:

> For eggs read reconstituted egg powder
> For milk read national dried milk
> For butter read margarine or dripping
> For cream read whipped margarine with vanilla
> For flour read mashed potato or oatmeal
> For fruit read grated vegetables
> For mayonnaise read condensed milk with vinegar
> For meat read offal
> For cheese read sour milk
> For pepper read grated turnip
> For lemon juice read rhubarb juice
> For coffee read barley or acorns
> For Christmas read substitute

This was also a world in which women, children and the elderly
dominated. With so many young men and women away in uni-
form, there were difficulties but also opportunities for those left
behind in the towns. Work on the railways or in munitions fact-
ories gave women in particular both chance to contribute to the
war effort and earn incomes of their own. Morgan Wood talks
about the effect of wartime employment in munitions on his
mother in Liverpool:

*While she had friends amongst the neighbours she wasn't economically in
a position to afford to go out, so she was reasonably easy satisfied. Well
she just had to be, because she didn't have any money. But once she got
that job I noticed the tremendous change in her. She started putting a bit
of lipstick on, she'd be picked up by a bus and taken right up to Speke ...
She had money for the first time in her life. I'd always been at her to go to
see films like* Mrs Miniver *that everybody was talking about. It was a
weepy and I knew she'd enjoy it, but ... once the money started showing,
... she started going along to the local cinema, so that was a wonderful
change for me to observe. There's a human being living in a real life now,
for the first time in her life, because the rest of it had been a struggle.*

Women who made barrage balloons for air defence, in fact-
ories located in many cities, worked long days in twelve-hour shifts.
They were not considered strong enough to handle the balloons
themselves, but by 1941 the official mood had changed. Within
months, half England's barrage-balloon sites were being oper-
ated by women. The Great Northern and Eastern Railway alone
employed 10,000 women as platelayers, labourers, porters and
ticket staff. Other women may not have been directly employed,
but contributed to the war effort in laundries, chopping fire-
wood, fetching coal, clearing bomb sites and knitting. By 1943,

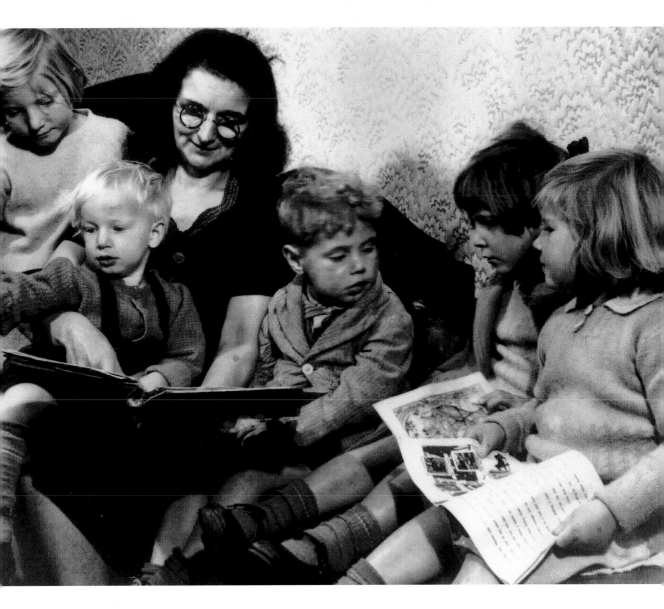

Mrs Dart from Bristol, looking after children whose mothers contributed to the war effort by working in industry. Factory work was a reserved occupation producing essentials. Even so, many men joined the armed services and had to be replaced by women, who often worked round the clock

nine out of ten single women and eight out of ten married women were considered to be 'engaged in essential war work'. A booklet issued to GIs, the American servicemen who started arriving in Britain in 1942, told them that 'women have proved themselves in this war.'

FLYING BOMBS

Just when it seemed that the perils of bombardment had passed, the bombs started to fall again. For Peter Goldfinger, son of the Hampstead-based architect Ernö Goldfinger, coming home to Willow Road was a return to now-expected danger:

The memory of a nightmare which turned out to be an air-raid warning remains with me. Then [my sister] Liz and I were evacuated to Canada for the duration, returning in time for the doodlebugs and V2 rockets and further use of that air-raid shelter.

Even though the tide had significantly turned by mid-1944, with the USA's entry into the war, Allied advances on most fronts and then the successful D-Day landings, there was one last phase in the German bombing campaign to be endured in towns and cities. The 'flying bomb' systems, the V1s – commonly known as doodlebugs or buzz bombs – and then the V2 rockets were launched from across the Channel with deadly effect. They were like something out of science fiction to James Lees-Milne when he first experienced them, recording in his diary on 16 June 1944: ' … last night 140 pilotless planes came over. They are guided by radio and when they land their bomb load of 2,000 lbs explodes. This is like an H.G. Wells story. It is almost inconceivable.' Harold Nicolson – on the very same day – gave a more physical description. He described V1s as being 'illuminated like little launches at a regatta … They make a terrific noise like an express train with a curious hidden undertone.'

In the second half of June a hundred V1s a day were launched, flying along the same 'Bomb Alley' of south-east England that had felt the brunt of the Battle of Britain four years before. Some were intercepted, and eventually only a few were getting through to their targets, but for a frightening few months more than half of the V1s reached London and other cities, usually with deadly effect. Croydon was the worst-affected place in Britain, but V1s were experienced as far away as Liverpool, as Marion Browne recalled:

When the sirens went, Mum used to come into the middle bedroom and bring my sister and me into her bed in the front bedroom which was a big double bed. And my brother of course would be in the middle of us all because he was just a baby then. It was just on that night that we saw the bomb going across the window. She'd come into the middle bedroom to fetch my sister and me and she just pointed out, 'Look!' And this thing with the flames out of its tail was going past the window, whistling ...

Ten days after he had first seen them, James Lees-Milne experienced the bomb's effects at first hand when the house he lived in on Cheyne Walk, Chelsea took a direct hit:

At 2.30 I was woken abruptly by a terrific concussion, sat up in bed, and

One of the many posters used to recruit women for essential war work. Some people were unsympathetic towards a mobilization programme which played havoc with social conventions

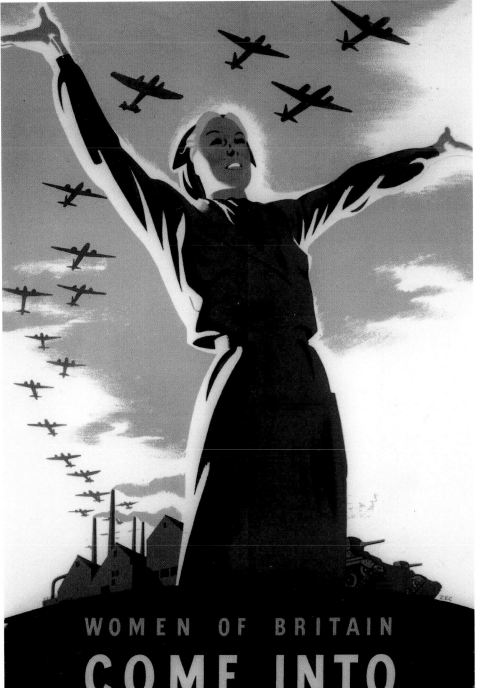

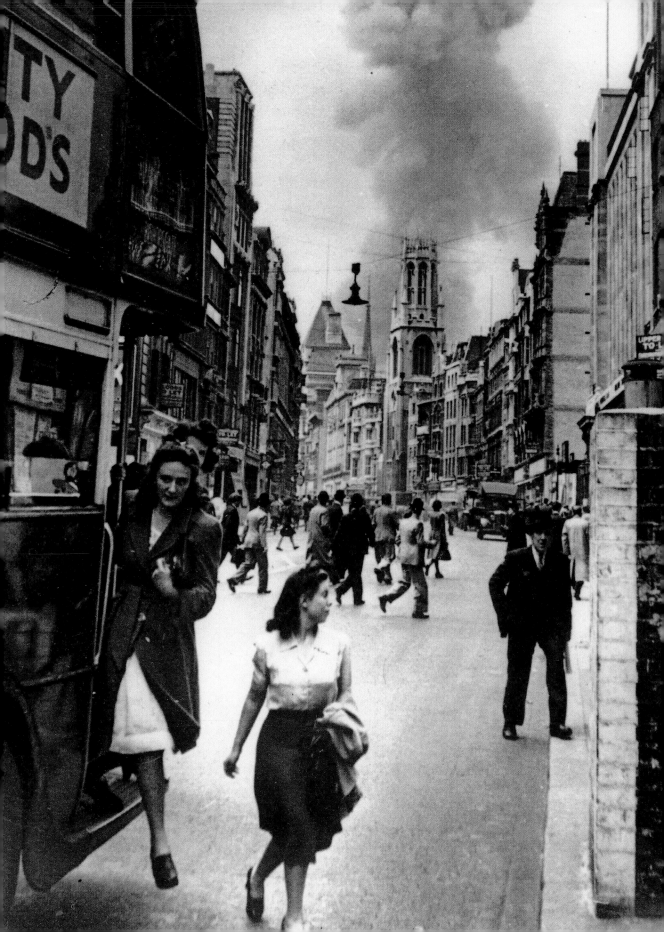

heard a cascade of glass, plaster and broken woodwork. But the house stood up. I was intensely alarmed, and went down to Miss P. [Florence Paterson, his housekeeper], now sleeping in the disused dining room. I did not know whether I should find her alive or dead, since not a sound came from her direction. She had been awake, heard the plane approaching and covered her head with a pillow, which with the rest of the bed was strewn with fragments of powdered glass. A tiny muffled voice came from under the bedclothes. I said, 'Don't move an inch until I can see what's happened.' My feet were crunching glass on the floor. I found the torch. Her bed looked as if buried under a snow drift. I removed the glass as carefully as I could and disinterred her. She was not even scratched. Neither of us was hurt a bit. The bombs had fallen in the river opposite Turner's house, which has already been blitzed, and 100 yards from us. We walked into the kitchen, and even in the dim light could see the air filled with clouds of dust. A cupboard had burst open and disclosed a chimney belching a heap of soot. The only window in the house not broken was my bedroom one. My big room was inundated with glass fragments, which had come across the room through the blinds and curtains, which were cut to ribbons. Nothing of furniture or objects was broken. All rugs inundated with soot and muck. The back door was blown across the passage. Window casements and wooden surrounds torn out, and the poor little house terribly shaken. Oddly enough this bomb killed no one.*

By the start of 1945, the second wave, the V2 rocket, was being used to attack Britain:

Yesterday [4 January] rockets fell like autumn leaves, and between dinner and midnight there were six near our house. Miss P. and I were terrified. I put every china ornament away in cupboards. The V2 has become far more alarming than the V1, quite contrary to what I thought at first, because it gives no warning sound. One finds oneself waiting for it, and jumps out of one's skin at the slightest bang or unexpected noise like a car backfire or even a door slam.

It was silent and therefore all the more deadly – except there were those who took comfort in the fact that you never knew it was coming until the instant it hit you and that would be a merciful release. Lees-Milne continued to suffer.

Finally, life started to return to normal as the Allied push through Europe extinguished the rocket launching sites and reached into the heartland of Germany. The bombs stopped falling, and talk of a new social order 'when the war was over' began to feel achievable. In battered and exhausted towns and cities, the prospect of an end to the fighting was in sight at last.

A VI bomb falls in the Aldwych section of Fleet Street in London on 30 June 1944. The bomb fell just outside the Air Ministry, opposite the BBC at Bush House, which was packed with people. Figures vary, but up to 200 people were killed and another 200 seriously injured. This photograph gives a very different impression of the disaster

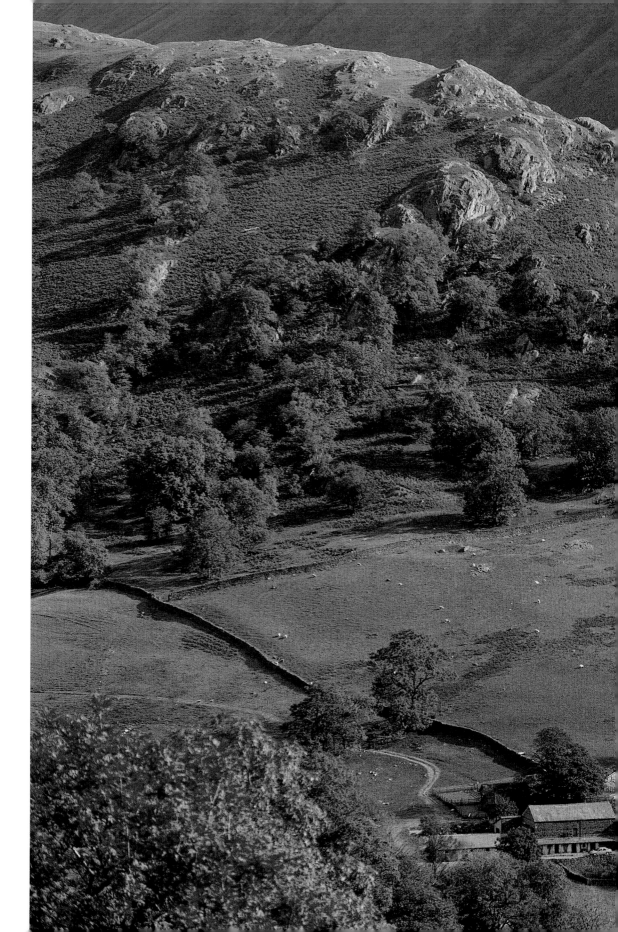

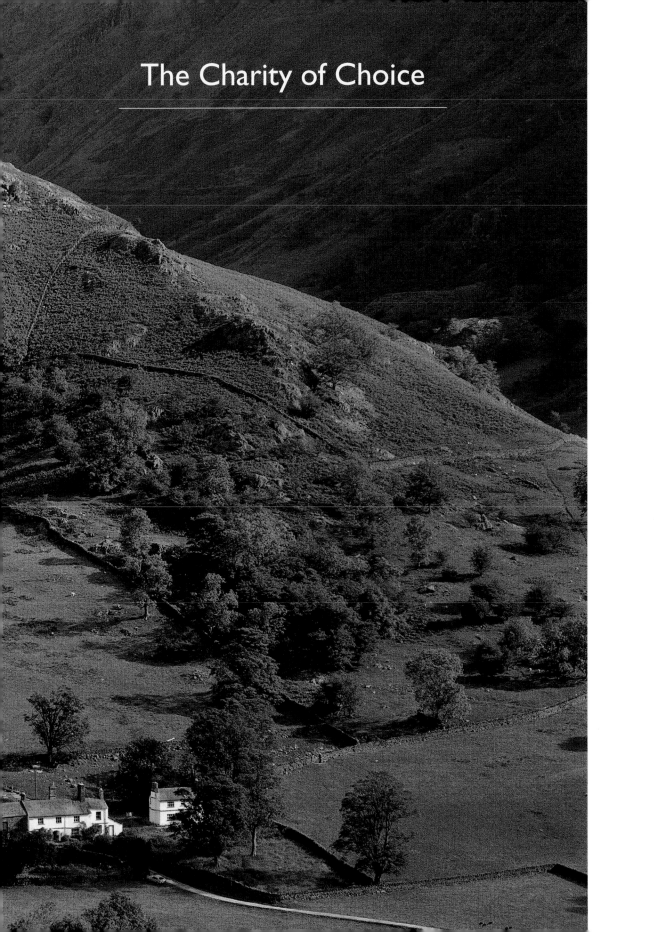

The Charity of Choice

TOM Storey was the shepherd who guided and cared for the children's author and Lake District farmer Mrs William Heelis, better known as Beatrix Potter. He recalled the event that marked the end of her long life:

She died at Christmas [1943]. I remember we'd just finished Christmas dinner when Mr Heelis landed in with this square tin, with newspaper round it. 'You know where you have to go, Storey?' he said. 'What are they?' 'Mrs Heelis's ashes.' 'Oh,' I said, 'yes.' And mind I did, I knew where they had to go all right, and he left them and out he went, leaving me to scatter the ashes. She asked me to do it, but she said, 'Whatever you do tell nobody, I want it kept a secret.'

What was not a secret was Beatrix Potter's deep affection for her adopted Lakeland home and her attachment to traditional farming ways. In her will, she left the estate she had built up of

Previous pages: Troutbeck Park Farm in the Lake District was the largest of several farms donated to the National Trust after the death of Beatrix Potter (Mrs William Heelis) in 1943

Right: The bedroom at Hill Top, Beatrix Potter's cottage at Near Sawrey in Cumbria. Sir William Hyde-Parker, his wife, children and nanny all slept in this room during the Second World War when they removed themselves from Melford Hall in Suffolk (see page 98)

Far right: Cottages at Tivington Knowle on the Holnicote Estate in Somerset. This estate, along with the family house and estate at Killerton in Devon, was given to the National Trust in 1944 by Sir Richard Acland (see page 176)

farms, fields, cottages, lakes and fellsides to the National Trust, one of the most significant landed bequests it received in its first fifty years of existence.

The Second World War was a watershed in the history of the National Trust. Its landholding was significantly increased by the continuing acceptance of legacies, large and small but all generously given. The main shift was in new acquisitions, especially larger country houses. Country-house owners' minds and energies were absorbed by the war. Many of their homes had been requisitioned for troops, intelligence, art stores, schools, emergency hospitals and government institutions. Most of the remainder were put under dustsheets and shut up. A brave few carried on as before. By 1942 the war had taken a new turn, the Allies

Stableblock at Hatchlands Park
in Surrey, home of Harry
Goodhart-Rendel (right)

were scoring victories and there was a prospect of peace. Owners
of the grander houses now had a future to look forward to, but
many did not know how they were going to afford to staff and
maintain their massive properties in the years ahead.

In the early 1930s this had not seemed an issue, but rising tax-
ation, high costs and a diminishing number of people willing to
go into service had all become problematic by the time war broke
out. Some owners had already sought the National Trust's help,
and during the war many turned to it to talk through their anxi-
eties. In 1939, the National Trust owned only two houses of sig-
nificant scale and architectural importance: Montacute House
and Barrington Court, both in Somerset. Neither had an estate
attached that would provide funds for its upkeep. Three years
previously the Trust had made its first moves, guided by the Mar-
quess of Lothian, towards acquiring houses and estates to pre-
serve them in their integrity for posterity.

Initially the National Trust had a 'hit list' of houses of consider-
able merit it would wish to acquire if offered. A series of Acts of
Parliament paved the way for acquiring estates together with
assets that could be used as endowments, while the Treasury even-
tually decided that individual properties should be considered for
acquisition on their merits, rather than by whether or not they
were on a list. During the war years a series of houses was trans-
ferred to Trust ownership. Lord Lothian bequeathed Blickling
Hall in Norfolk in 1941. Wallington Hall and Lindisfarne Castle,
both Northumberland houses, Cliveden and West Wycombe Park
in Buckinghamshire, Speke Hall just outside Liverpool, Polesden

The architect Harry Goodhart-Rendel who gave Hatchlands Park in Surrey to the National Trust in 1945.
He is shown on the left with R.C. Norman, the Trust's Vice- Chairman

Miss Matilda Talbot handing over the deeds of Lacock Abbey and Village in Wiltshire in 1944 to Lord Esher (standing), the Chairman of the Country Houses Committee of the National Trust in 1944. During the war, the Abbey housed evacuees from south London

Lacey and Hatchlands Park in Surrey were among the more important properties that came to the National Trust through transfer or bequest. Within six years the Trust's portfolio had changed beyond recognition.

The opening years of the war were almost completely inoperative for the Trust. Its staff and committee members were all engaged on active service or useful war work. In 1942 the Trust's office was installed at West Wycombe Park where it had moved shortly after the outbreak of war. 'When I rejoined it,' wrote James Lees-Milne who had first been taken on in 1936 and came back after serving his country, 'the entire male staff consisted of the harassed secretary, Donald MacLeod Matheson, an extremely able but delicate man, and Eardley Knollys who had recently been taken on as his helper. Of the female staff two stalwart ladies had remained.'

Back in London later that year, Lees-Milne was frequently on the move, visiting existing properties and sizing up new opportunities for the Trust. It was not an easy task. 'Nearly every train journey was fraught with misadventure,' he wrote in 1995. 'All were late; some did not reach their destination, and might come to a dead halt in a siding for the night. If a passenger was lucky he had a seat. If unlucky he squatted in the corridor. It was prudent always to carry a packet of biscuits and a hip flask.'

In Northern Ireland, on a smaller scale, the National Trust was

also emerging from its fallow period. Dick Rogers, who became Honorary Secretary for the Trust in Northern Ireland, was a civil servant. He had not been allowed to join up in 1939 because of the important strategic role he would be able to play. 'By the end of 1942 the tide was turning,' he recalled, 'there was no longer the threat of an invasion and the work [as private secretary to the Minister of Public Security] slackened.' The process of acquiring significant holdings of coast and countryside, as well as a number of important historic houses, changed gear in the Province too.

Throughout England, Wales and Northern Ireland the Trust became in a short time the charity of choice for many country-house owners. In some cases the families were given the right to continue to live in the houses they had transferred, while in other cases – often in its eagerness to acquire a significant property – the Trust failed to secure sufficient endowment for its future upkeep. There were missed opportunities, but also opportunities grasped. Important houses and historic landscapes were preserved for the nation. Otherwise, they might have suffered the fate of many once-great houses in the 1950s, some of which disappeared under the demolition hammer, while others suffered the encroachment of sprawling towns or insensitive development. The landscapes, coastlines and historic buildings that the National Trust was anxious to preserve were, after all, the embodiment of what the nation had been fighting for.

The medieval nunnery of Lacock Abbey, which was turned into a country house at the Dissolution of the Monasteries

A New Era

7 MAY 1945

*At 3 comes the news ... Germany [is] obliged to surrender uncond-
itionally, crushed by the overwhelming might of her enemies. Ben
and I dash to tell [Vita Sackville-West] who is in the courtyard. The three of
us climb the turret stairs, tie the flag to the ropes, and hoist it in the soft south-
west breeze. It looks very proud and gay after five years of confinement.*

Flags flew, church bells rang, the lights came on again. The
jubilation of Harold Nicolson and his family at Sissinghurst was
matched across Britain. War in Europe officially came to an end
with the victory celebrations on 8 May 1945.

Sir Richard Hyde-Parker had grown up in the war. His family
home, Melford Hall, was taken over by troops and the surround-
ing Suffolk countryside had been filled with encampments of the
armed forces:

*I was a child on VE Day, standing by the biggest bonfire I had ever seen,
burning on Melford Green. There were no fireworks during the war, so the
army fired endless flares criss-crossing like the previous searchlights
around the village but in red, green and yellow. The concept of victory
made less impression then than the diversity of the gathering lit by the
flames. There were troops from the camps at Melford Hall and Kentwell
Hall, Americans from the aerodromes at Alpheton and Acton and us from
Melford with the many evacuees who came from London to live with us.*

In London, James Lees-Milne was celebrating with friends:

*This is V day at last ... We walked arm in arm into the middle of Pic-
cadilly Circus which was brilliantly illuminated by arc lamps. Here the
crowds were singing and yelling and laughing. They were orderly and
good-humoured. All the English virtues were on the surface.*

For the great majority of people in Britain this was the celebra-
tion that mattered, Victory in Europe, because that had direct
impact upon their everyday lives. For those with family members
in the Far East, whether in captivity or fighting, the last few
months of the Second World War were agonising, not least
because it looked as if there would be a long and drawn-out end
to the hostilities there. The date that marked Victory over Japan
was 15 August 1945, after the Japanese surrender following the
dropping of the first tactical atomic weapons on Hiroshima on 6
August and on Nagasaki three days later. The relief was mingled
with shock. The Hon. Mrs Caroline Partridge, who lived at Belton
House in Lincolnshire, recalls:

*When the atomic bomb was dropped on Hiroshima, we were at Belton and
my father stood up and said, 'This is the beginning of a new era. The
nuclear era.'*

The celebrations were redoubled. David Sales, a schoolboy in
the Dorset village of Studland, had been a witness both to the D-
Day rehearsals and to the testing of anti-invasion devices that
included setting the surface of the sea alight.

*On VJ Night, the people that burnt the oil in the war had three tanks and
explosives. They built an enormous bonfire with pistols and Very lights,
and the village celebrated VJ with the grandest bonfire.*

Previous pages: Studland Bay in
Dorset from sand dunes south of
Shell Bay. Studland was used to
replicate many of the Normandy
beaches for training purposes
in the weeks leading up to the
D-Day landings. The heathland
behind has since become a
National Nature Reserve,
a haven for many rare birds

Right: The parish church of SS
Peter and Paul at Belton House
in Lincolnshire

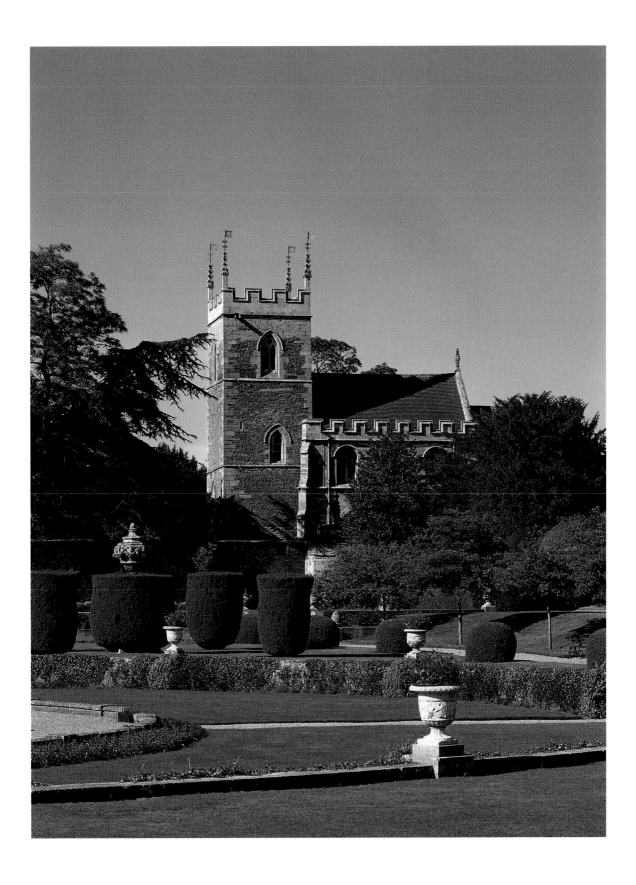

The conflict had ended, but the process of reconstruction was only just beginning. After VE Day, Winston Churchill had proposed that the coalition government he led should either continue in office until the war in the Far East was won – which at the time seemed a distant prospect – or be wound up for a swift general election. Choosing the second course, Churchill resigned on 23 May but continued with a caretaker government while the election campaign got under way.

The first signs for both major political parties, Labour and Conservative, were not good as the first by-election to be held (just before VE Day) saw a huge Conservative majority at Chelmsford overturned by a candidate for Common Wealth. This was the party in which Sir Richard Acland was a leading light. In line with the reforming socialist agenda of Common Wealth, the previous year, Sir Richard had given the National Trust the huge gift of his estates at Killerton in Devon and Holnicote in Somerset. The principal item in the Common Wealth manifesto was that Britain should adopt the recommendations of the Beveridge Report of 1942.

At the close of 1942, while the war was still at its height, Sir William Beveridge had published the schemes that if adopted would usher in a welfare state offering support 'from cradle to grave'. Once the war had been won, Britain should provide for all its people through a contributory social-insurance scheme, with family allowances, full employment policies, improved old-age pensions and a National Health Service that was free to all. 'A revolutionary moment in the world's history is time for revolutions, not for patching,' he wrote. The Churchill government received many of the proposals with barely disguised horror, and tried to water down Beveridge's official recommendations, but the prospect of a new order struck a common chord with the electorate.

Out of the ruins of shattered wartime Britain emerged a new belief in planning, whether of the economy, of townscapes or of employment policy. It was on this that the major parties diverged in the 1945 general-election campaign. The Conservatives saw planning as a wartime necessity that would disappear in peace, and Churchill in particular preached the importance of lowering taxes. The campaign was centred upon Churchill himself: 'Help him finish the job'. In contrast, the Labour party wanted to use planning as a tool for social reform. They spoke about building a new nation together.

Polling day was 5 July. The results were delayed to allow the votes of servicemen abroad to be collected. When the returns came in on 26 July the outcome was electrifying. The Liberals had been reduced to a dozen seats, Common Wealth had been annihilated and was left with one seat (the one gained in the May by-election) and the Conservatives had 213 seats against Labour's 393. Although there had been a widespread belief that the Conservatives would win, instead there was a Labour landslide. Clement Attlee became prime minister, and it was he who represented the nation in the final days of war and in ultimate victory. Churchill

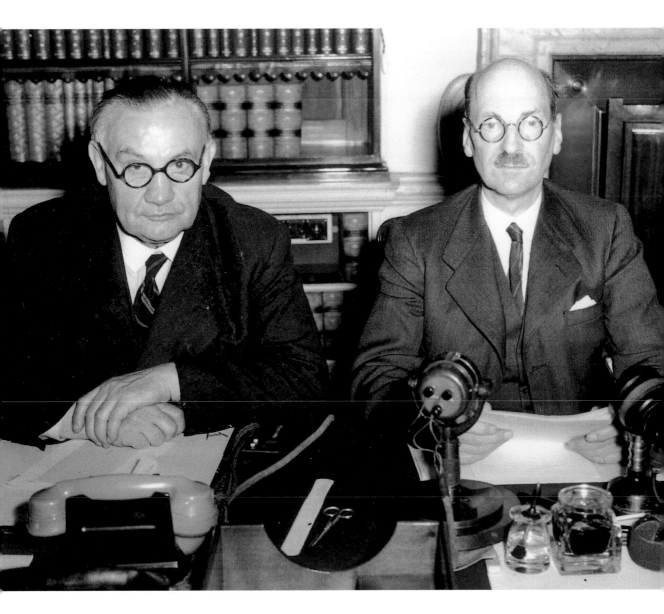

Prime Minister Clement Attlee (right) and Foreign Secretary Ernest Bevin photographed at
No. 10 Downing Street at midnight on 14 August 1945, after announcing, in a BBC Broadcast
to Britain and the Empire, the news of the Japanese surrender in the Far East

went back to Chartwell, his Kent home that had been closed up for the war, to contemplate the seeming ingratitude of the people, to paint, and to write history and of his part in it.

The Labour government did usher in the welfare state, most powerfully symbolised by the National Health Service and the National Insurance scheme. Both came into existence on 5 July 1948. The government programme of nationalisation began. There was an economic recovery and full employment. Yet austerity lasted until the 1950s and, with severe shortages of construction materials, building programmes were particularly slow. Labour had been elected on promises of building new houses and improving the existing stock. The fiery Liverpool MP Bessie Braddock, who had lived through the Blitz and its aftermath, shocked the House of Commons with her maiden speech. 'Our people are living in flea-ridden, bug-ridden, rat-ridden, lousy hellholes,' she said. There had been a pre-war housing construction boom, but that was not matched after the war in spite of the extent of the physical devastation of towns and cities. That was where the 1945 Labour government failed to deliver.

Reconstruction happened at every level. Even where property had not suffered from bombing, there was usually a six-year period of neglect to be overcome. Fred Jones had been a gardener to the Baker family at Owletts in Kent. He went off to the RAF, and returned to his former job when he was demobbed:

I came back to Owletts and, believe me, it was like a wilderness ... there was no one at Owletts at all when I came back, and it was a very depressing sight ... The grass on the lawn was two, three feet high. All we had was a scythe to cut it with and a very ancient lawnmower – and basic enthusiasm ...

Above right: Two men and their dogs on their last leave in West Wycombe in Buckinghamshire before being demobbed at the end of the war

Above far right: Wren Daphne Hickman on leave in West Wycombe in 1943. The suitcase she proudly holds was bought with money left to her by her grandfather

Below right: Aylsham Old Hall on the Blickling Hall estate in Norfolk which was occupied by the army during the war. James Lees-Milne expressed his disgust (see left) at the austerity measures which would delay its repair

Up and down Britain, as houses and estates were handed back to their owners, the extent of the damage became visible. The nation's continuing financial insecurity together with a chronic shortage of both materials and craft skills meant that it was going to be a long haul. The National Trust's representatives met on the Blickling estate in July 1945 to assess what was to be done with one of the historic properties that were part of the Lothian bequest. As James Lees-Milne recorded:

At 2 o'clock [I] met Birkbeck and the painter at Aylsham Old Hall. The army have de-requisitioned it, and given us £450 for dilapidations, out of which we are allowed to spend only £100 if the work is undertaken before August 1st. After that date only £10 p.a. is allowed, which means that no one can possibly inhabit large houses after troops have been billeted in them for six years. It would be quite acceptable if the army, on clearing out, were allowed to reinstate what they had spoilt. As it stands the regulation is unfair and absurd.

In some places clearing-up operations had begun before the end of the war, as on the beaches at Studland. 'After D-Day,' recalls David Sales, 'Studland quietly wound down from war activities, and moved into clearing-up activities. They did a good job.

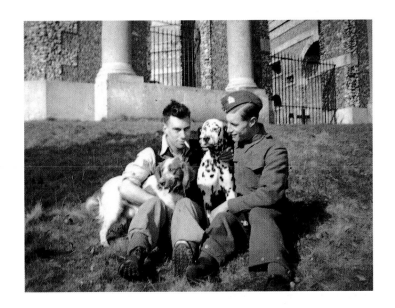

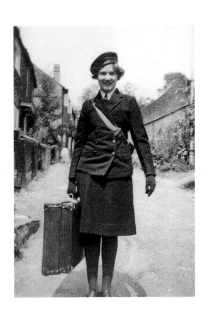

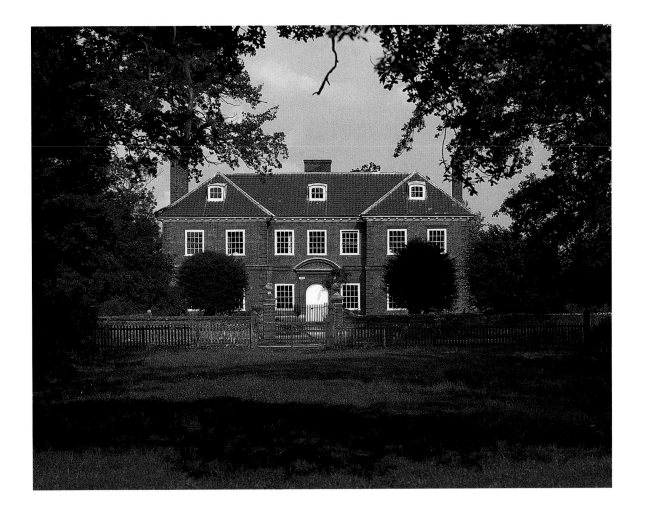

Kingston Lacy in Dorset. The parkland was returned to the Bankes family in 1958

I don't recall anybody after the war being killed by stray ordnance.' Elsewhere it was a very lengthy process. In Clumber Park, Nottinghamshire, which had been a huge ammunitions store, the army moved out very slowly. 'It took a long, long time to clear the ammunition,' John Alcock remembers, 'several years – [it was] more like 1950 [when] – it was cleared. They had to go over it with a toothcomb to find ammunition scattered about.'

Views of London and other cities show empty bomb sites well into the 1950s, waiting for the rebuilding boom to begin. In the countryside, the architectural historian John Harris described a scene far removed from what he would have seen before the war:

The traveller through England after 1945 journeyed in a dream-like landscape, so many empty mansions standing forlornly in their parks, all in a vacuum, awaiting the return of their owners to decide their ultimate fate; the process towards compensation was so slow that several houses collapsed in the interim. This state of uncertainty lasted until well beyond 1960.

The Bankes estate in Dorset finally got the parkland back at Kingston Lacy in 1958; the US Army hospital buildings had been a useful post-war facility, serving as overspill council housing, accommodation for refugees from Hungary, and storage for various official bodies.

Nowadays, there is almost nothing to see at Kingston Lacy to show the extent of the hospital; time and nature have covered the

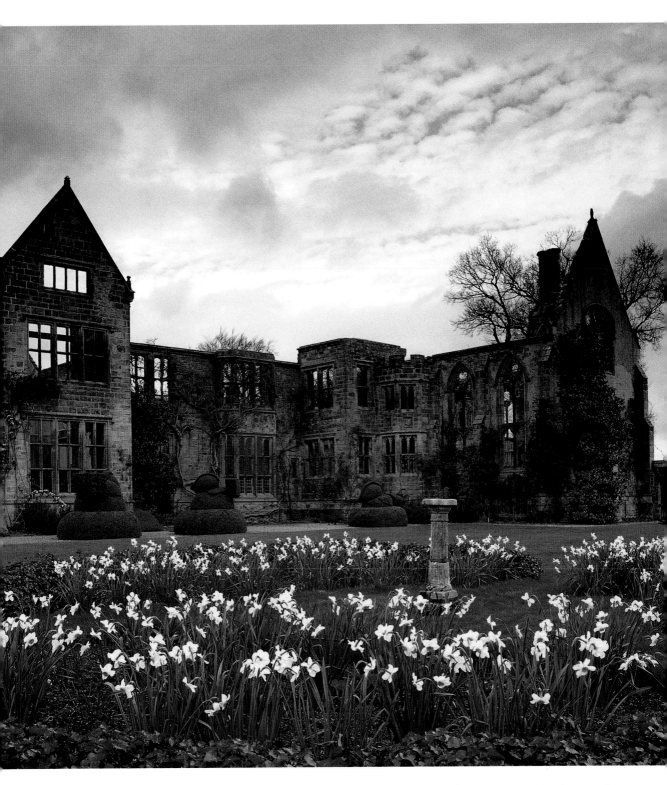

The remains of the manor house at Nymans in West Sussex. The house burned down in 1948 leaving only a shell, and Nymans is now reputed for its garden. There is little trace of how it was used to house boys from a school in Wesminister during the war years

evidence over. To those surveying the wreckage of war at the time, the task of recovery sometimes seemed hopeless and the destruction cruel. On one of his journeys in Surrey, James Lees-Milne '... passed Witley Common, which Hubert [Smith, the Trust's Chief Agent] says can never be reinstated – it has been turned into a parade ground with tarmac roadways and brick barracks ...' Vita Sackville-West wrote to her husband Harold Nicolson from Sissinghurst:

I have lost all pleasure in the lake, and indeed in the woods, since soldiers came and invaded them and robbed them of all the privacy I so loved. You didn't understand when I minded the tanks cutting up the wild flowers. It was a thing of beauty, now tarnished for ever – one of the few things I had preserved against this horrible new world ...

Today, again, there are no signs in either place that this all happened. Only memories, and they are fading fast.

Witley Common had been given to the National Trust in the 1920s. Ownership of Sissinghurst Castle and its famous gardens was transferred to the Trust in 1967. These places, and hundreds of others now in the care of the National Trust, all have stories of war to be told. Some of those stories have been recounted here. Stories of fear and joy, children's cares and children's carefreeness. Tales of death and rebirth, ingenuity and coercion, secret work and public celebration. Scenes from the country house, the beach, the village street and the urban terrace. Memories of bewilderment and loss, set against the determination to survive and pass on something worthwhile.

Just as the Second World War was breaking out, Edith Olivier had paid a hasty visit to Hardwick Hall and other great houses in Derbyshire, knowing that they would soon be closed to view – and fearing they might not survive the coming onslaught. If they did survive, then the future should ensure that they were kept in the best way and for all to share. She wrote of her trip:

Edith Olivier paid a visit to the great Tudor house, Hardwick Hall in Derbyshire before the outbreak of war and commented how life would never be the same again for large country houses

Yesterday's drive was over a no-man's-land. It lay between the past and the present and I know not where we are tending ... I believe that those stately days will never quite come back. The beauty, the history, the happiness, and the pervading sense of a great past brooding over each of those houses – all of these will suffer eclipse at least for a time. Yet those who have known what all this means will surely be bigger people to face what is to come ... Maybe, this is what those of us who survive will see most clearly, and admire most wholeheartedly, in the coming years – the rising generation rising to a task which we know to be beyond ourselves.

Acknowledgements

The author would like to thank all those at the National Trust who helped to produce this book, notably:

Helen Dunkerley, who had the original idea for this book in her former role as Assistant Guidebook Editor; Grant Berry, Andrew Cummins, Margaret Willes from the Publishing department; David Adshead, Frances Bailey, Sue Baumbach, Kelly Betts, Malcolm Billings, Clair Bissell, Emily Burningham, Jill Burton, Sophie Chessum, Megan Doole, Jane Fletcher, Nancy Grace, Margaret Gray, Rebecca Graham, Rebecca Marshall, Denise Melhuish, Hugh Meller, Martin Papworth, Jeremy Pearson, Lucy Porten, Charles Pugh, Tina Salter, Francesca Scoones, Margit Soderstrom, Diana Stone, Shelley Tobin, Samantha Wyndham.

Special thanks must go to the following who provided photographs, reminiscences and otherwise assisted in the publishing process:

Anna Ap-Richard, Jill Banks, Mrs Beale, George Behrend, the Blakiston family, Andrew Bridgewater, Ruth Burgess, Margaret Daly, Sir Edward Dashwood, Laura Dunaway, Anne-Marie Ehrlich, Peggy Fell, Molly Gibson, Peter Goldfinger, Beryl Griffiths, Daphne Hickman, Graham Hicks, Betty Hockey, Sir Richard Hyde-Parker, Joyce Jones, Lindsay Jones, Thomas Lisle, Betty Lockington, Douglas McCarthy, Frank Mayling, Jim Moore, the late Nigel Nicolson, Yvonne Oliver, David Oosterman, Cathy Pearson, Hazel Powell, Sylvia Priestley, Grace Qualls, Phillip Reeves, Tim Richardson, Helen Samain, Peter Schweiger, Nadine Shiner, Howard Sledmere, Greg Sohrweide, Jean Stacey, Andrew Trend, Janet Turnbull, John Wells, Robert White, Philip Winterbottom, Marguerita Young, and all those who were interviewed and who conducted the interviews over the years for the National Trust Oral History Archive.

Quotations

Unless otherwise noted here, quotations in the text are taken from tapes in the National Trust Oral History Archive or other National Trust Archives (for more details, see back jacket-flap).

Published Material:

Quotations from Sheila Donnelly from the National Trust booklet by Laura Hetherington and Yvonne Hurt, *The War Child : World War II evacuation*; quotations from Sir Richard Hyde-Parker, Lady Iliffe and Peter Goldfinger are from the National Trust guidebooks to Melford Hall, Basildon Park and 2 Willow Road; quotations from Marion Browne, Pearl Cartwright, Dorothy Laycock, John McEwan and Morgan Wood are from the Liverpool Oral History archive:
http://www.liverpoolmuseums.org.uk/maritime/

Other quotations taken from:

Grace Bradbeer, *The Land Changed its Face: the Evacuation of Devon's South Hams 1943-1944*
Angus Calder, *The People's War: Britain 1939-45*
Ralph Dutton, *A Hampshire Manor*
Eric Ennion, *Adventurers' Fen*
Desmond Flower and James Reeves (eds), *The War 1939-1945*
John Harris, *No voice from the hall: early memories of a country house snooper*
Nicolas McCamley, *Saving Britain's Art Treasures*
Russell Miller, *Nothing Less Than Victory: an oral history of D-Day*
James Lees-Milne, *Diaries 1942-1945*
Harold Nicolson, *Diaries and Letters 1939-45*
Edith Olivier, *Night Thoughts of a Country Landlady: being the pacific experiences of Miss Emma Nightingale in time of war*
Vita Sackville-West, *The Women's Land Army*
Nicola Tyrer, *They Fought in the Fields. The women's land army: the story of a forgotten victory*
Ben Wicks, *No Time to Wave Goodbye*

Picture Credits

The author and publisher would like to thank the following who have given permission to reproduce their material.

Individuals: Molly Andrew: 45; Anna Ap-Richard: 30, 31; Blakiston family: 88, 89, 90, 91; Sir Edward Dashwood: 87; Daphne Hickman: 21, 179; Jim Moore: 92, 93; Betty Lockington: 97; C. Needham: 51; Hazel Powell: 81, 97; Phillip Reeves: 60, 97, 99; Tim Richardson: 34; Jean Stacey: 63; Samantha Wyndham: 169, 170

Organisations: Art Archive: 47, 75; DACS: 46, 57; Imperial War Museum Photographic Archive: 3, 11,14, 15, 19, 23, 27, 41, 42, 53, 58, 65, 73, 77, 93, 141, 153, 155, 159, 161, 162, 177; Board of Trustees of the National Museum and Galleries of Merseyside (Steward Bale archive): 139, 145, 147; National Gallery: 84; English Heritage (NMR) RAF Photography: 115; National Trust: 36; Royal Bank of Scotland: 129

Photos from the National Trust Photographic Library: Matthew Antrobus: 84, 109, 111; John Blake: 156; Andrew Butler: 127, 171; Michael Caldwell: 107; Joe Cornish: 55, 113; Derek Croucher: 61, 86, 125, 133; Andreas von Einsiedel: 24, 33; Geoffrey Frosh: 166; Dennis Gilbert: 143, 144; Ray Hallett: 37; John Hammond: 136; Andrea Jones: 130; Anthony Kersting: 49; Horst Kolo: 94; Nick Meers: 22, 91, 135, 150, 167, 183; John Miller: 168; David Sellman: 67; Ian Shaw: 121, 181; Robert Thrift: 165; Martin Trelawney: 20, 70; Rupert Truman: 17, 99, 175; Ian West: 9, 79, 173, 180; Andy Williams: 53; Mike Williams: 25, 179

Photos from National Trust Properties: Ashridge Estate: 105; Attingham Park: 95, 101; Chartwell: 69; Clumber Park: 105; Corfe Castle: 116, 117; Hardwick Hall: 106, 107; Killerton: 124, 125; Lyme Park: 134, 135; Nymans: 22, 119, 121, 122; Powis Castle: 126; 59 Rodney St. (E.Chambré-Hardman archive): 148, 149; Saltram: 83, 100, 101; Sutton Hoo: 35, 39, 56, 63; Waddesdon Manor: front cover, 29, 30, 123; 2 Willow Road: 142, 157

Further Reading

The Second World War is one of the most written-about periods in history. This is a brief guide to works that were useful in writing this book or will help provide guidance for wider exploration.

The National Trust's guidebooks to individual properties were also invaluable in providing information about how the war years affected its properties, as were many local history and privately published pamphlets and reminiscences.

Grace Bradbeer, *The Land Changed its Face: the Evacuation of Devon's South Hams 1943-1944* (David & Charles, 1973)

Asa Briggs, *Go to It! Victory on the Home Front 1939-1945* (Mitchell Beazley, 2000)

Angus Calder, *The People's War: Britain 1939-45* (Cape, 1969)

Juliet Gardiner, *The 1940s House* (Channel 4, 2000)

Juliet Gardiner, *Wartime: Britain 1939-1945* (Headline, 2004)

Laura Hetherington and Yvonne Hurt (National Trust booklet), *The War Child : World War II evacuation : Understanding history through drama & theatre : a source book for schools* (National Trust and Haddenham, 2000)

Vere Hodgson, *Few Eggs and No Oranges : a diary showing how unimportant people in London and Birmingham lived throughout the war years 1940-45* (Persephone, 1999)

Ruth Inglis, *The Children's War: Evacuation 1939-1945* (Collins, 1989)

Fred Kitchen, *The Farming Front* (Dent, 1943)

James Lees-Milne, *Diaries 1942-1945: Ancestral Voices & Prophesying Peace* (John Murray, 1995) Originally published in 2 vols. as: *Ancestral Voices* (Chatto & Windus, 1975); *Prophesying Peace* (Chatto & Windus, 1977)

Nicholas McCamley, *Saving Britain's Art Treasures* (Leo Cooper, 2003)

S.P. MacKenzie, *The Home Guard: a military and political history* (Oxford University Press, 1995)

Arthur Marwick, *The Home Front: The British and the Second World War* (Thames & Hudson, 1976)

Rayne Minns, *Bombers and Mash: The Domestic Front 1939-45* (Virago, 1980)

Harold Nicolson (ed. Nigel Nicolson), *Diaries and Letters 1939-45* (Collins, 1967)

Edith Olivier, *Night Thoughts of a Country Landlady: Being the Pacific Experiences of Miss Emma Nightingale in Time of War* (Batsford, 1943)

John Martin Robinson, *The Country House at War* (Bodley Head, 1989)

Vita Sackville-West, *The Women's Land Army* (Michael Joseph, 1944)

John Stevenson, *British Society 1914-45* (Penguin, 1984)

Judy Taylor, *Beatrix Potter: Artist, storyteller and countrywoman* (Frederick Warne, 1986)

Judy Taylor (ed.), *Beatrix Potter's letters* (Frederick Warne, 1989)

Nicola Tyrer, *They Fought in the Fields: The women's land army: the story of a forgotten victory* (Mandarin, 1997)

Ben Wicks, *No Time to Wave Goodbye: True stories of Britain's 3,500,000 evacuees* (Bloomsbury, 1988)

Index